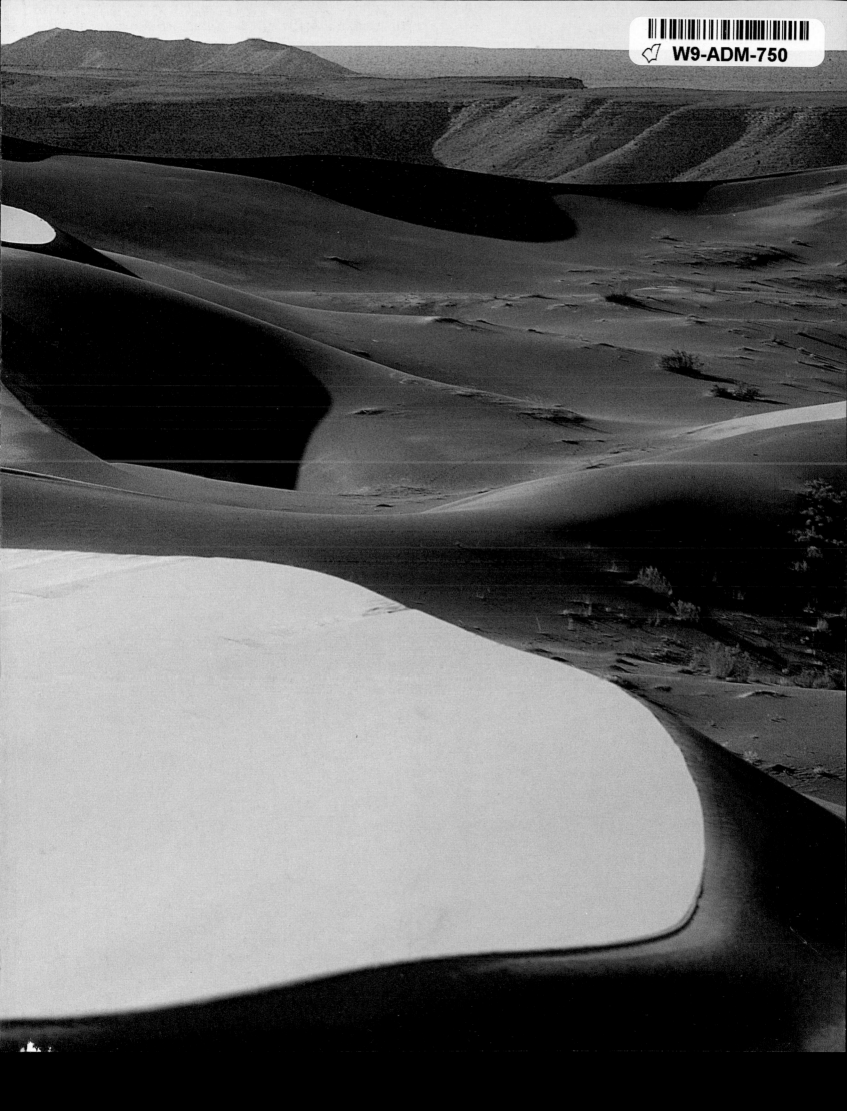

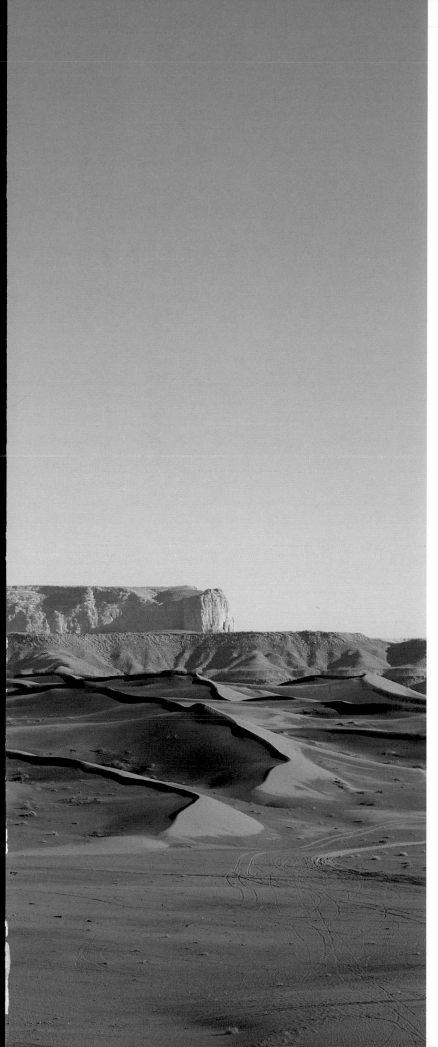

MYSTERIES OF THE DESERT

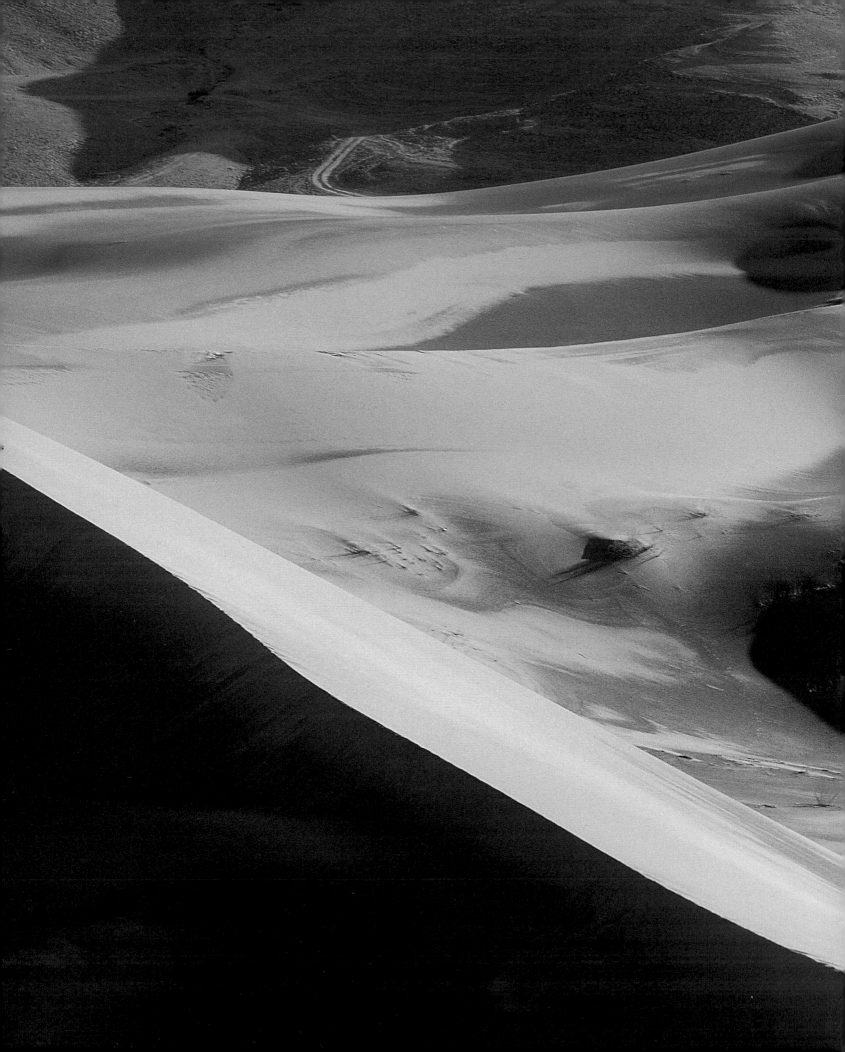

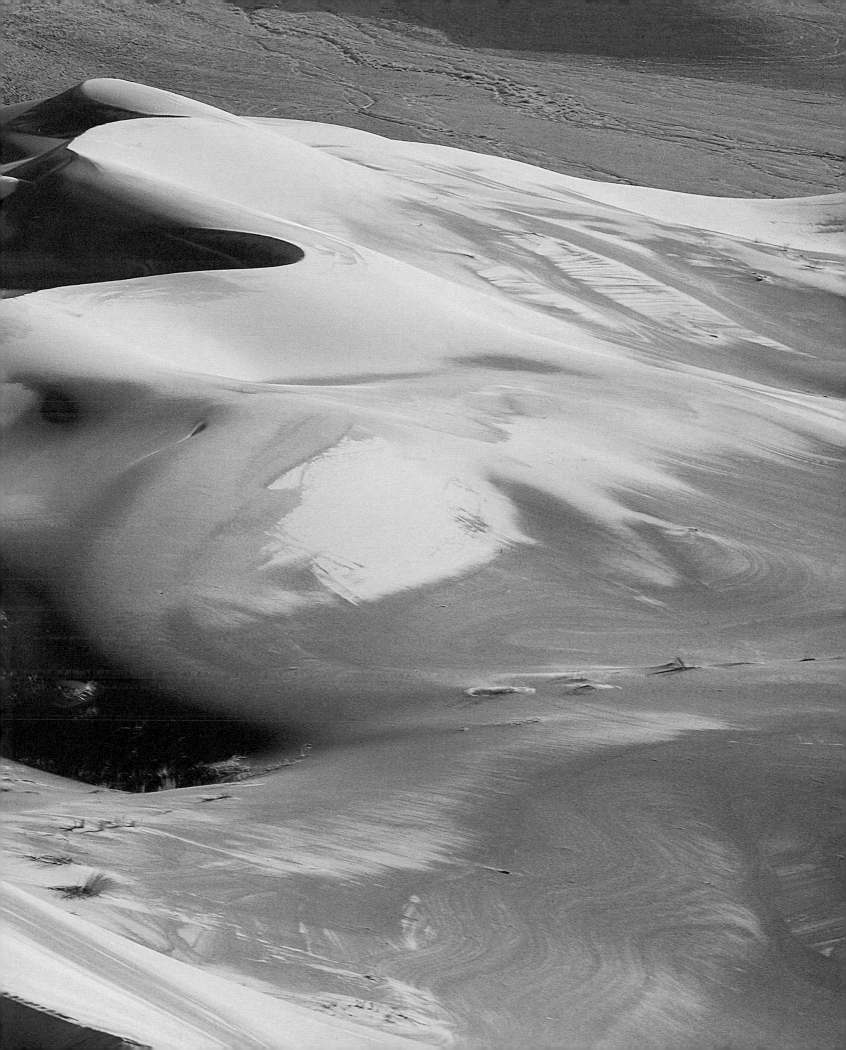

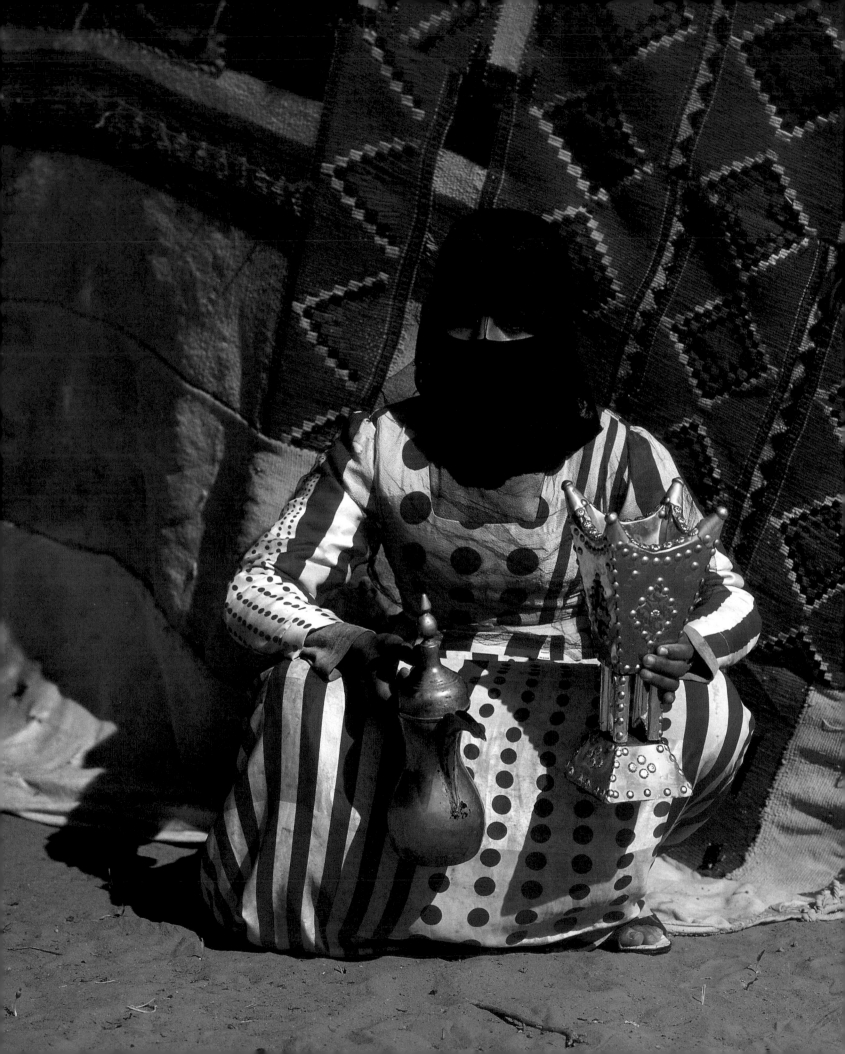

MYSTERIES OF THE DESERT

A View of Saudi Arabia

ISABEL CUTLER

RIZZOLI
NEW YORK

ANTHOLOGY TRANSLATIONS

Pg. 24 Translated by Christopher Tingley, Salma Khadra Jayyusi and
Richard Wilbur

Pg. 35 Translated by Sharif Elmusa and Naomi Shihab Nye (bottom)

Pg. 37 Translated by Salma Khadra Jayyusi and Naomi Shibab Nye

Pg. 41 Translated by Lena Jayyusi and Naomi Shihab Nye (bottom)

Pg. 47 Translated by Lena Jayyusi and Naomi Shihab Nye (top), and Mustafa
Badawi and John Heath-Stubbs (bottom)

Pg. 57 Translated by Patricia Alanat Byrne and Salma Khadra Jayyusi

Pg. 58 Translated by Sharif Elmusa and Naomi Shihab Nye

Pg. 61 Translated by Adnan Haydar and Michael Beard

Pg. 62 Translated by Sargon Boulus and Christopher Middleton

Pg. 66 Translated by Lena Jayyusi and Naomi Shihab Nye (bottom)

Pg. 74 Translated by Adnan Haydar and Michael Beard (top)

pg. 83 Translated by Lena Jayyusi and Naomi Shihab Nye (top)

Pg. 84 Translated by John Heath-Stubbs and Salma Khadra Jayyusi

Pg. 93 Translated by C. A Helminski, K. Helminski and Ibrahim Al-Shihabi

Pg. 101 Translated by Lena Jayyusi and Diana Der Hovannessiann

Pg. 115 Translated by Lena Jayyusi and Samuel Hazo (top)

Pg. 123 Transalated by Patricia Alanab Byrne and Salma Khadra Jayyusi

Pg. 126 Translated by May Jayyusi and Charles Doria

Pg. 134 Translated by Issa Boullata and Thomas G. Ezzy

Pg. 137 Translated by Lena Jayyusi and Naomi Shihab Nye

Pg. 139 Translated by Sargon Boulus and John Heath-Stubbs

Pg. 140 Transalted by Matthew Sorenson and Patricia Alanab Byrne

Pg. 143 Translated by Issa Boullata and Thomas G. Ezzy

Pg. 148 Translated by Patricia Alanab Byrne and Salma Khadra Jayyusi

Pg. 157 Translated by Salma Khadra Jayyusi and Charles Doria (top and bottom)

First published in the United States of America in 2001 by
Rizzoli International Publications, Inc.
300 Park Avenue South
New York, NY 10010

Copyright © 2001 Rizzoli International Publications, Inc.
All photographs © 2001 Isabel Cutler

Design by Lynne Yeamans

ISBN: 0-8478-2359-8
Library of Congress 00-111268

Printed and bound in Italy

ACKNOWLEDGMENTS

This book was produced with the support and encouragement of many people. Although I will never be able to repay them, I hope they will find in the following pages a worthy tribute to this unique part of the world.

I am grateful to my Saudi friends for my first introduction to the mysteries of the Arabian desert, in particular to the late Ibrahim Obaid and his wife, Su'ad Al-Dabbagh. During my years in the Kingdom and on subsequent return trips, Brigadier General Nicholas Cocking and his wife, Anna, were unfailingly generous in serving as guides and companions on frequent desert forays, as were Verne and Jeannie Cassin. Their knowledge of the terrain and patience while I was photographing were invaluable. Our driver Mursal became an expert in navigating the sands.

My admiration and gratitude go to the many poets and authors whose words accompany my pictures. I am honored to be able to include among them such distinguished and well-known Saudi poets as His Royal Highness, Prince Khalid Al-Faisal, Governor of the Province of the Asir, and Ghazi Al-Gosaibi, the Ambassador of Saudi Arabia to the Court of St. James. I am grateful to the collectors of Arabic poetry, both ancient and modern, who have produced the splendid anthologies from which I have selected the poems, and to the many translators, poets in themselves, who through their brilliant translations have enabled me to appreciate, and now to share, at least a part of the wealth of Arabic poetry.

I am greatly indebted to the Library of Congress, in particular to Georges Atiyeh, former director of the Middle East/Africa division, who initially pointed me towards the many volumes of English translations of Arabic poetry, and to Mary Jane Deeb, his successor. The library of the Middle East Institute in Washington, D.C., was also an exceptionally useful resource.

A special thank you to Aida Karaoglan for her constant support and good advice; to Patricia Haas, Reine Battle, and Kemp Battle for guiding me on the way to publication; to the helpful staff at the Embassy of Saudi Arabia in Washington, D.C.; to Alexander Hoyt, my agent; to Ellen Hogan Elsen, my editor; to Rizzoli International Publications, Inc., my publisher; and to my daughter, Frederika Brookfield, for her unfailing encouragement.

Finally, my unending appreciation goes to my friend and sponsor Sheikh Abdul Aziz Al-Sulaiman whose support and encouragement from the very beginning helped me to realize my goal. I am also most grateful to Saudi Aramco and BP for their generous sponsorship. Their confidence and trust in me helped to make this book a reality.

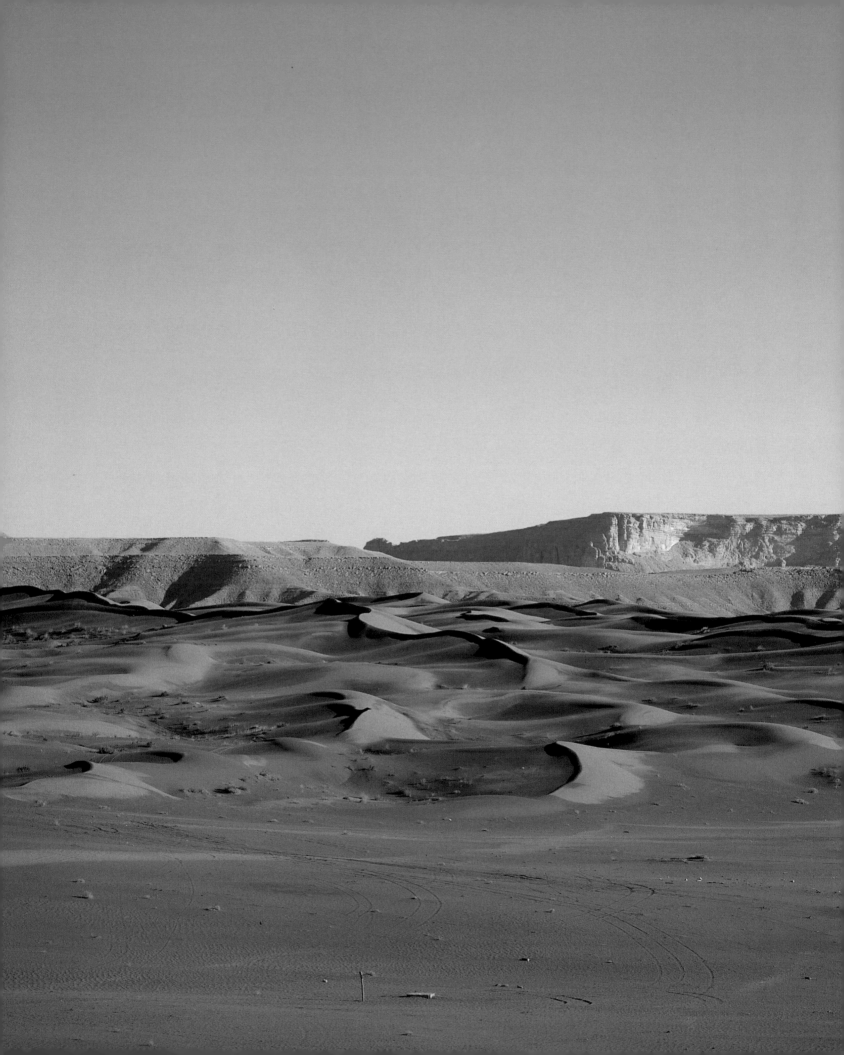

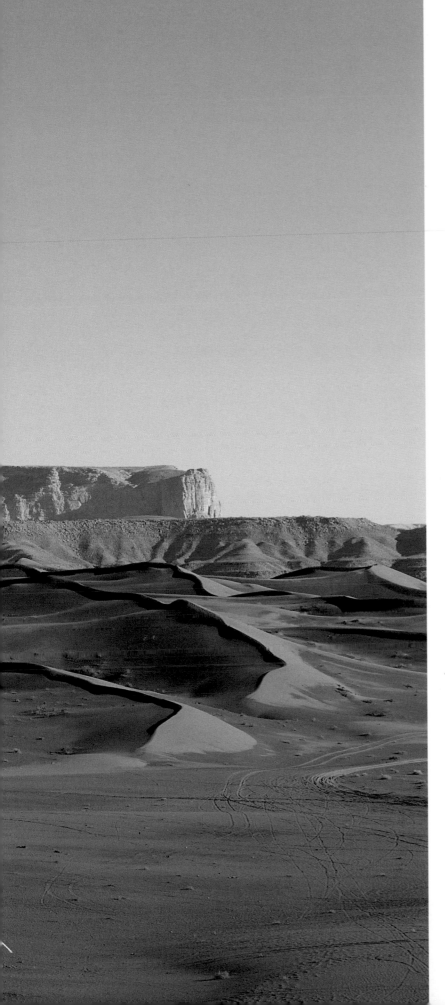

FOR WALT,

who first led me to this unique and fascinating part of the world.

The many years I spent living in the Middle East, and my annual sojourns there since, have imbued me with a deep and enduring love for this extraordinary part of the world. Aroused by the exotic beauty of the desert, humbled by the sand-washed splendor of ancient ruins, enchanted by the faces of men, women, and children—I had to record it all. As a child I always lived near the water. What I remembered as the seemingly endless nature of the sea was mirrored in the equally endless rolling dunes of the desert. I was mesmerized. I wanted not only to capture the magnificence of this land-scape, but also to know more about the people who called it their home, and to experience their famous "desert hospitality"—those legendary three days when it is customary to offer food and shelter, even to your enemy.

This book is in large measure a tribute to the mystical beauty of the Arabian desert and to the values which have sprung from it. Although desert life cannot escape the incursions of modern-day technology, these timeless values continue to shape life today not only in the Arabian peninsula, but throughout the Arab world.

My first visual impression of Saudi Arabia was from an airplane: miles and miles of barren desert—vast, empty, so seemingly remote from civilization, with the exception of a few scattered Bedouin tents and wandering camels. As night began to fall, it covered the desert with a blanket of darkness broken only rarely by the faint flicker of a campfire. Suddenly, as the plane prepared to land, the sky shed its mantle of black and became a sea of sparkling lights illuminating the ultramodern capital city of Riyadh. Serpentine highways, palaces, hotels, and office high-rises—all blazing away in the middle of nowhere. The Desert Kingdom, home of the continual oil boom, had electricity to spare. These two strikingly different visual impressions remain fixed in my mind as symbolic of the skillful weaving together of tradition and modernity that has enabled Saudi Arabia to cherish and preserve its traditions, while embracing today's breathtaking development.

It was the desert that inspired me to photograph. The never-ending variations of color, form, and texture, the sensation of sands stretching endlessly to the horizon, the feeling of serenity, the for-

midable emptiness—all elicited in me a compulsion to capture the essence of this magnificent ter-

rain. Gertrude Bell, the well-known adventurer, described this magic so well when she wrote,

"I never tire of looking at the red gold landscape and wondering at its amazing desolation. I like

marching on through it and wonder whether there is anywhere that I am anxious to reach."

One cannot become immersed in the culture of the Middle East without being aware of its long tradi-

tion of poetry, originating from a sense of romance, chivalry, love of land, and devotion to God and

family. Although my original intent was to produce a book of photographs, I became convinced that a

selection of the sentiments so poignantly expressed in both oral and written poetry—from pre-Islamic

times to modern days, from Bedouin bards still living in the desert to poets now residing in urban

areas—would complement and enhance what I had captured with my camera.

I buried myself in tomes of poems and marveled at the descriptive words of the earliest Bedouin

poetry. Both pre-Islamic poetry and the wealth of poetry in the centuries following the birth of Islam

have been brilliantly translated by scholars from around the world. I was particularly fortunate to find

a collection of poems by a Bedouin bard who had lived in the desert not far from the city of Riyadh,

who died only recently, and whose poems had been translated by a Dutch diplomat. For lovers and

students of modern Arabic poetry there are excellent anthologies available today, much as in ancient

times when the poems were gathered into collections such as the Mu'allaqat and the Hamasa. I also

found an unending source of wisdom in old Arabic proverbs which provide insights into human nature

that apply not only to the Bedouin and those living in desert habitats, but also to those residing in

cities.

The compelling descriptions of such noted travelers as Wilfred Thesiger, Pierre Loti, Gertrude Bell,

and T. E. Lawrence have also contributed greatly to the literature about the Arabian desert, and so I

have included some of their words as well. I myself speak only rarely throughout this book, because

the poets of the region have said it best. It was a privilege to spend my days immersed in their works.

With their words and my pictures, I have sought to portray at least a portion of the awesome majesty

of this very special part of the world.

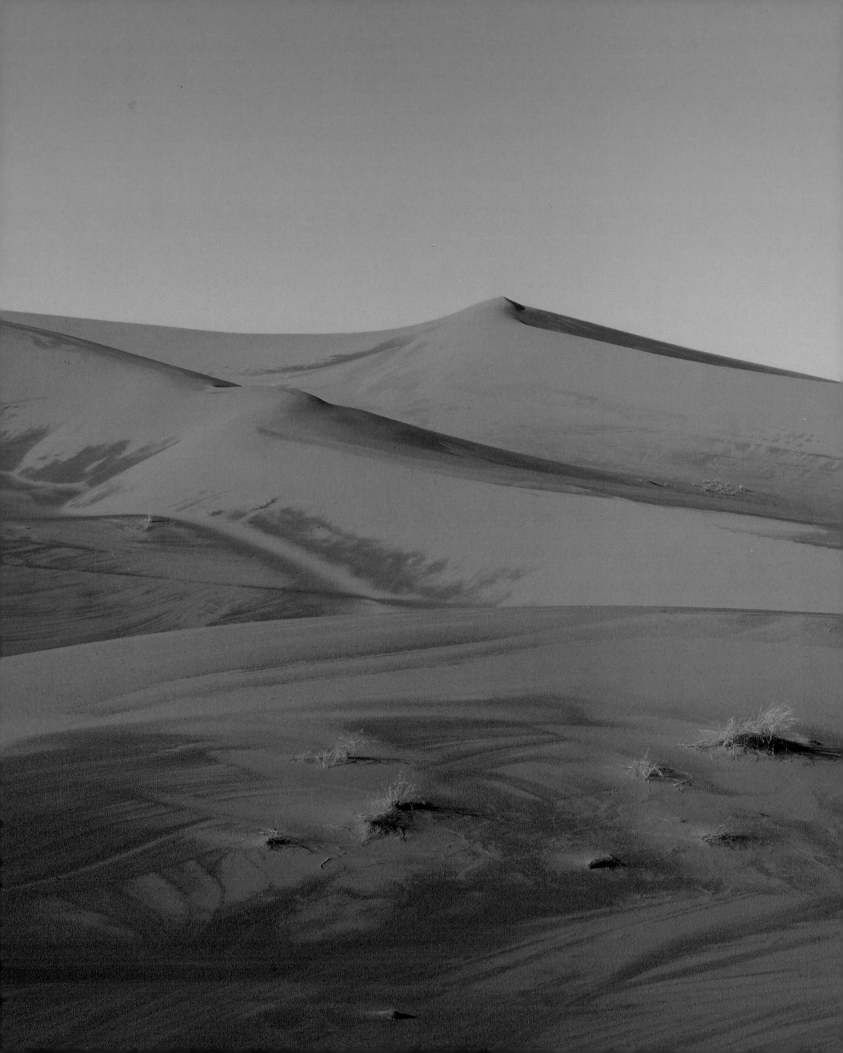

INTRODUCTION

Geologists believe that some 35 million years ago Arabia broke away from the continent of Africa. The split formed a long trough which today is the Red Sea. Although much of the land is desert now, it was not always so. Remains of hippopotami and water buffalo, and fossils of sea urchins and clams are evidence of a milder era with a moister climate.

The immense quantities of sand which eventually blanketed these areas were produced from the erosion of rock over time. Floods surging through dry river beds carried a mixture of water and sand to the plains. As the water evaporated the sands were blown into dunes of an infinite variety of forms. Today the imposing contours of the dunes are new and ever-evolving shapes of those skillfully sculpted by winds over the centuries. The shamal—a wind which blows in winter and late spring—was an important factor as it redistributed coastal sand from the area which is now the Arabian Gulf, but which many years ago was mostly above sea level.

More than a million square miles in area, the Arabian peninsula has for thousands of years supported herding and hunting cultures, and, in more recent times, agriculture. Today, it is home to seven independent countries, the largest by far being the Kingdom of Saudi Arabia with a population of about l7 million. The others are Kuwait, Bahrain, Qatar, the United Arab Emirates, Oman, and Yemen. Linked by history and religion, sand and sea, each country nevertheless retains a unique personality.

Gentle peaks of the Al-Dahna Desert.

Saudi Arabia, occupying approximately three-fourths of the peninsula, is divided into four vast regions: Al-Hasa in the east, extending along the coast of the Arabian Gulf; the Najd, covering the northern and central regions; the Hijaz in the west, including the mountain chain paralleling the Red Sea coast from Jordan to Yemen; and the Asir in the south, including the Sarawat mountain range. Climates range from hot and humid along the coasts of the Red Sea and the Arabian Gulf, to hot and dry in the interior, to cool and moist in the mountains. The desert, often scorchingly hot by day, can become surprisingly cold at night. Rain is a rarity, except in the mountainous areas of the southwest. There are three principal deserts in Saudi Arabia: the Great Nafud in the north, the vast Rub al-Khali (also known as the Empty Quarter) in the south, and the Al-Dahna Desert, which forms a link between the two.

In contemplating the mysteries of the desert, one can sense the spirituality and the strength of those who make it their home. As Wilfred Thesiger, noted explorer and traveler of the early l900s, put it so penetratingly, "All that is best in the Arabs has come to them from the desert" Strength of character gained from unique hardships associated with nomadic existence; steadfast devotion to religion as a comfort in the face of the starkness of life in a barren land; a sense of humor, courage, patience, dignity; a passionate love for poetry; and, finally, the riches from oil which have catapulted the region into modern times—all are essentially products of the desert.

The Rub al-Khali is unquestionably one of the most forbidding and least-known deserts in the world. Long an object of fascination for explorers and writers, it is one of the largest unbroken stretches of sand desert on earth, with grandiose dunes of multicolored hues rising over a thousand feet above grayish-white salt flats formed from ancient sea beds. Extending from the mountains of Oman in the east to Yemen in the south and west, it derives its name from the fact that for six months of the year stifling temperatures of over 120 degrees Fahrenheit, with sand temperatures over l70 degrees, render the desert too scorching for human survival. Awesome, fascinating, and always challenging, its mysterious aura is not unlike a lunar landscape. Parts of the Rub al-Khali may go without rain for as long as thirty years. When it does rain, however, the water gathers and is stored in the dampened

sand grains. As little evaporation occurs once rain water sinks below seven feet, it is believed that some plants today are still drawing moisture from rain that fell more than a thousand years ago.

The only people with sufficient knowledge to survive the perils of the desert are the Bedouin. Even today, with Toyota trucks replacing camels, it is these savants of the terrain who know the humors of the sands and how to master them. Word of the best grazing areas is passed among members of the families who hover on the desert's edge during the summer, and then in winter move into the interior in search of pasture for their camels and other livestock. Up until recently the Bedouin lived the life of their ancestors, as they knew no other way.

T. E. Lawrence, in describing the rigors of desert life for the Bedouin, fully understood the spell which it cast upon them: "Bedouin ways were hard even for those brought up in them, and for strangers, terrible: a death in life. No man can live this life and emerge unchanged. He will carry, however faint, the imprint of the desert, the brand which marks the nomad: and he will have within him the yearning to return, weak or insistent according to his nature. For this cruel land can cast a spell which no temperate clime can match."

There are still many Bedouin tribes in the Kingdom of Saudi Arabia today. The ruling Al-Saud family traces its heritage to the Anazah tribe of northern Arabia. Saudis who no longer lead the wandering life of the Bedouin and have settled in the cities, point with pride to their Bedouin roots and to the authenticity of their heritage.

It is commonly claimed that the Bedouin speak a pure Arabic, and that even the prophet Mohammed, who as a boy spent time with the Bedouin in the desert, spoke "the tongue of the desert." It is not surprising that others, confronted with the Bedouin's strong sense of self and instinct for survival, feel a sense of personal inferiority in their presence. Although the Bedouin generally marry within their own tribe, King Abdul Aziz, the venerable founder of Saudi Arabia, married daughters of diverse tribes in his quest to unite the country.

The harshness of Bedouin life has in many ways rendered men and women equal. Their tasks are clearly delineated, neither being able to survive without the other. Women cook, sew, and keep camp. Men protect their families and provide the animals which, in ancient times, meant raiding other tribes. The grimness of Bedouin life in former times is illustrated by the eighth-century poet Abu Nuwas:

Amongst the Bedouins seek not enjoyment out.

What do they enjoy? They live in hunger and in drought.

Let them drink their bowls of milk and leave them alone,

To whom life's finer pleasures are all unknown.

There are, however, joys in the life of the Bedouin as well: the birth of a boy, for example, or the arrival of a new colt. So, too, is the advent of a poet. Composing odes describing not only the travails but also the romance of life provides the poet as well as his listeners with relief from the grimness of the fight for survival. In emphasizing bravery, patience, persistence, and protection of the weak, poetry has created a certain standard of Arabian values.

Traditionally, a poet recited his poems in the form of an ode, often as long as 120 lines. The ode offered a series of glimpses into the life of the poet and his immediate surroundings—his horse, his camel, his beloved, and his tribe. As men gathered around to hear him recite, his powerful words and noble expressions enthralled his listeners with the accuracy and truth with which he described the life they knew so well. A poet was a spokesman for their honor and a voice to perpetuate their glorious conquests and establish their fame forever.

Every serious poet had his *rawi* who accompanied him everywhere and memorized his poems. Often poets themselves, the rawis frequently interpreted the poems as they recited them. It is through these poems, passed down orally from one generation to another, that we are able to catch a glimpse of desert life in the sixth and seventh centuries. Although some of the richest Bedouin poetry flourished at this time, it was not until the late seventh century that these poems were actually transcribed.

While the rigors of Bedouin life continue today, they are greatly lessened as modern technology makes inroads into the sands. The burden of transport is no longer the sole responsibility of the camel. One is likely to find four-wheel-drive vehicles snaking across the desert, a water tank beside the Bedouin's tent, and children in the early morning leaving their tents to be driven to school in a pick-up truck. It is inevitable that many traditional customs are fading as life in the twenty-first century increasingly affects the ways of the Bedouin.

The Bedouin are traditionally known for their bravery, chivalry, generosity, and hospitality. The extreme harshness of life impelled them to accord a traveler the basic amenities of life. The code of the desert required that even one's enemy be offered food and shelter for three days. The custom of preparing and offering coffee to a guest has played an essential role in the hospitality of the desert for centuries. The smell of slowly roasting coffee beans is a signal to neighbors that they are welcome. At just the right moment the husks are shed and the roasted beans are pounded. Saying that a man "pounds coffee from morning till night" is the Bedouin way of indicating the man is a particularly generous host. The ritual of preparing coffee is quite elaborate. After the pounding the coffee is emptied into a large pot, boiled, and allowed to settle. It is then poured into a smaller pot where saffron, cloves, and ground cardommon seed are added. With great ceremony it is passed to the guest of honor and then down the line. It is never filled to the top as that would be a signal to drink and leave immediately.

During my stay in Saudi Arabia I made frequent trips to the desert. When I encountered a Bedouin encampment the women would often signal me to join them. The men were off on other business and the women, quite naturally, were curious as to who I was, why I was there, and where I was from. I would be invited to join them in their tent for coffee. They eagerly accepted the Polaroid photographs I took and offered to them. Inevitably they would ask me how I liked their country. To this day, the aroma of cardommon coffee fills me with nostalgia.

Generosity ranks among the most important of Bedouin values. Wilfred Thesiger tells of a time when a very old, haggard man came limping into a tent. Poor and sick, he was effusively greeted by all. Wondering

at the unusual warmth with which this guest was greeted, Thesiger later learned that the man had once been enormously rich. To every visitor who came to his tent, he had offered a freshly slaughtered camel. Finally, he had nothing left save his reputation. All who knew him envied and praised his generosity. Such hospitality is both accurately and poignantly described in the words of Hatim, a pre-Islamic poet:

The guest's slave am I, 'tis true, as long as he bides with me,
Although in my nature else no trait of the slave is shown.

This legendary hospitality is found today throughout the Middle East where the mores and ethics of the desert have been widely accepted.

A book about desert life must also pay homage to that magnificent "ship of the desert"—the camel. Ad-Dindan, a Bedouin bard living in the Najd, once said:

Camels! One cannot speak of camels but with the deepest respect;
With the Lord no other species can boast a comparable status.

Over the ages, this largest of all Arabian animals was used for battle, sold for currency, sheared for wool, and employed as transport. Also, a source of milk and food, the camel has long served as total provider for the Bedouin. Man's companion in the Arabian peninsula for four thousand years, its use as a domestic animal is recorded in the Bible, reporting that Sarah, wife of Abraham, possessed camels and asses. Majestic as it roams over the barren terrain, the camel can survive up to fifteen days without water in temperatures of 95 degrees Fahrenheit. In summer's heat it needs to replace 20 to 30 liters of water a day. In winter, on the other hand, the camel hardly needs to drink at all, deriving enough moisture from vegetation. The camel can lose up to 40 percent of its body water and still survive, whereas humans can lose only 12 percent. It can drink from 10 to 20 liters of water a minute and often consumes over 100 liters at one time. Anatomically adapted to the desert clime, its eyelids are translucent, enabling it to see with closed eyes in a sand storm.

During the years I lived in the Middle East, and on each of my return visits, I have been struck by the simplicity of dress of the men. Clad for the most part in long white cotton robes, known as *thobes*, there is a sense of uniformity which gives dignity to all men, regardless of their station in life. White, or red and white checkered, scarves, called *ghutras*, meticulously folded over their heads and kept in place with a circular roping agal on top, and, in urban areas, black or tan outer capes, often with gold embroidered edging, add an elegance and allure unequaled in other parts of the world. The black robes or *abayas* worn by women form a sharp contrast to the white of the men's thobes and create a striking scene when seen side by side on a street. Bedouin women in the desert wear colorful dresses, but cover their faces with black veils with slits for the eyes. Jewelry not only adds color and sparkle, but also denotes social status.

No book on Saudi Arabia would be complete without portraying the central role of Islam in everyday life. The uniquely compelling architecture of its mosques is a striking visible testament to the religion's powerful influence. From the sands of the desert to the cities now being built upon it, Islam is embraced as a source of both inspiration and comfort—a constant companion throughout life. The rigors of desert life—the staggering and endless emptiness of it—created a profound religious instinct among the Bedouin. Faced with their own fragility in the fight for survival, the Bedouin found strength and solace in religion. Today one is constantly reminded of the all-pervasive force of Islam by the daily sight of Muslims bent in prayer toward Mecca, whether they are beside their camels on a lonely desert track, at home surrounded by their family, in the crowded terminals of modern airports, or with friends at a local mosque.

In this book I have attempted to convey my sense of the desert as a unifying thread throughout the centuries and to demonstrate visually how—through its majestic beauty, vast emptiness, and physical challenges—it has helped form the values we find throughout this part of the world today: inner strength, personal courage, warmth of hospitality, and a powerful devotion to God and family. No matter how dramatically the most recent gift of the desert, the discovery of oil, has propelled the Kingdom into the twenty-first century, these values remain and endure.

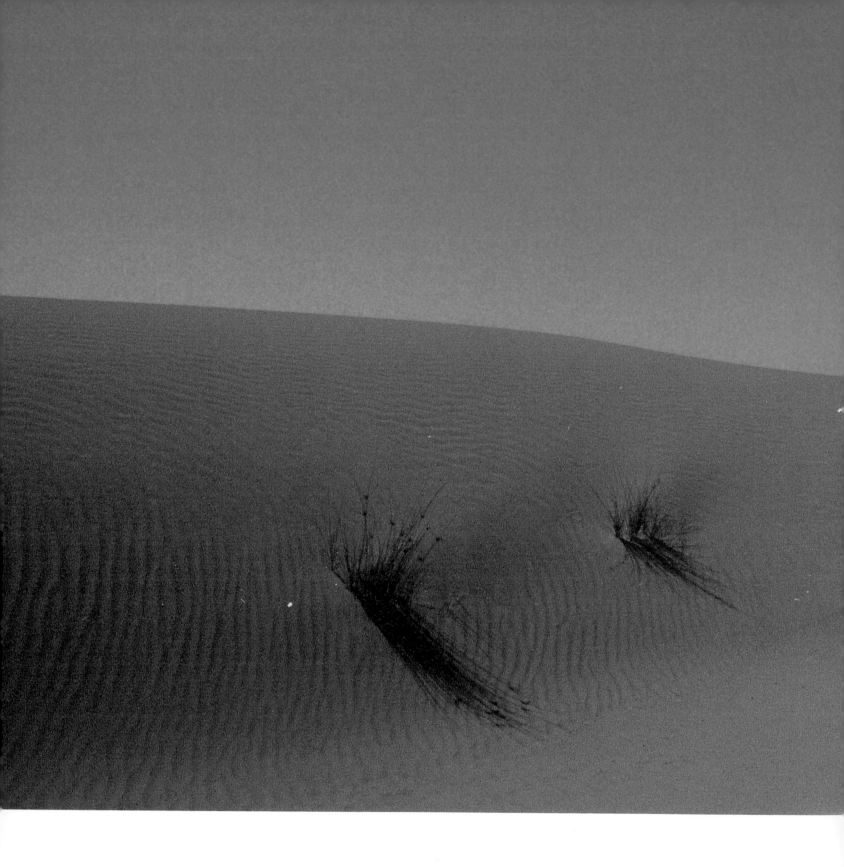

Early morning in the Rub al-Khali, the vast southern desert in Arabia.

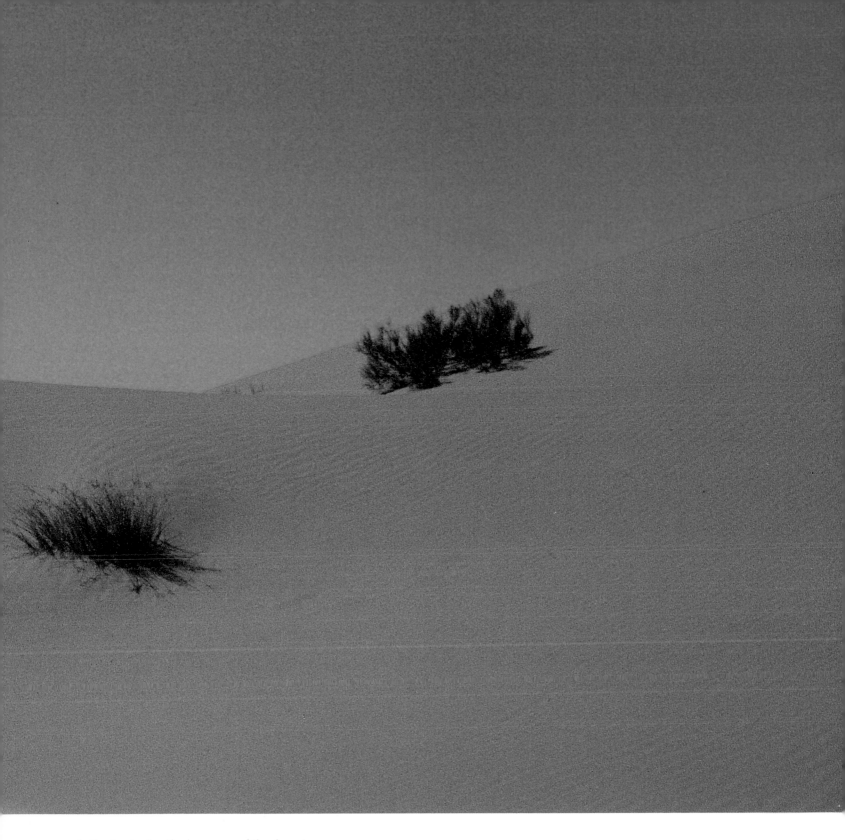

In the beginning the language of the desert
was thrusting weeds flourishing against a wall of winds . . .

Al-Munsif al-Wahaybi
from "The Desert"

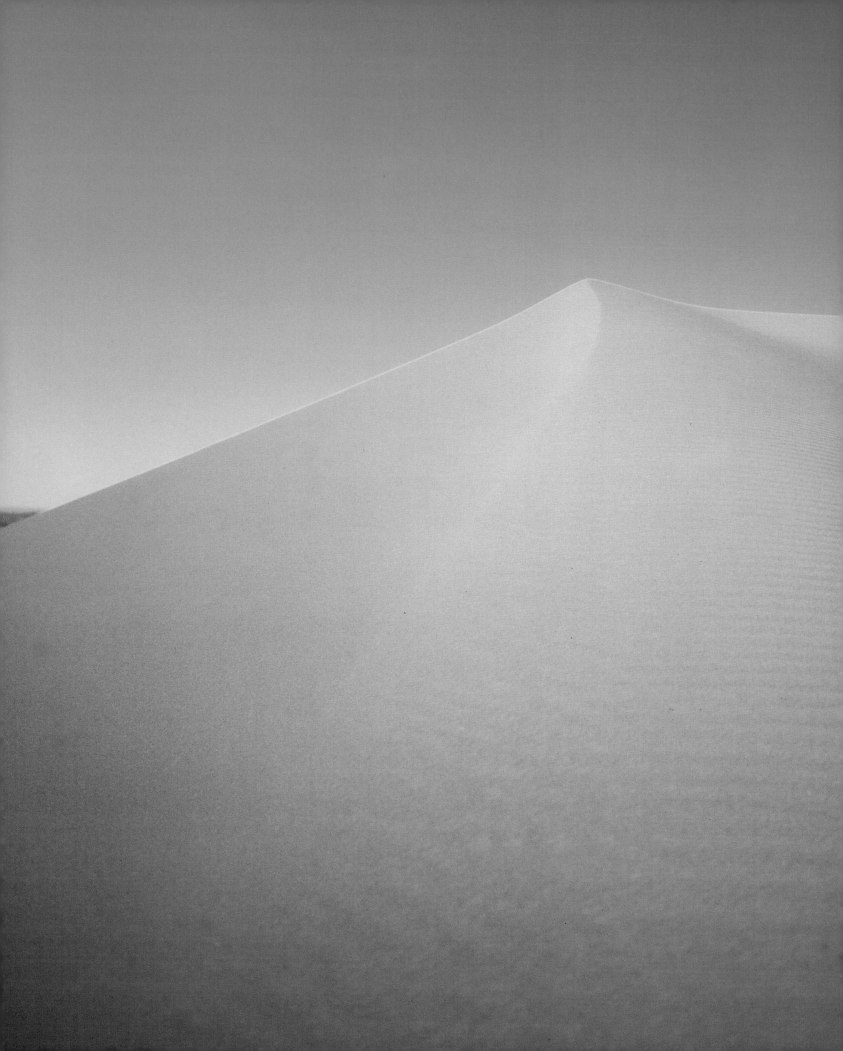

One single word only is sufficient for the wise.

Arabic Proverb

A sense of overwhelming silence in the sands of the al-Dahna Desert.

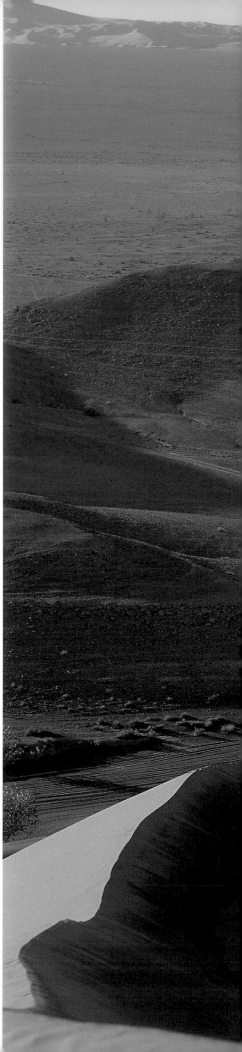

A mirage has offered its solace to my heart
leading me on with a promise to end my drought.

How is it that I, who know of its dissembling,
Love this mirage, desire it, seek it out?

Pity the desert mirage which the dark sands,
From wilderness to wilderness, pass by.

It deceives with the promise of water, and yet it thirsts
For a fountain to love it, to make its soil less dry.

It offers the glittering ghost of a pure spring,
But its heart is ever unwatered, nonetheless.

By day it smiles, to cheat poor travelers;
Each night it spends in bitter nothingness.

If its victims knew of its secret, they would grieve
Not for themselves but for its cruel plight.

Badawi al-Jabal
from "Dark Mirage"

Black volcanic rock creates a striking contrast to the shifting
red sands near the Tuwaiq Escarpment southwest of Riyadh.

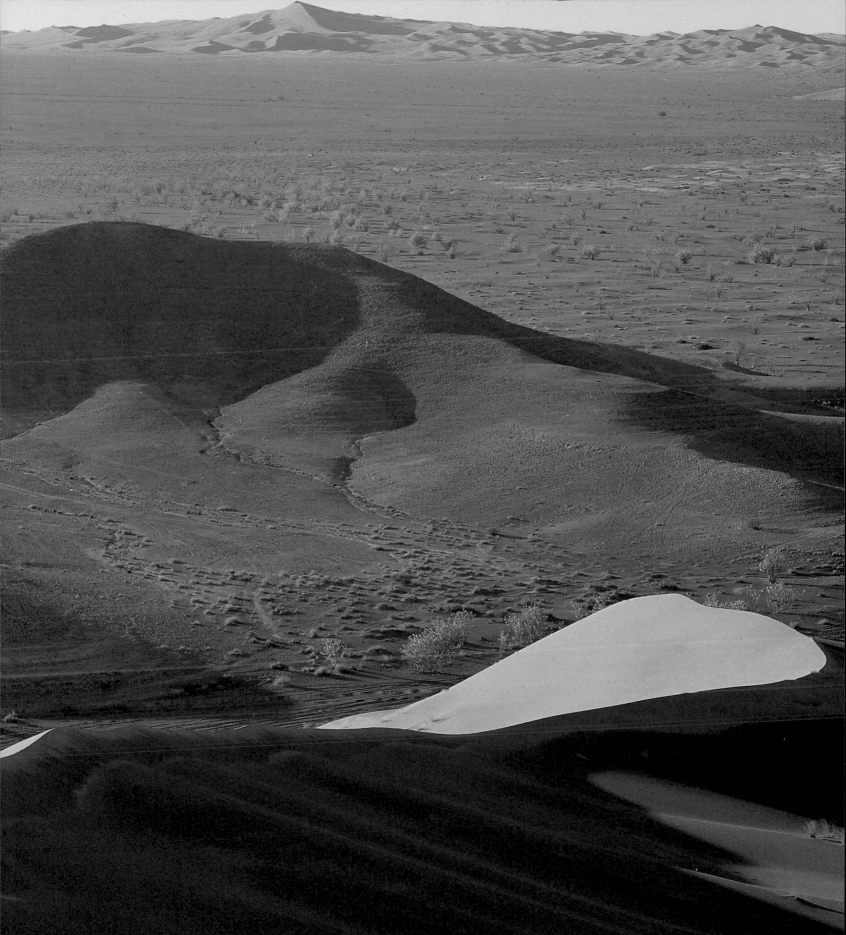

Their proud boast, "We are Bedu" was their answer to every hardship and challenge. Their reward was the freedom they valued above all else, a freedom which we, with our craving for possessions, can never really know.

Wilfred Thesiger
from Bedouin Poetry from Sinai and the Negev

Bedouin shepherd.

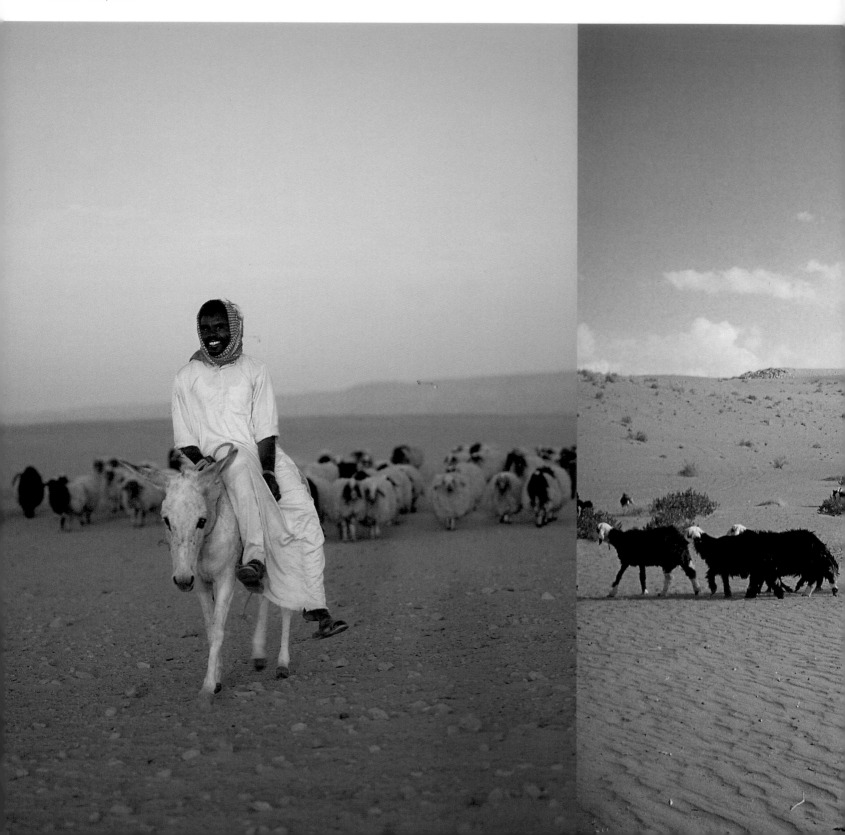

The Bedouin of the desert, born and grown up in it, had embraced with all his soul this nakedness too harsh for volunteers, for the reason, felt but inarticulated, that there he found himself indubitably free.

T. E. Lawrence
from Seven Pillars of Wisdom

A Bedouin guides his sheep to the best, and often hard to find, grazing areas.

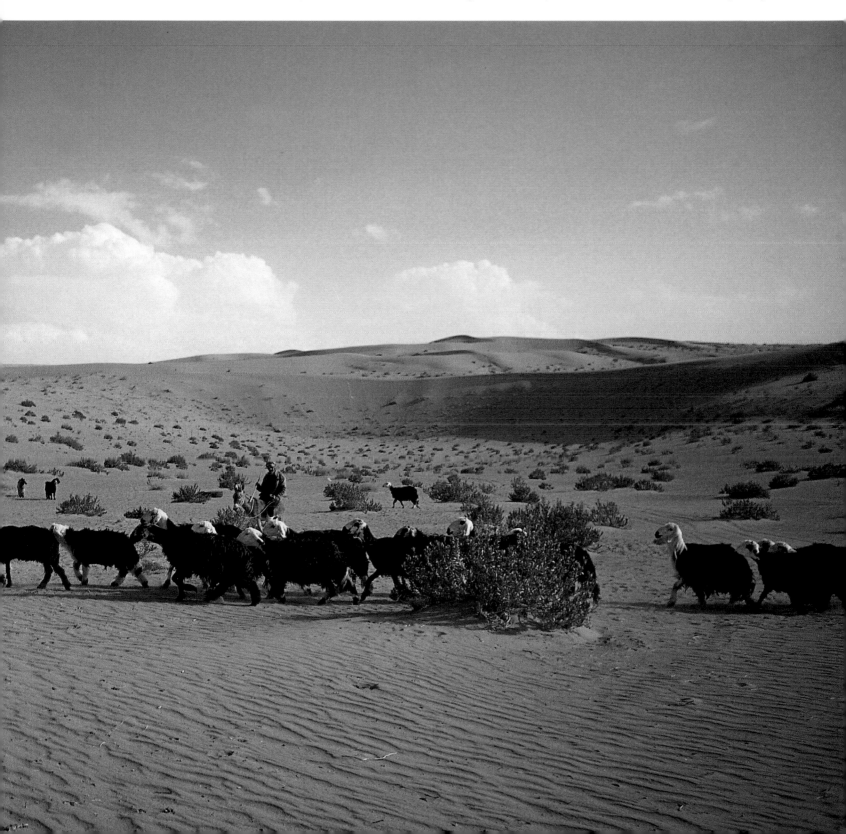

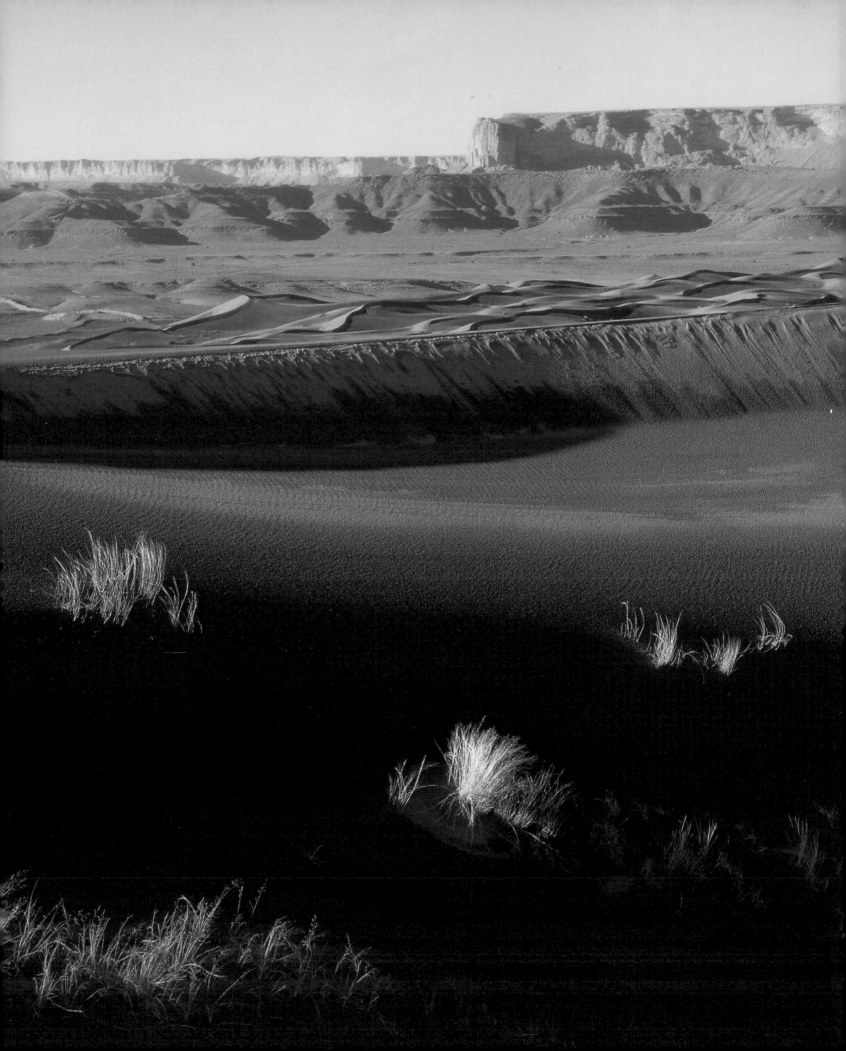

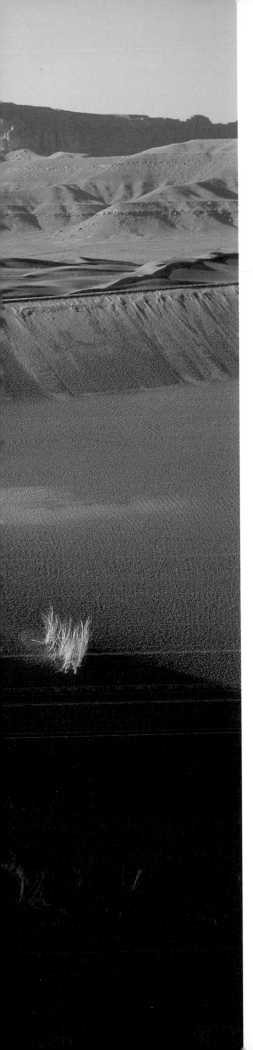

If I were God, I'd have changed the day
I met her into a miraculous day.
I'd have ordered the sun to gaze triumphantly
bathing the earth in light, dispelling darkness.

Mahmud Abu al-Wafa
from "A Sacred Cow"

After the rains, the colors of the sands deepen in intensity, highlighting the grasses lit by the sun.

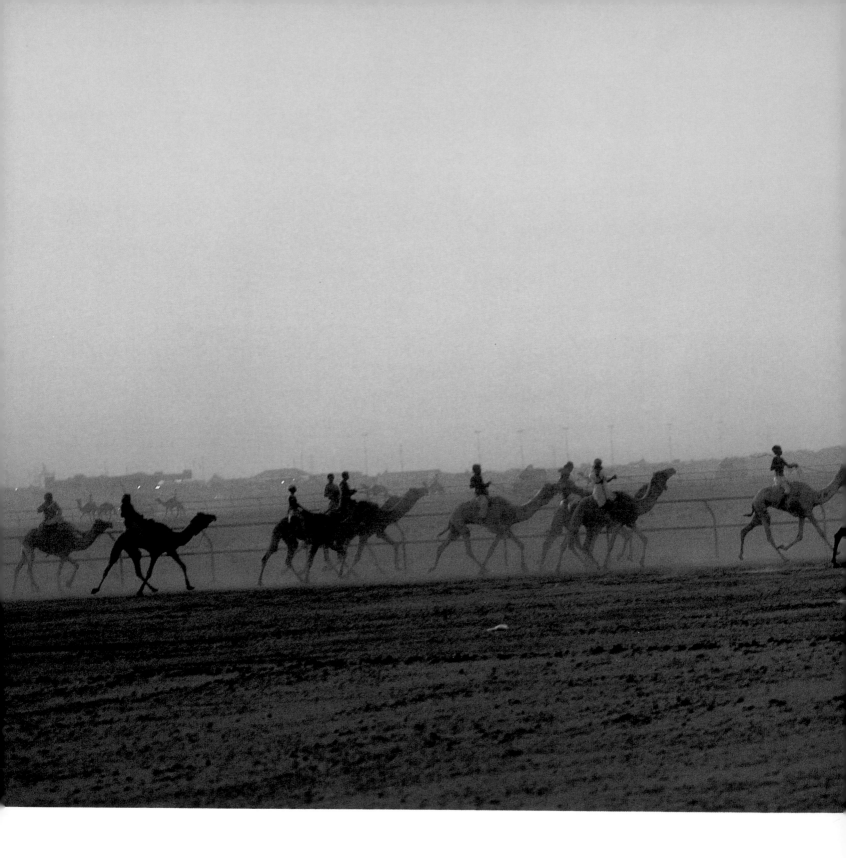

Annual camel race at the Janadriyah.

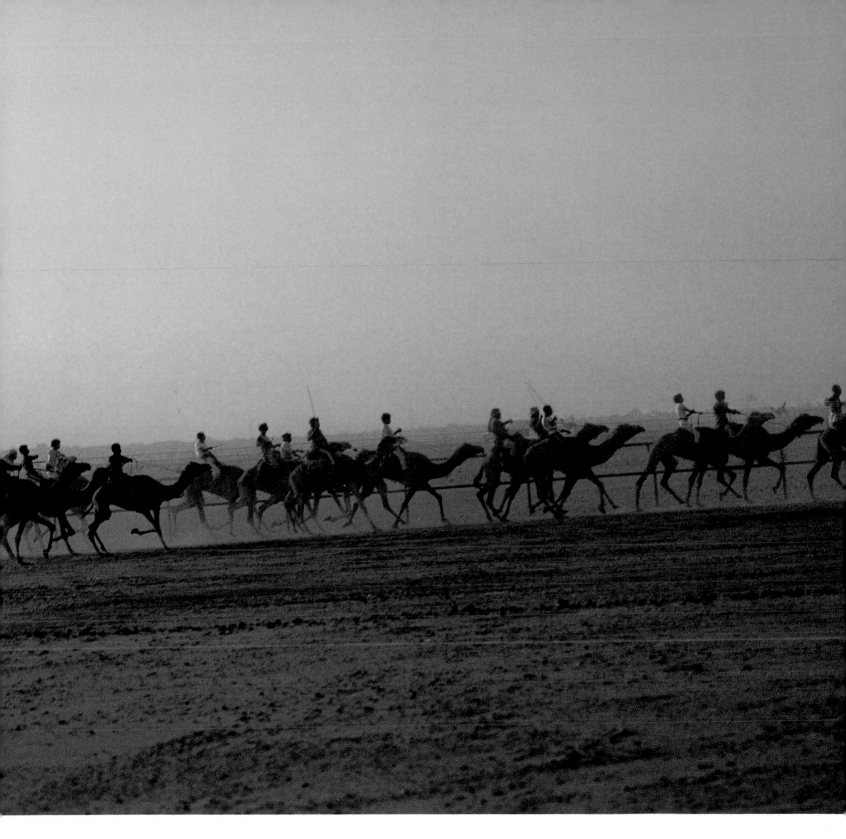

By God, there is only one way to dampen the flames of a thirsting heart:
To ram the desert on swift camels running their best.
Nothing throws me in raptures like their calm, swaggering gait,
Now moving at an easy pace, then trotting steadily, in the late afternoon.
Until the end of my days this will be my heart's deepest desire:
To feel the cool air stream over my face as I ride on their backs.

Ad-Dindan

The gentle aura of the setting sun provides a feeling of serenity and peace.

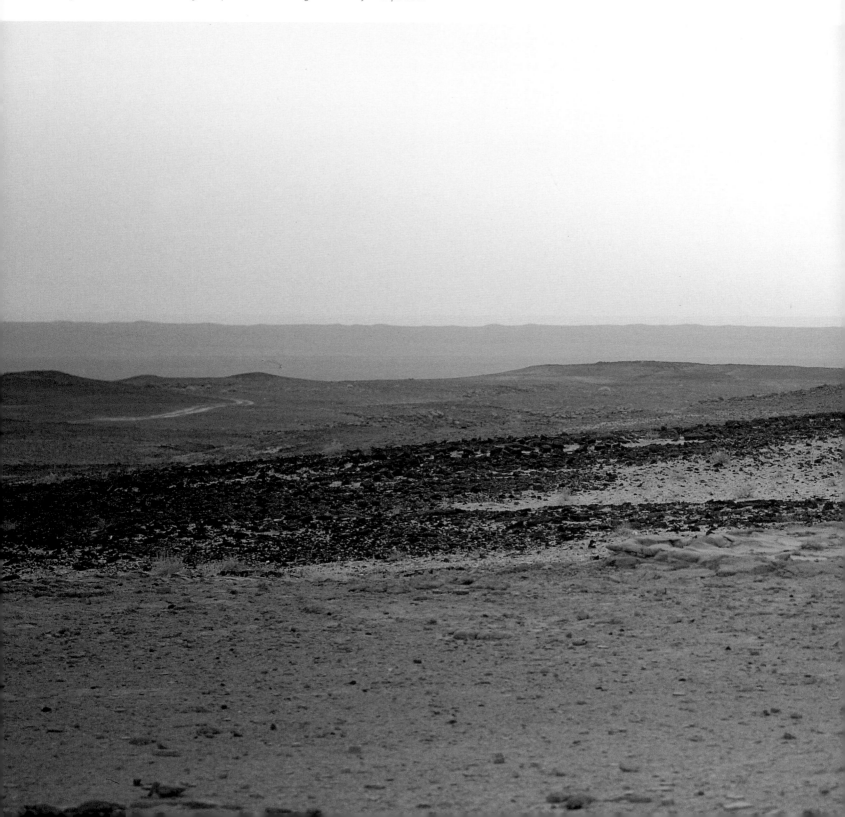

Praising the beauty of the sun,
 westerners sing:
"How glorious is this day
 with sunshine warming our hearts and minds."
The opposite view is held in the east
 where Arabs sigh:
"You're scorching us, oh sun,
 where are the soft, cloud-bearing winds?"

Muhammad Hassan Faqi
from "West and East"

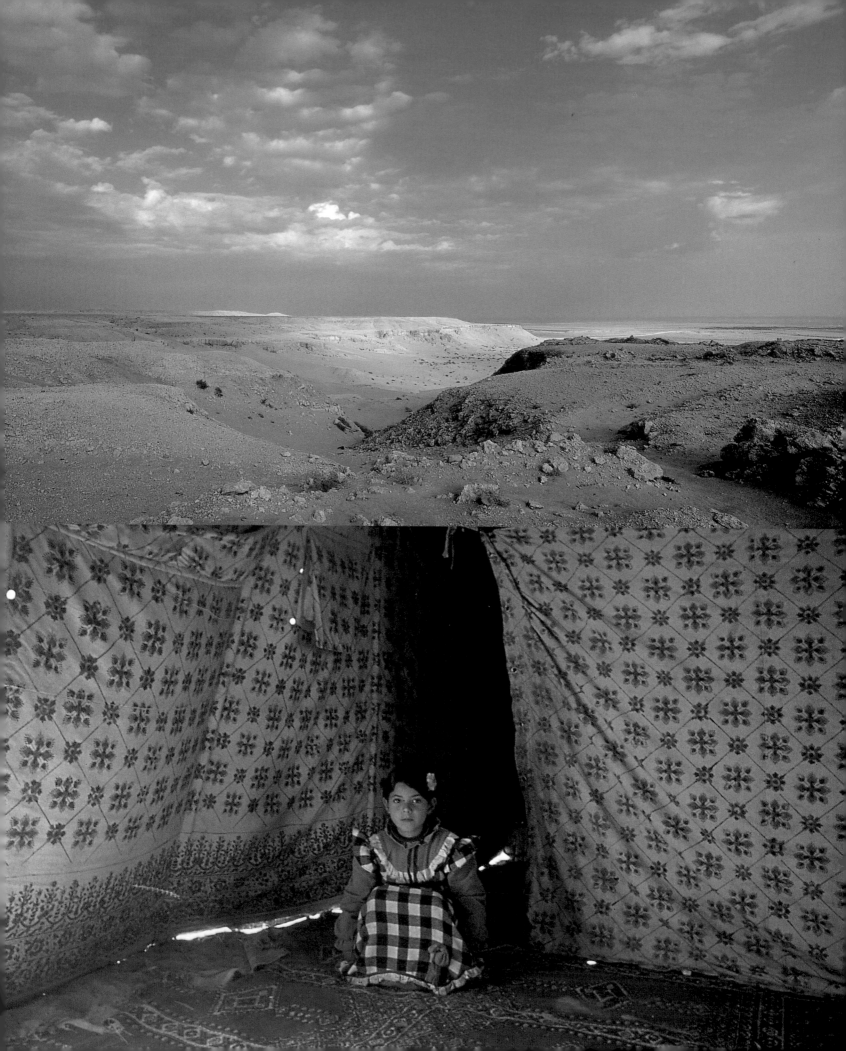

Live with him who prays, and thou prayest; live with the singer, and thou singest.

Arabic Proverb

Contrasting colors and textures create a unique desert tapestry.

Come with me, Bedouin girl,
you who have not yet spoken,
come, let's give names to new things,
they may give us back our own names in return.

Samih al-Qasim
from "After the Apocalypse"

Young Bedouin girls help their mothers with the daily chores of housekeeping.

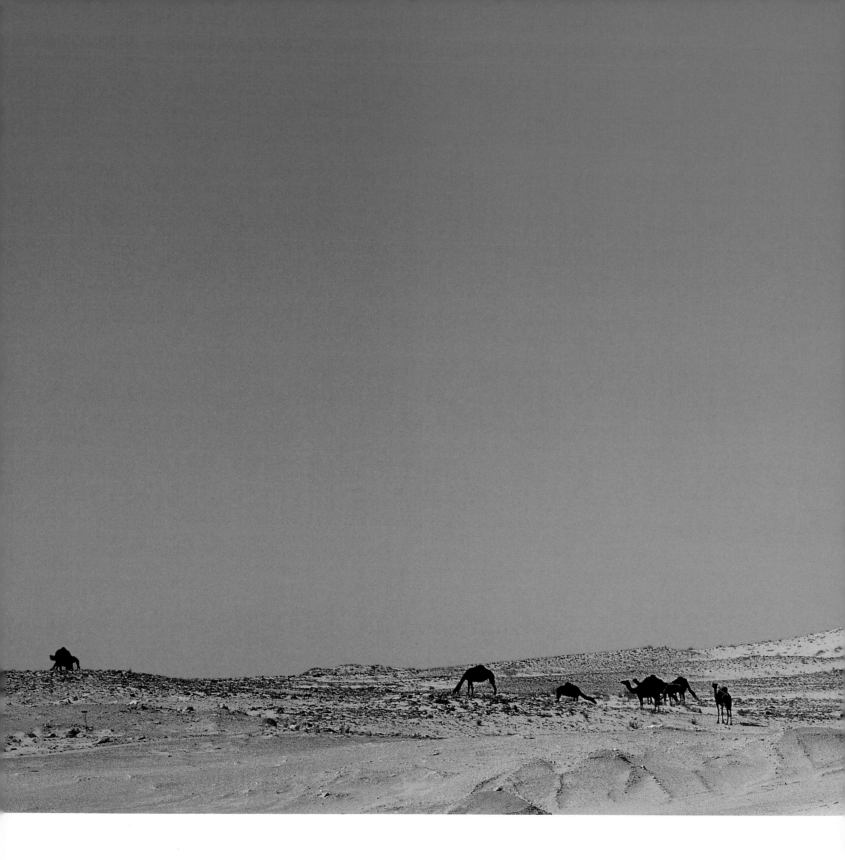

Sparse vegetation in certain areas provides food for grazing camels.

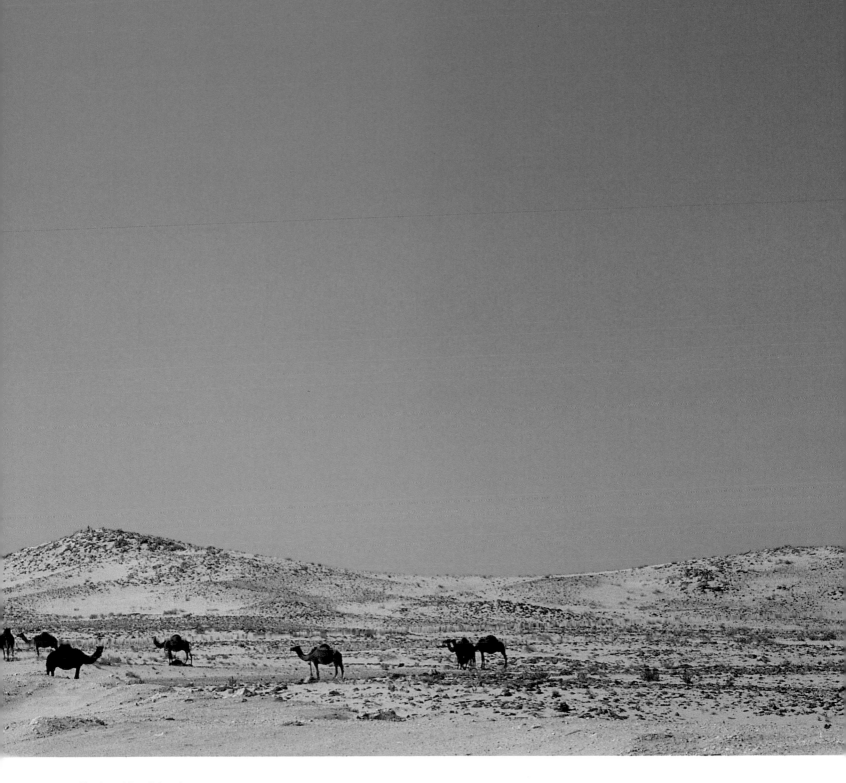

To the ship of the desert,
the bridge that joins the barren land with green
I raise this praise.

Al-Munsif al-Wahaybi
from "The Camel"

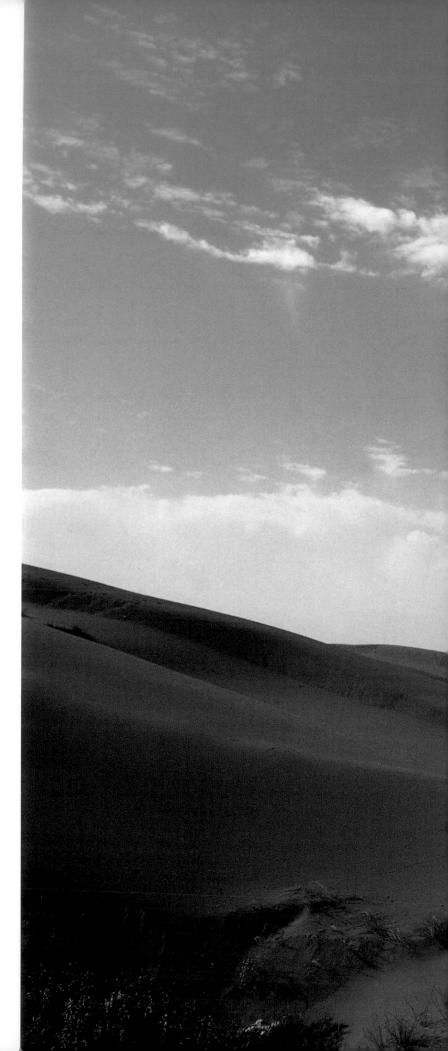

38

I best know the sun of my own country.

Arabic proverb

Wispy clouds over the Tuwaiq Escarpment, an elevated part of the desert which winds around in a crescent formation from the north of Riyadh to the southwest.

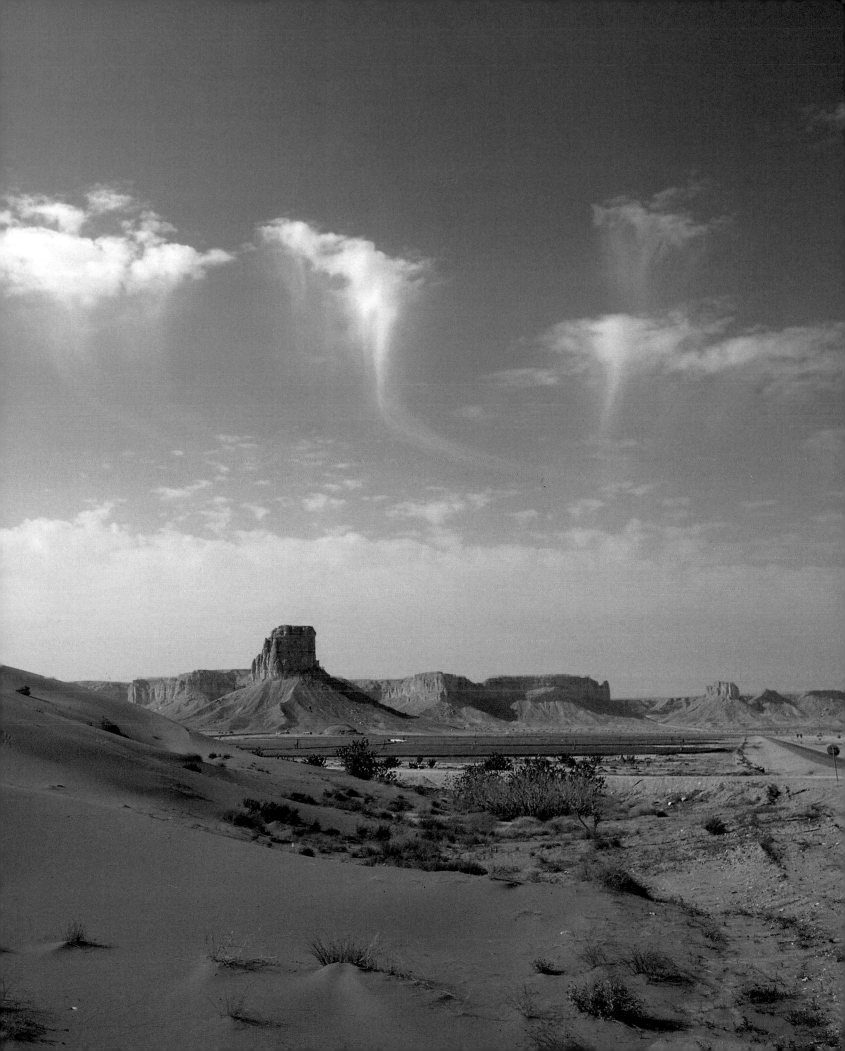

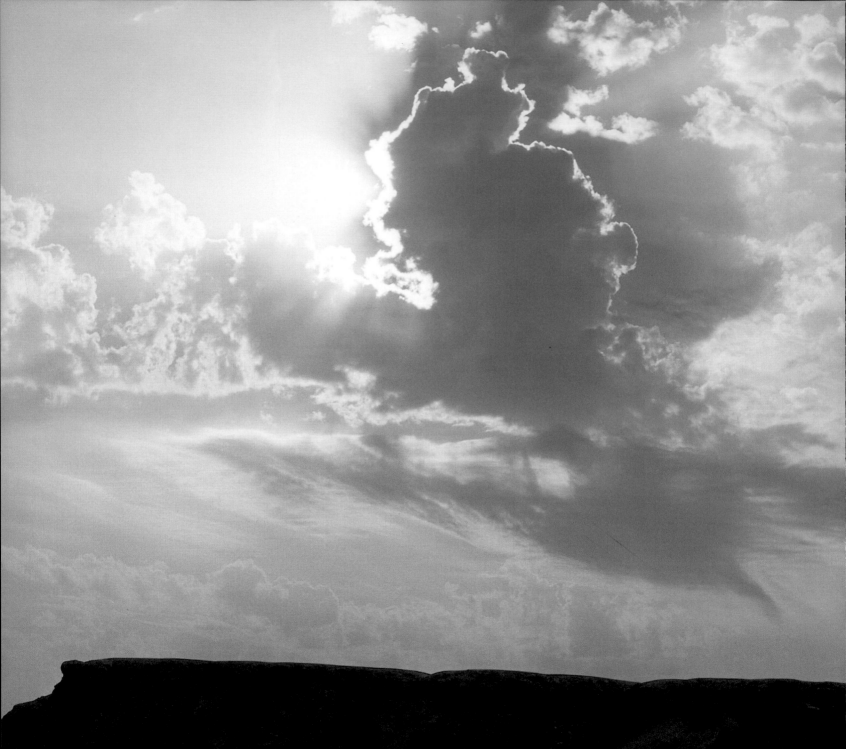

O God, grant us a night with the promise of flashing lightning
And heavy clouds, their backs piling up into a rumbling cumulus.

Ad-Dindan

Promises of stormy weather as night settles over the escarpment.

Were you not once free of heart and vision?
Were you not once a child with a beautiful secret,
A child who did not judge others?

*Mahmoud al-Buraikan
from "Man of the Stone City"*

Young Bedouin boy.

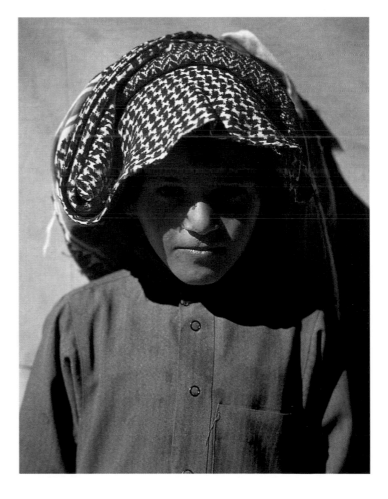

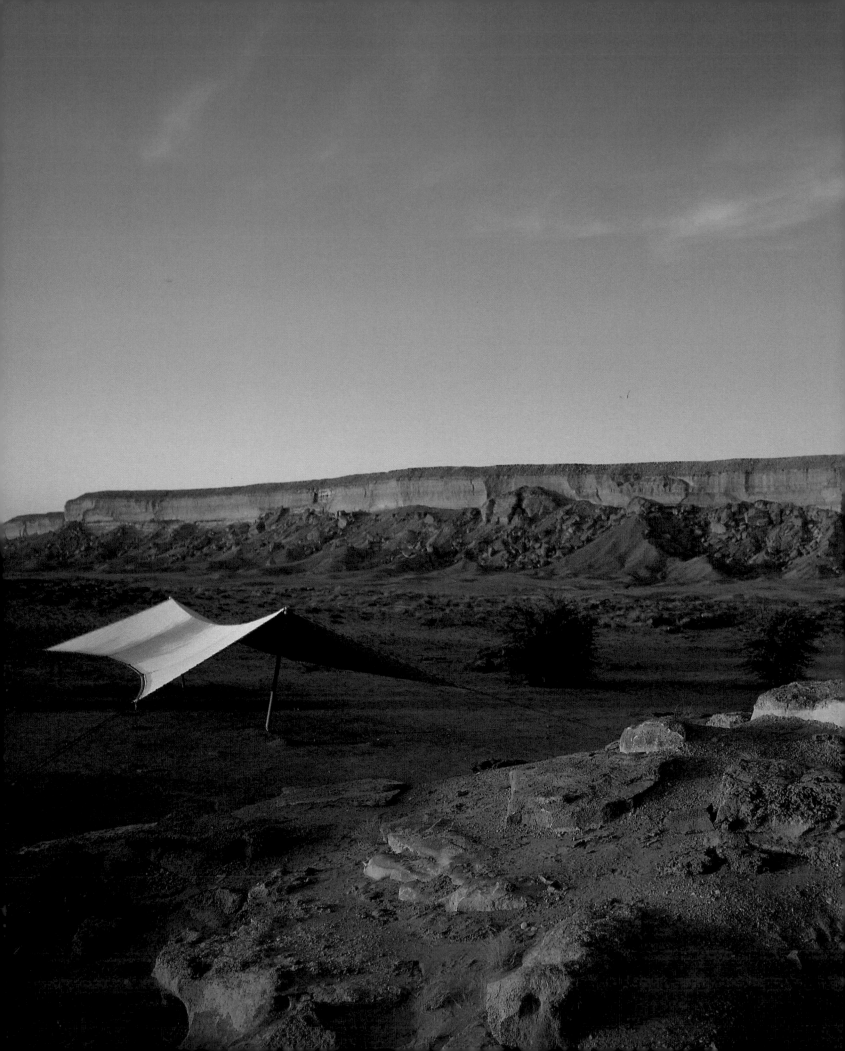

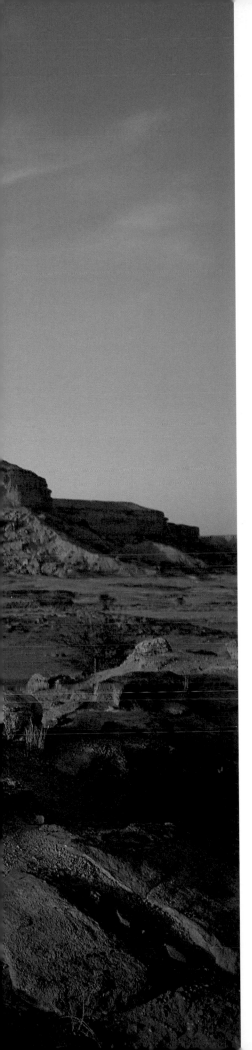

Halt my friends and let us weep
for the memory of a loved one
and a camp by the dune. . .

*Imru' u'l-Qays
from the Mu'allaqat*

A solitary tent offers shelter from the sun in the nature preserve of Al-Thumama in the Najd region.

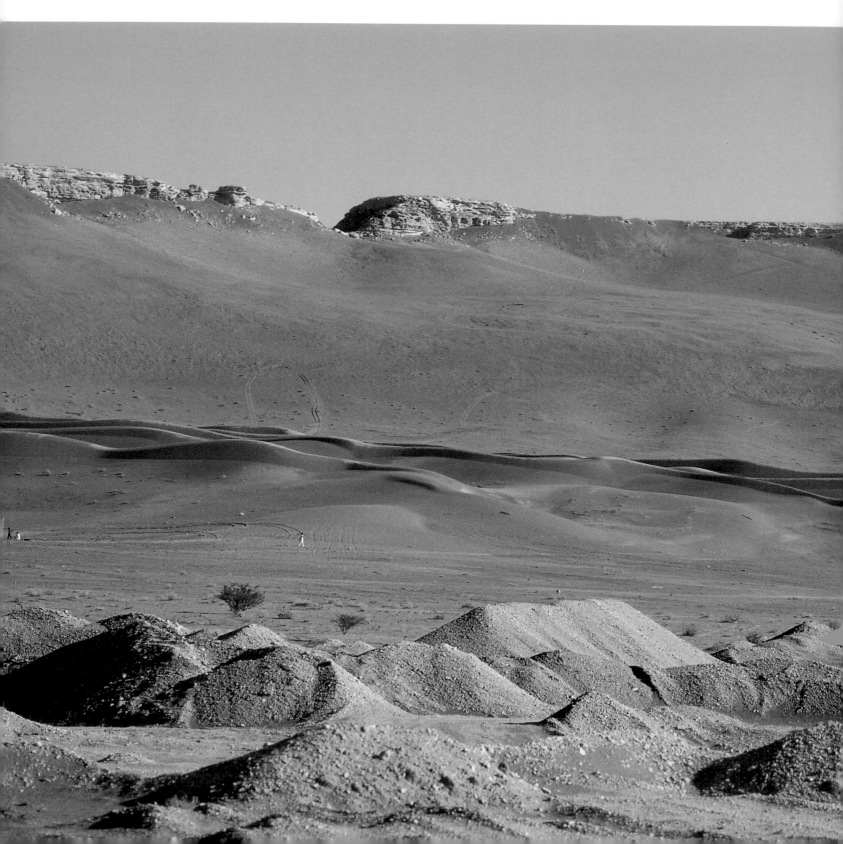

The red sands.

The colour of the sands, from a distance, is pure carmine in the low morning light, changing under midday glare to white, and at dusk they appear wine red and of an intangibly velvety texture. But at close quarters the sands are every shade of yellow and red, blending softly into an amazing mixture for which one can find no name.

Douglas Carruthers

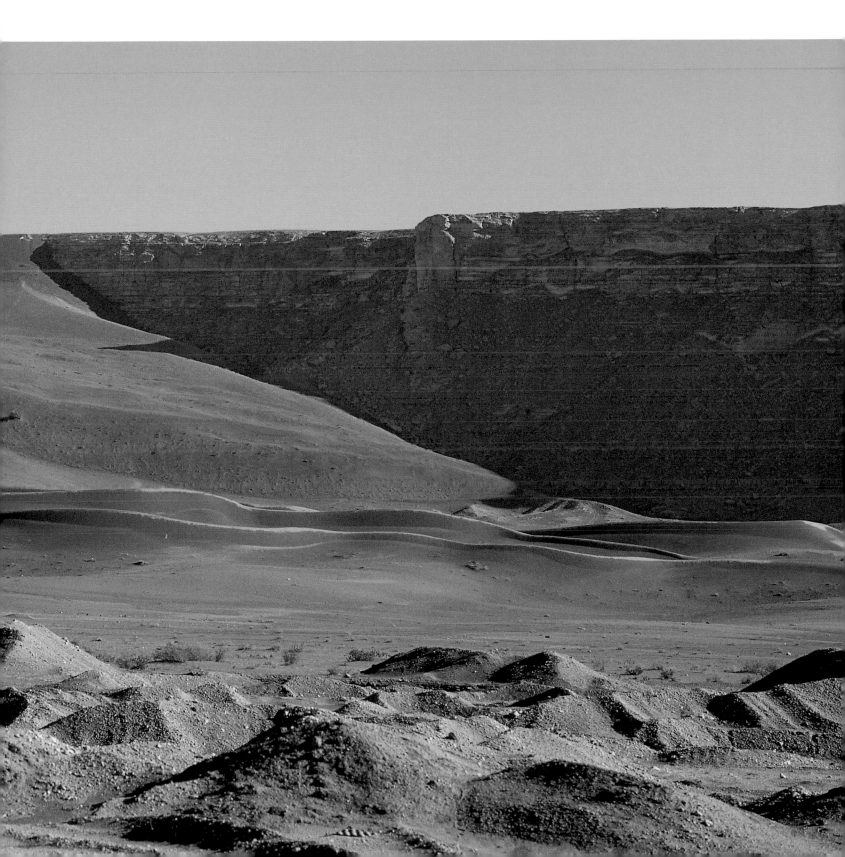

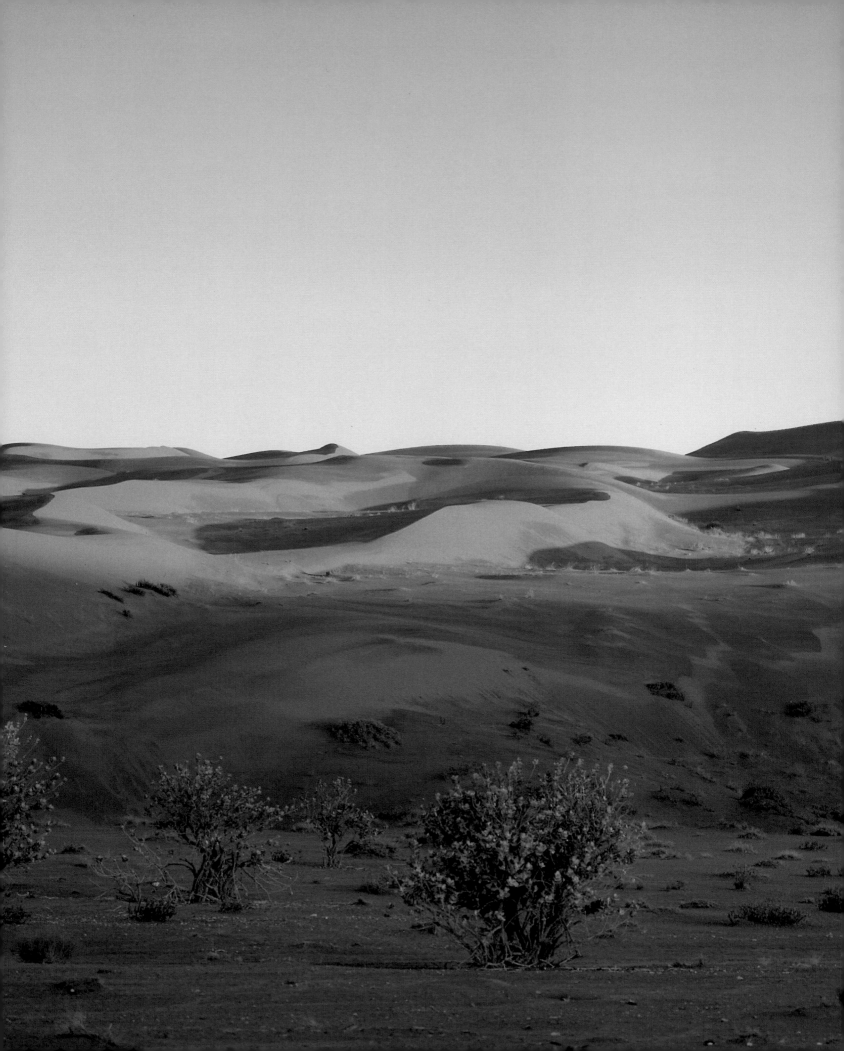

The sea recedes, only the shells remain
at the bottom of the earth
wind after wind
redistributes the red sands.

Mahmoud al-Buraikan
from "Tale of the Assyrian Statue"

The Great Nafud Desert extends north
of the Najd to the Jordanian border.

Lovely companionship of school, lovely those days,
Lovely the children, so full of fun, life's reins restrain
Them for they are tender and young.
Smiles of the world they are, the fragrant scent
That breathes from the flowers of its sweet basil.

Ahmad Shauqi
from "Thoughts on Schoolchildren"

Park, Diplomatic Quarter, Riyadh.

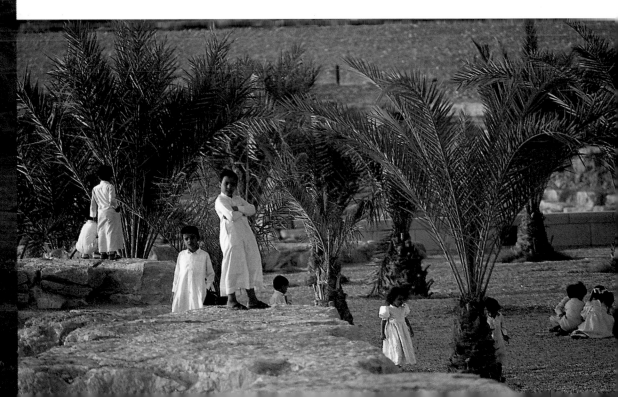

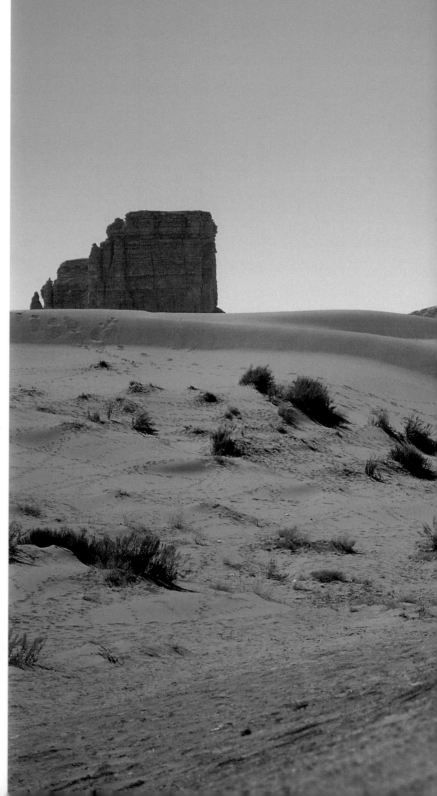

48

Camels with necks as graceful
as those of gazelles
And dark backs, animals always
commanding high prices,
Well covered with fat and their
wooly hair coal-black
With some silvery ones behind
their ears; by God, they are
matchless!
These fine animals, may they be
blessed with happiness. . .

Ad-Dindan

Camels cross the road by the Tuwaiq Escarpment in search of pasture.

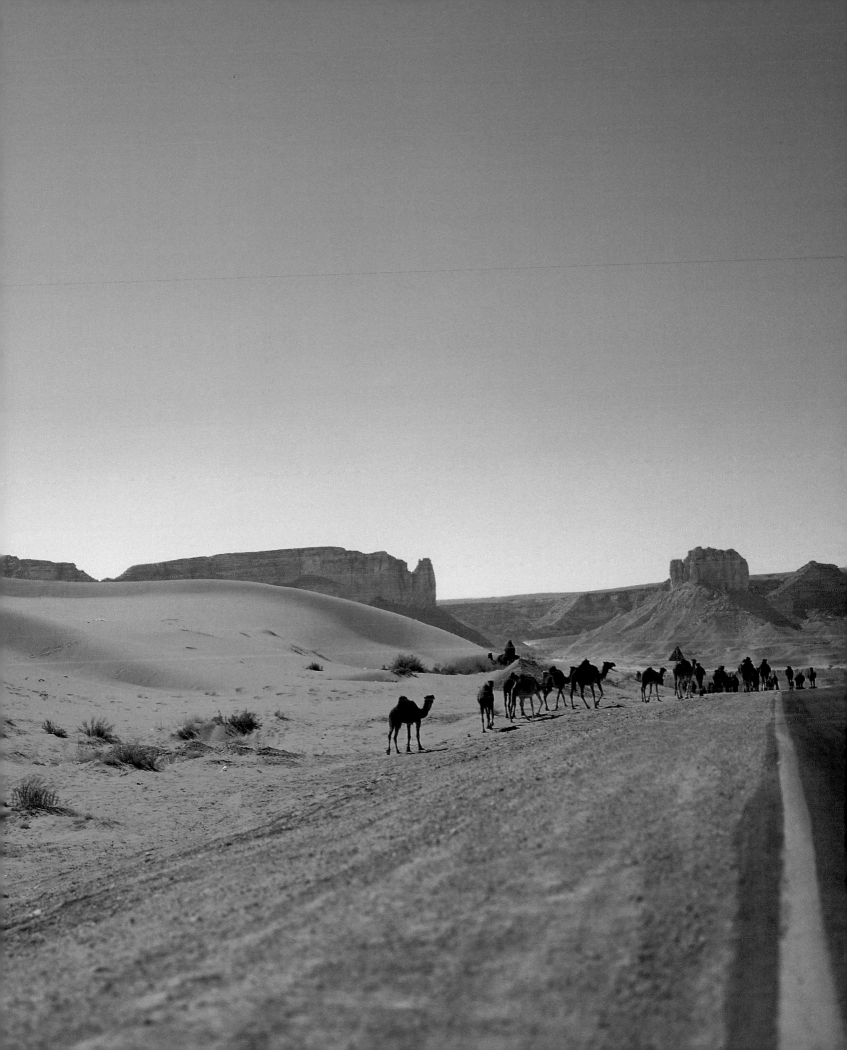

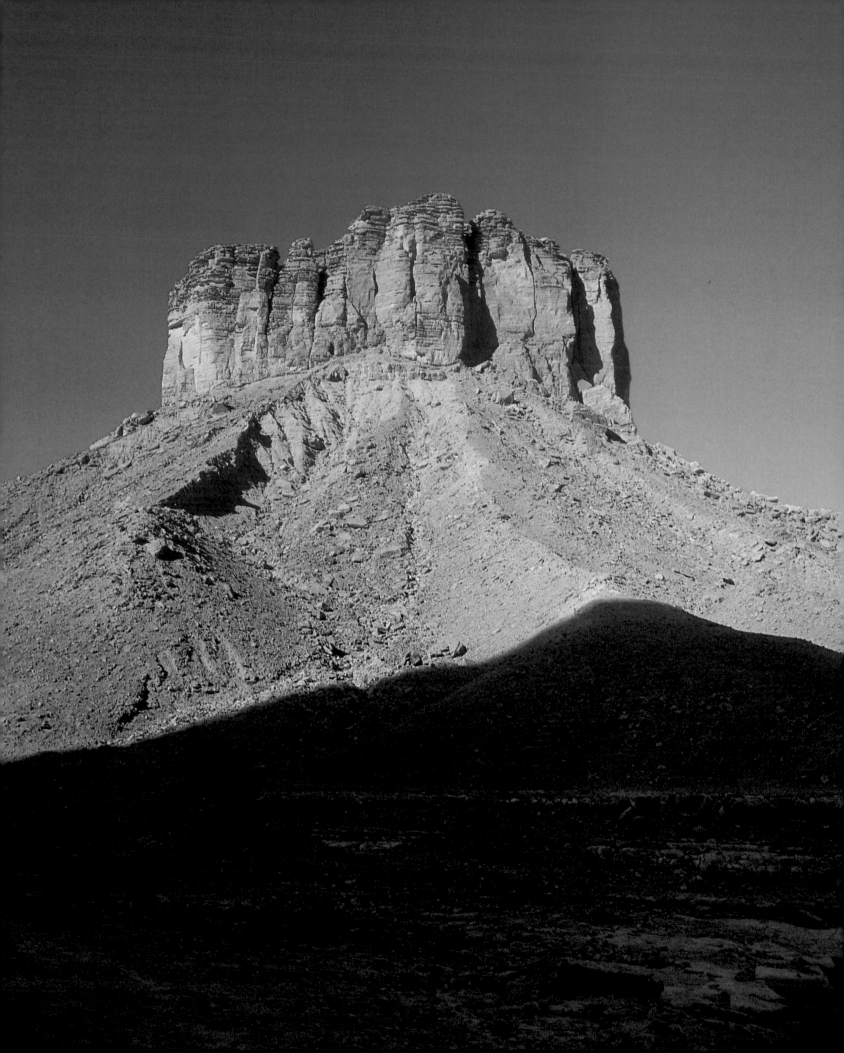

Who seeks far away from kin for housing, takes foe for friend:
who honours himself not well, no honour gains he from men.

Zuhayr
from the Mu'allaqat

Majestic rock formation of the Tuwaiq Escarpment.

The shape of a camel's head can be seen among the jutting cliffs of the Al-Qara Caves.

And wash from our hearts sour speech of wisdom with cups abrim,
 and cut short the ills of Life with laughter and jest and joy!
Yea, when once a moment comes of rest from the whirl, be quick
 and grasp it: for Time's tooth bites and quits not, and mischief waits;
And sure, if a bright hour lifts thy soul to a little peace,
 enough in the path there lies of shadow and grief and pain!

Iyas, son of Al-Aratt, of Tayyi
from the Hamasa

Festive celebration of camels and their riders.

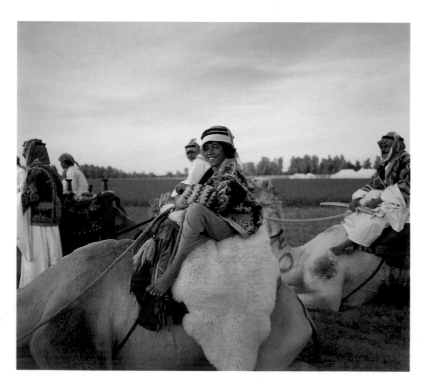

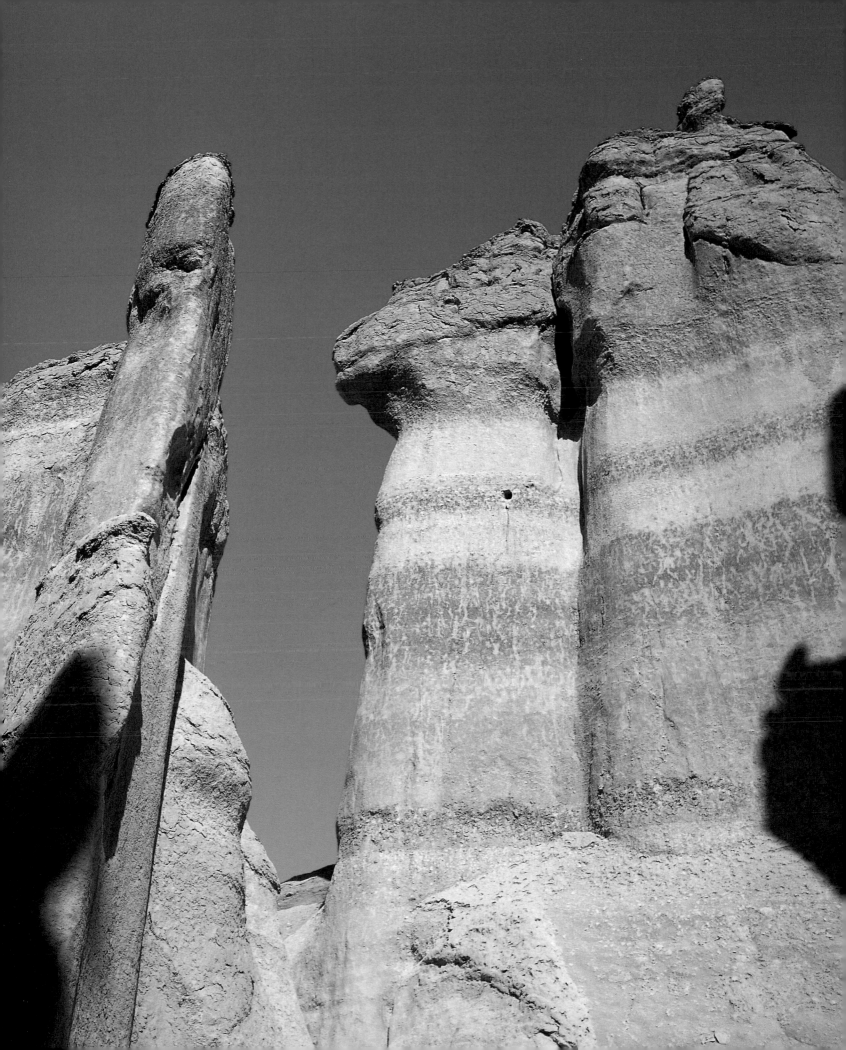

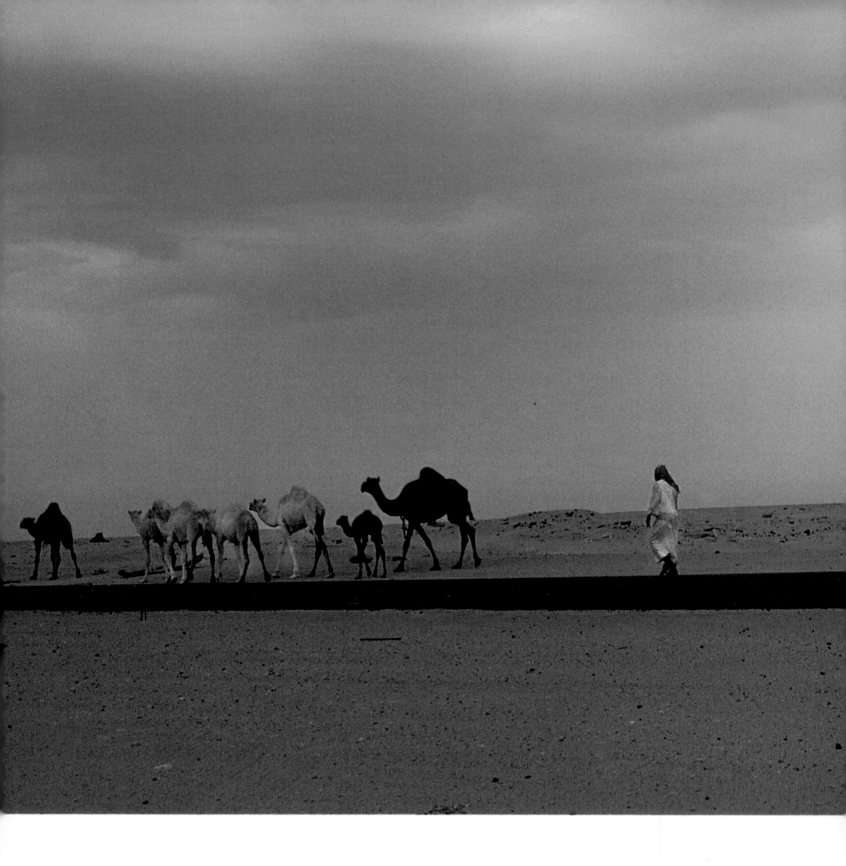

The daily search for grazing areas.

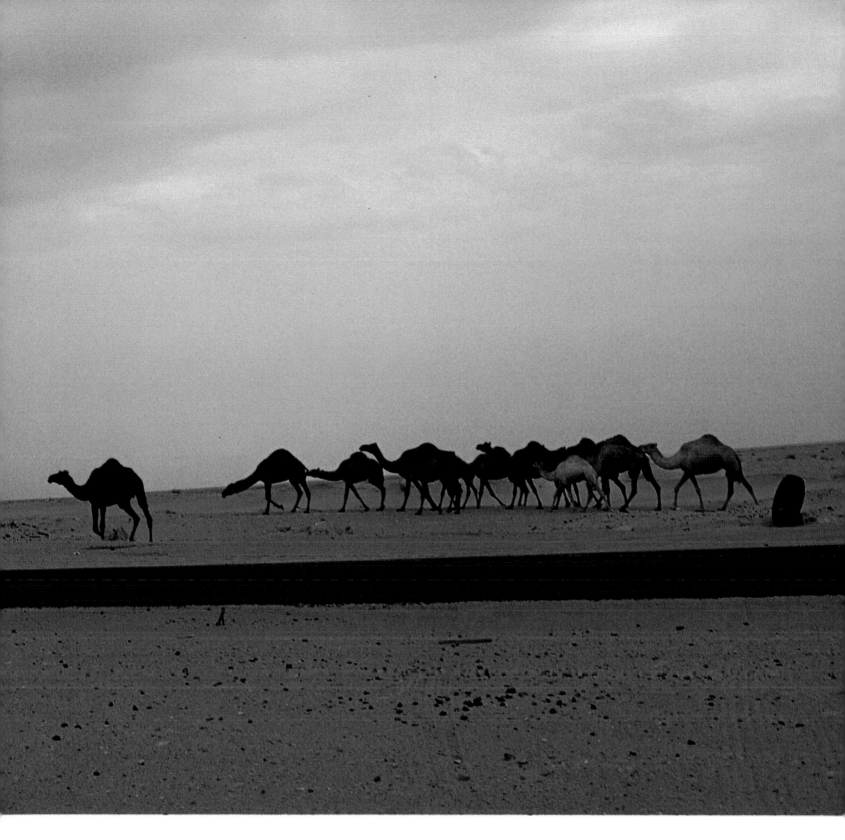

The camel has his projects, and the camel driver has his projects.

Arabic Proverb

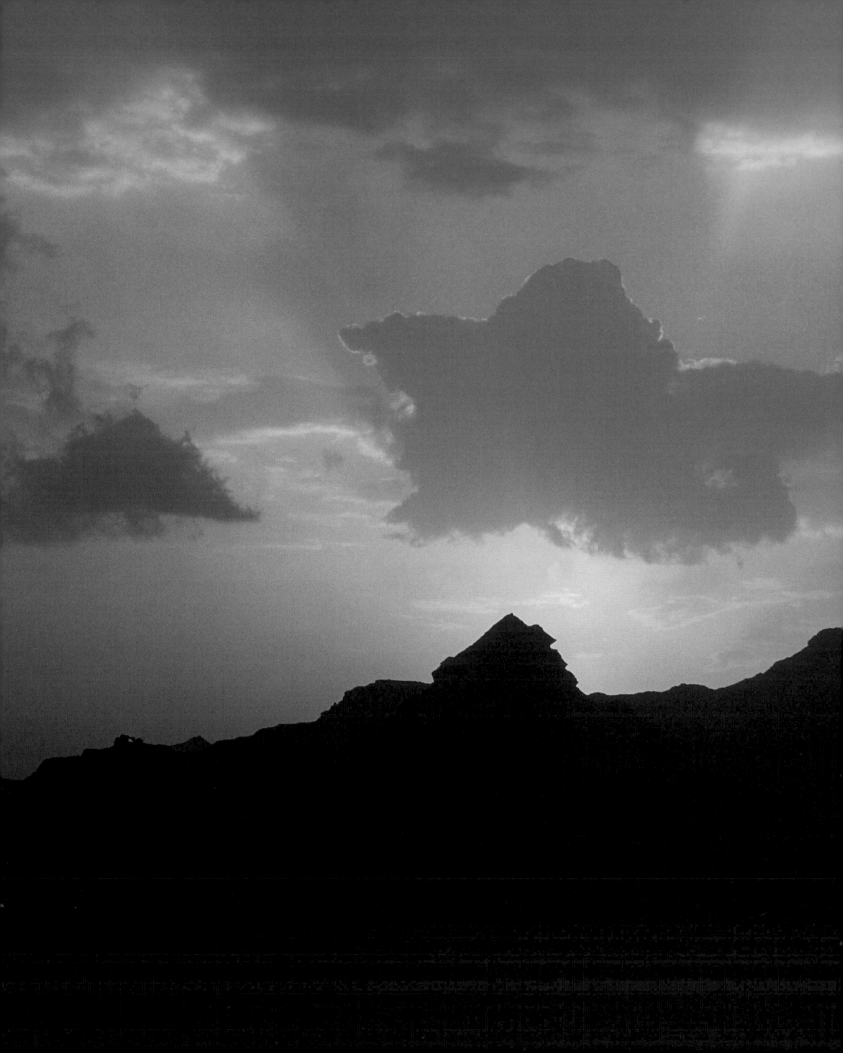

The desert sun flirted with the clouds
in the hall of silence, or of those thirsty sands;
nothingness delivered the blow of death.
What harm to repeat the story?

What harm to us?
The season of creation begins in
the season of nothingness
if it is tended carefully.

But
by climbing,
one reaches the top of the slope.
Shall we begin?
Or is this
the beginning of the end?

Zuhur Dixon
from "Season of Beginning and End"

Sunset over silhouetted peaks in the Asir region.

O Virgin desert!
Here we are, sent by the heart and mind
on an official mission
to build the world anew.

Samih al-Qasim
from "After the Apocalypse"

The Great Nafud Desert.

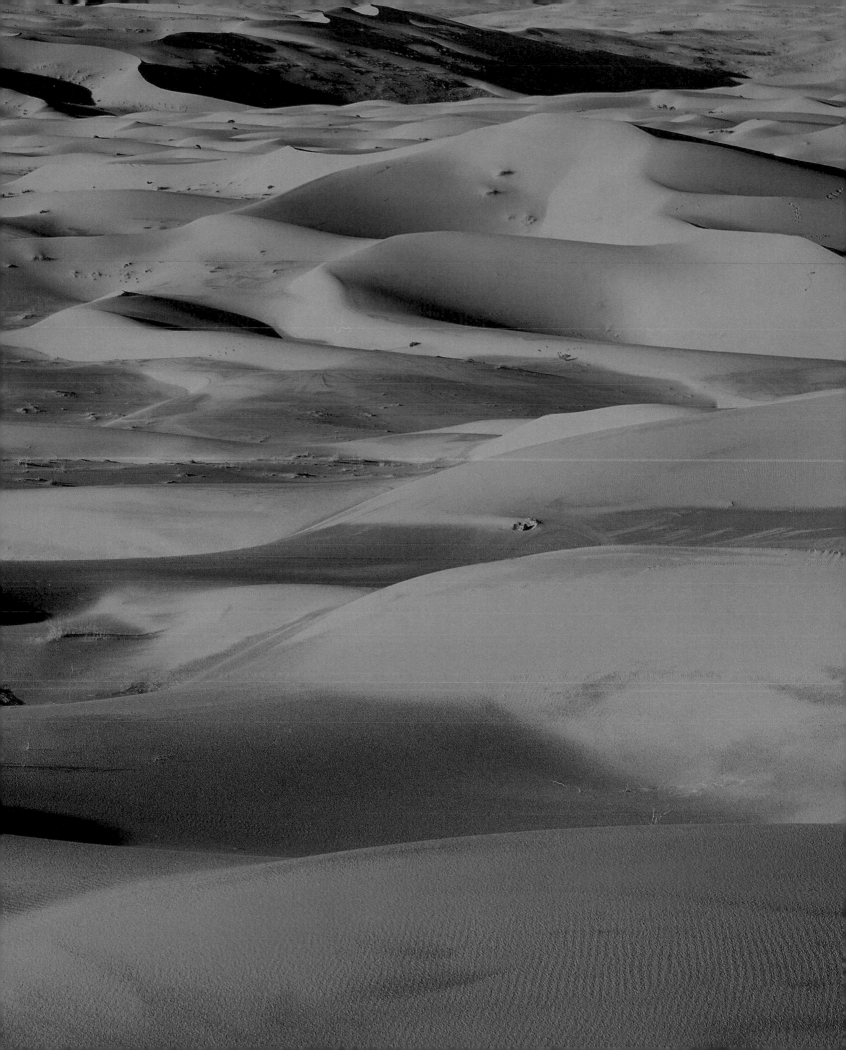

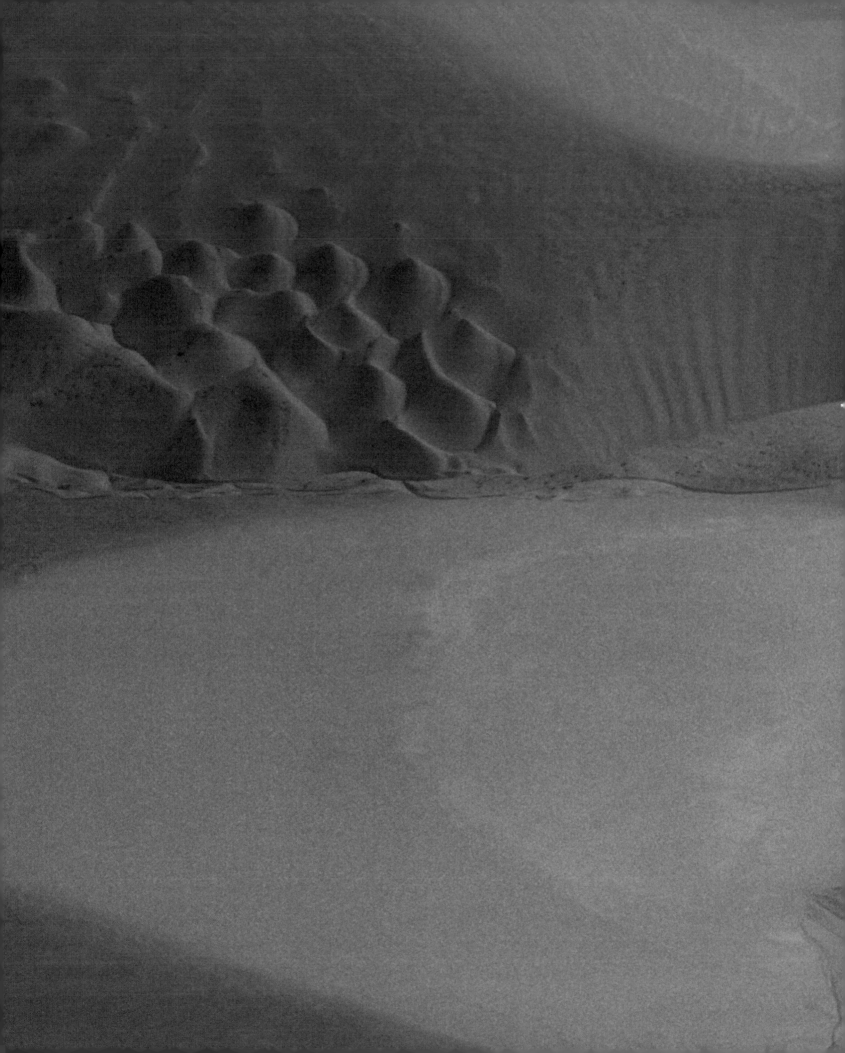

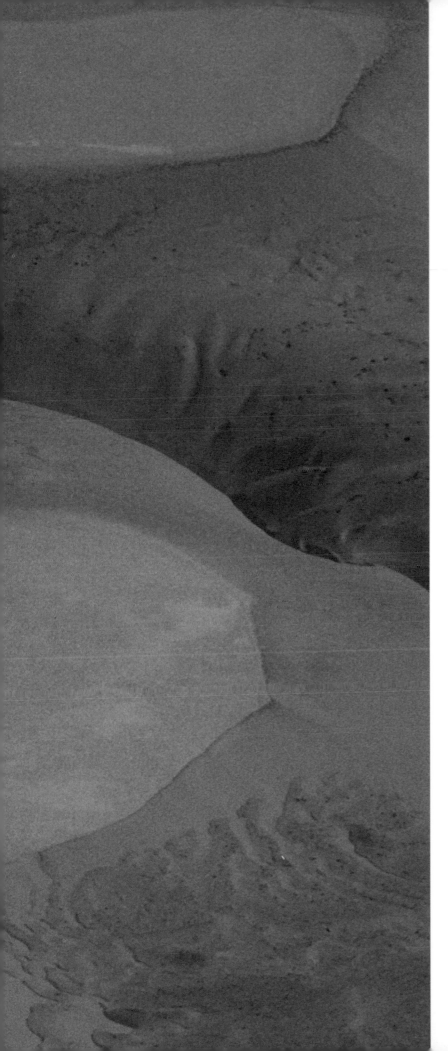

Earth issues forth from Earth forcibly, reluctantly,
Then earth struts on Earth arrogantly, proudly.
And earth fashions from Earth palaces, towers, temples.
And earth founds upon the Earth legends, dogmas, laws.

Then Earth gets tired of the deeds of Earth,
 and so it weaves from
Earth's own haloes ghosts, illusions, dreams.

Then Earth's drowsiness beguiles the eyelid of Earth,
 and so Earth too sleeps solemnly, soundly, eternally.

Then Earth calls out to Earth saying: I am the womb
 and the grave, and
I shall remain so until the stars fade and the sun
 settles to ashes.

Gibran Kahlil Gibran
"Earth"

Moonlike formations of sand and rock
stretch endlessly in the Empty Quarter.

Whoever never felt
Life celebrating him
Must vanish like the mist;
Whoever never felt
Sweeping through him
The glow of life
Succumbs to nothingness.

Abu al-Qasim al-Shabbi
from "Life's Will"

Swords wave in celebration as men dance the "Ardah," the traditional dance
in which Saudi men express their courage and manhood with swords and drums.

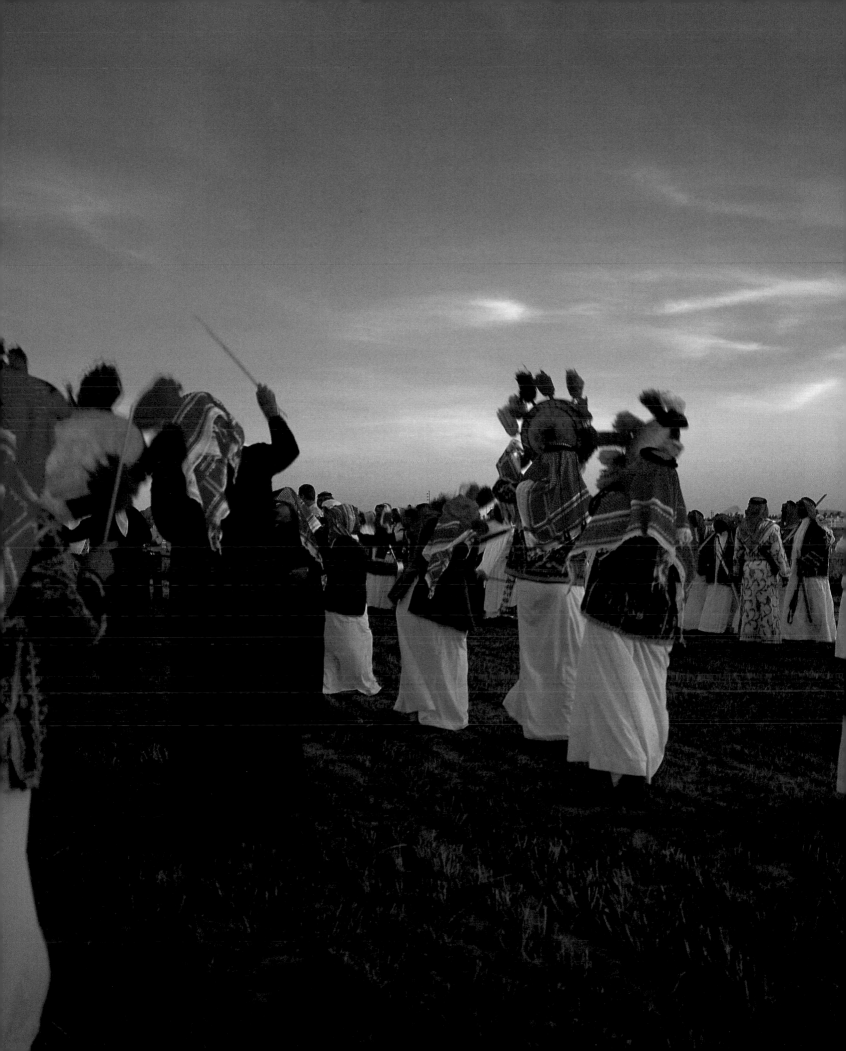

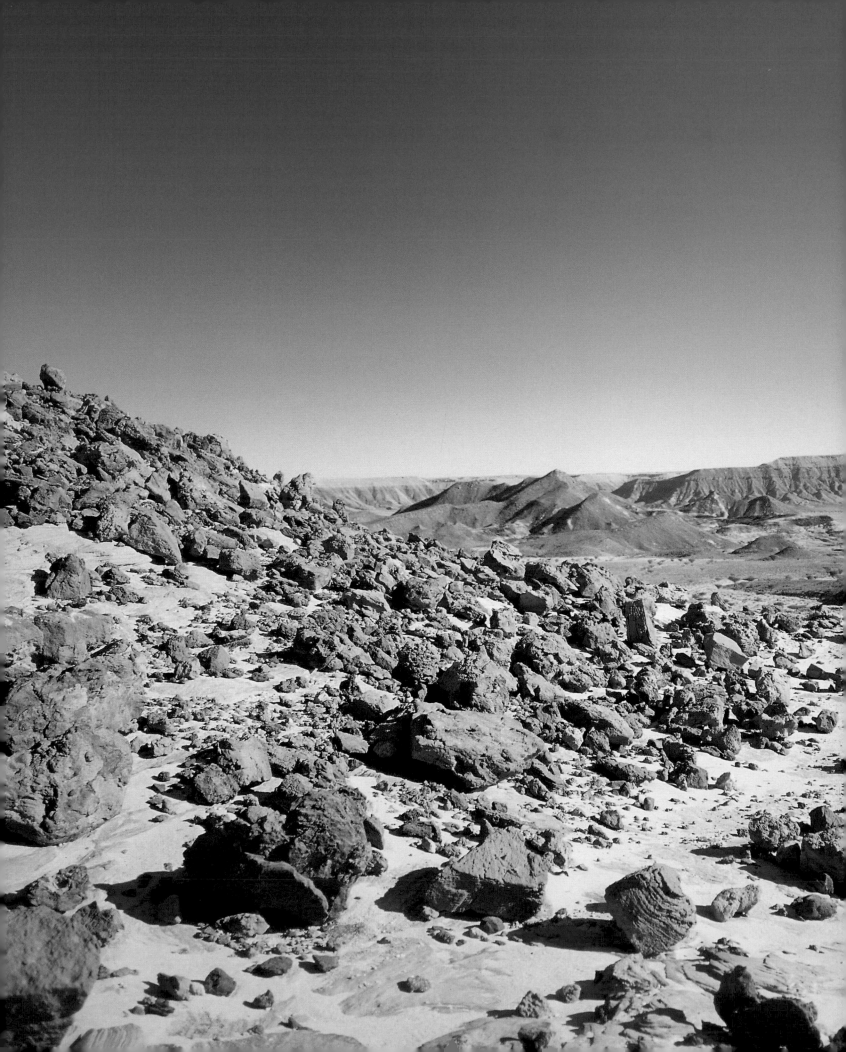

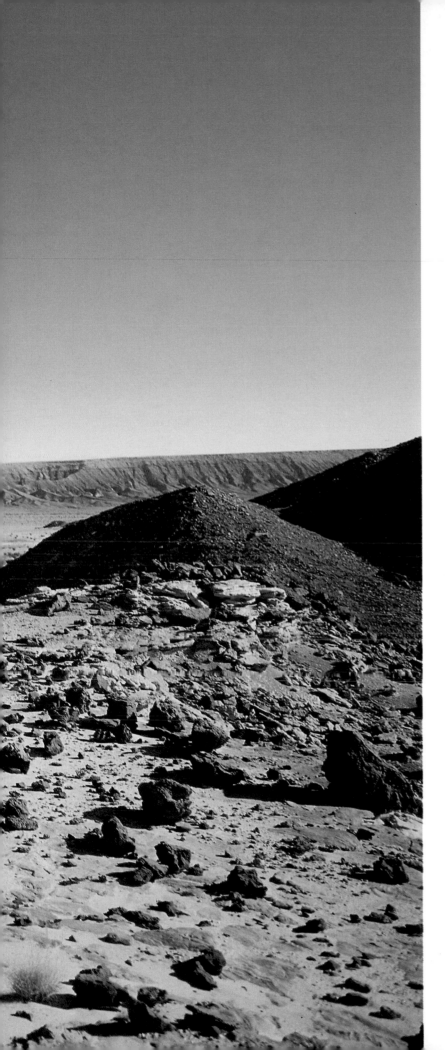

I'd sooner swallow the dust,
a dry mouthful,
 then take some man's
condescending favors.

Shanfara
from "Arabian Ode in 'L'"

Although sand deserts make up approximately one-third
of the Arabian deserts, there are also deserts of stone.

What is brought by the wind
will be carried away by the wind.

Arabic Proverb

An unusual sighting of horsetail clouds.

In your eyes there is
something about the spring
about a sky untouched by dreadful nothingness
about a gentle laughing place
washed by the dawn, watered by light alone.

Mahmoud al-Buraikan
from "Man of the Stone City"

Windows of the soul.

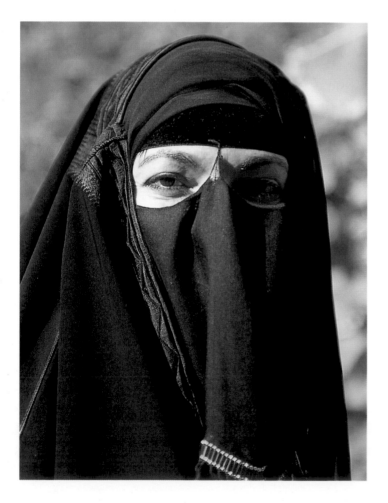

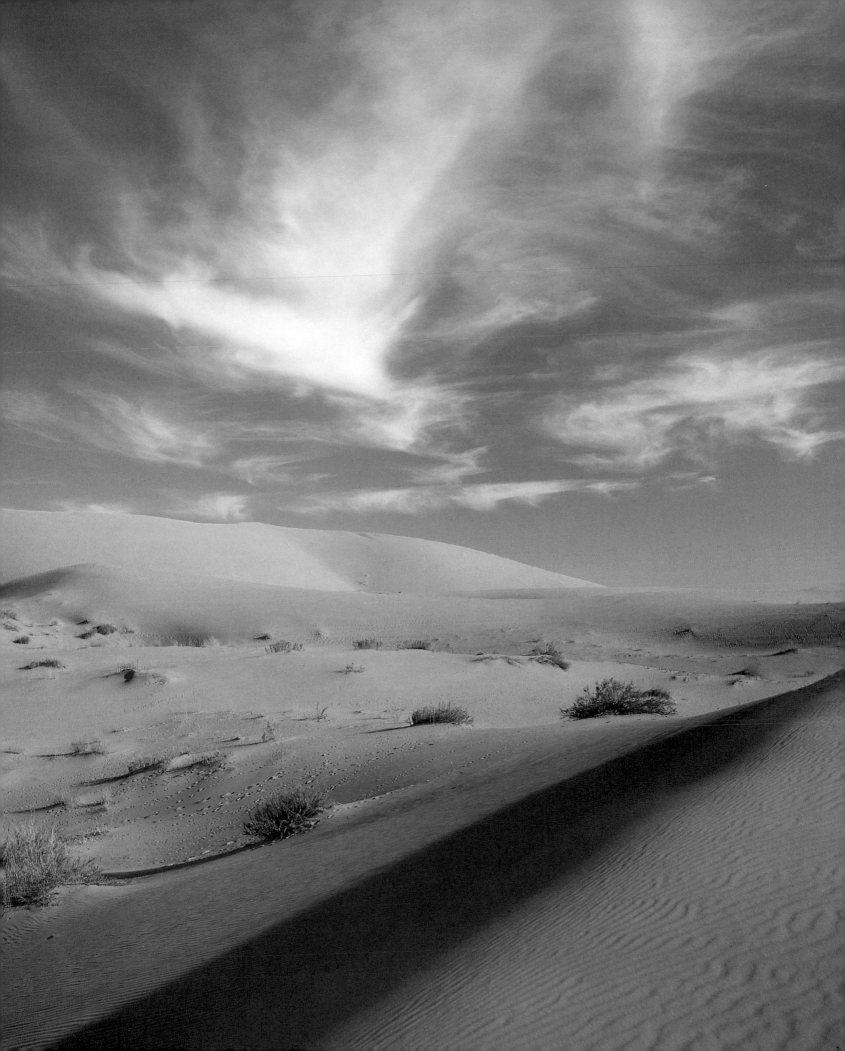

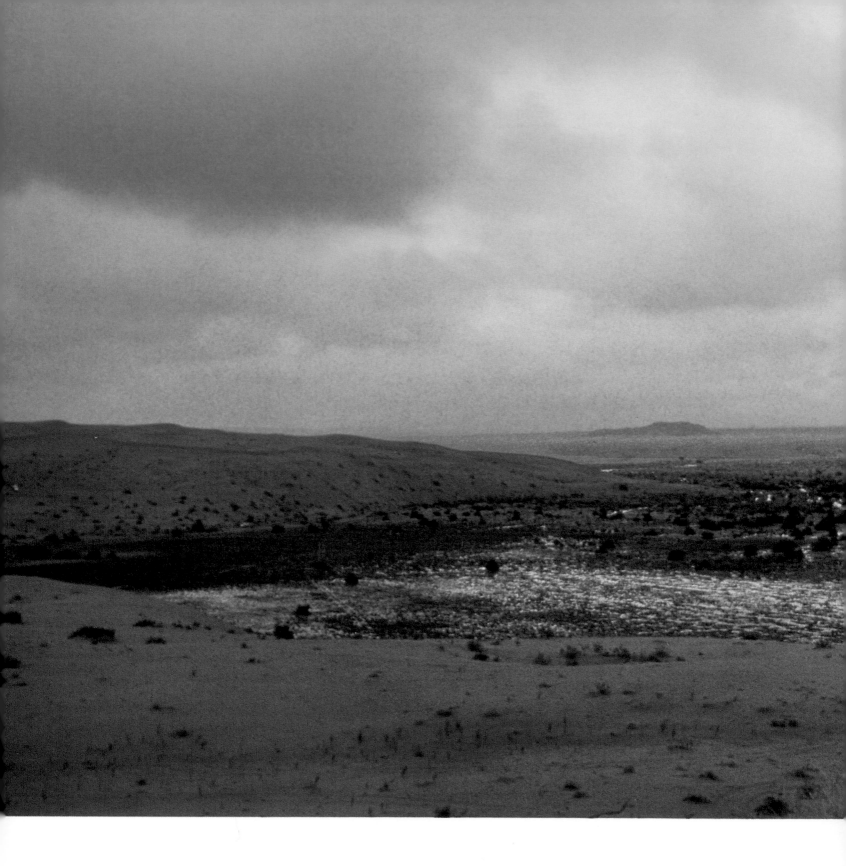

A rare greening of the desert, following a rainstorm.

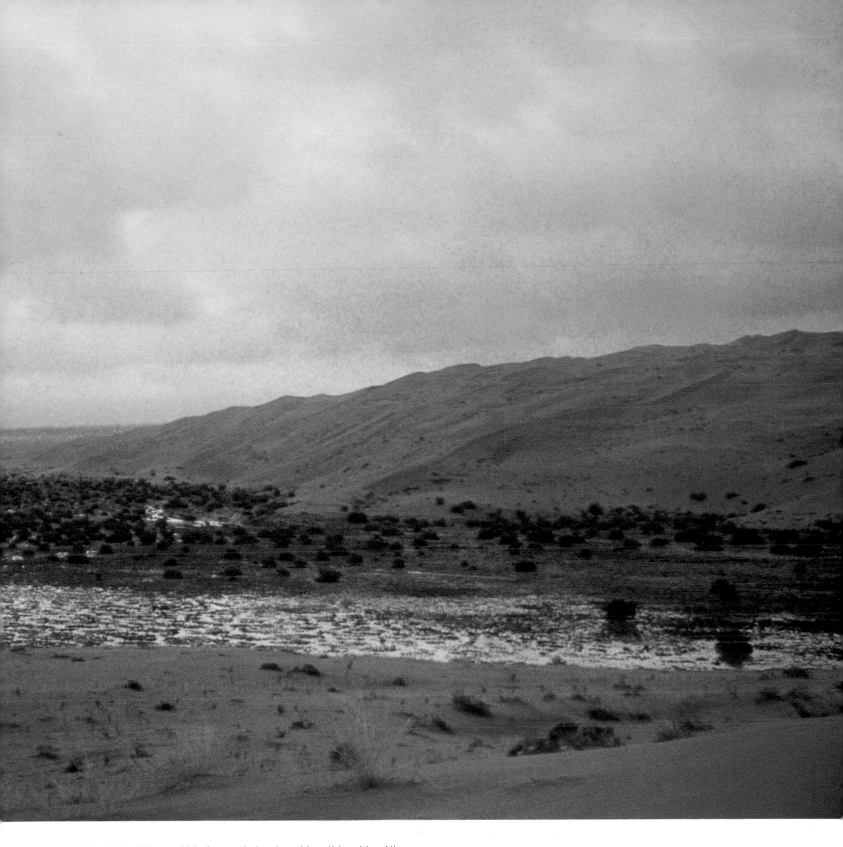

O God, He Whose aid is fervently implored by all invoking His name.
The munificent dispenser of generosity to Whom the winds obey,
I pray, grant us dark clouds drifing eastward at Your behest
Bucketing down its rain with splashing violence on the bare hills,
Pitch-black, grumbling thunderheads opening their floodgates at His command,
To release the downpours from the clouds in His heights onto the desert floor.

Ad-Dindan

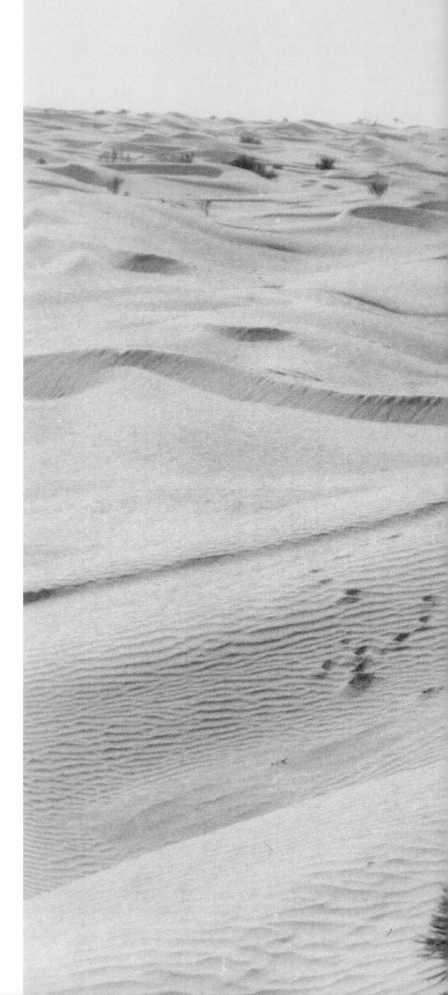

70

Glory in life is complete for
the one who dies
for a principle, for an ideal,
for a grain of sand.

Hasan Abdullah al-Qurashi
from "To Whom the Glory"

The constant shifting of sands which often covers
rails and roads makes it imperative to find ways,
such as this "vegetation fence," to block the winds.

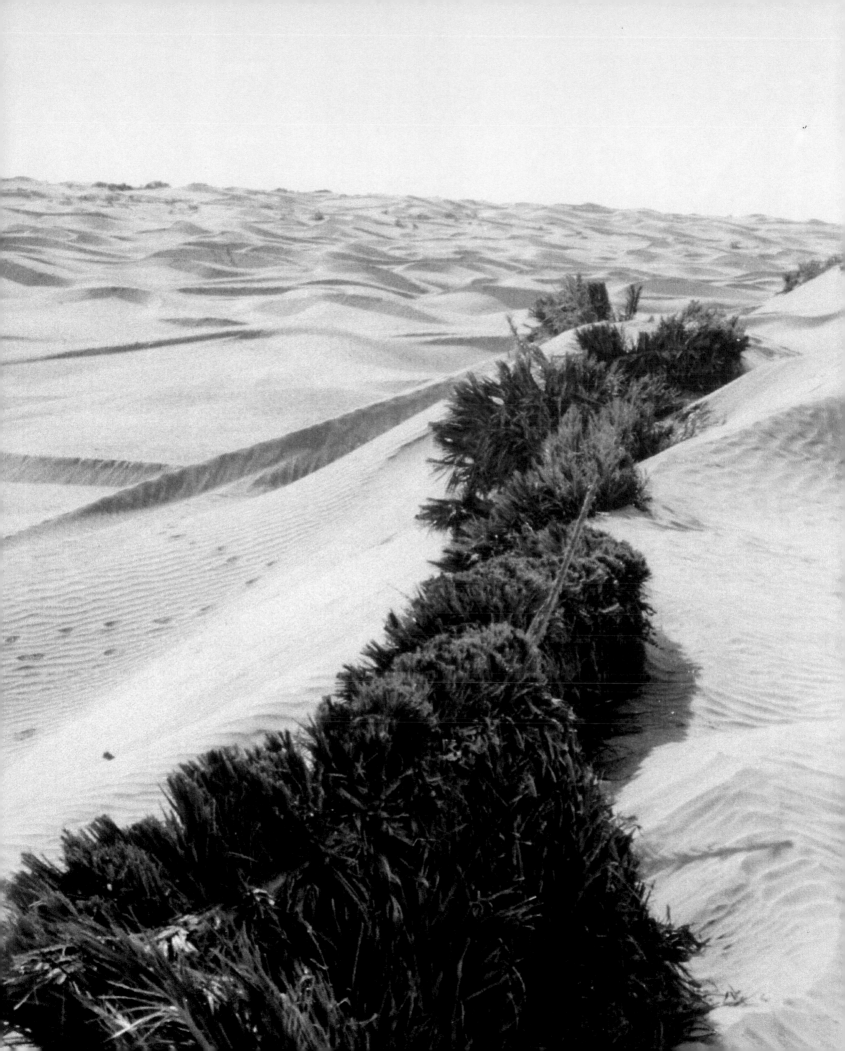

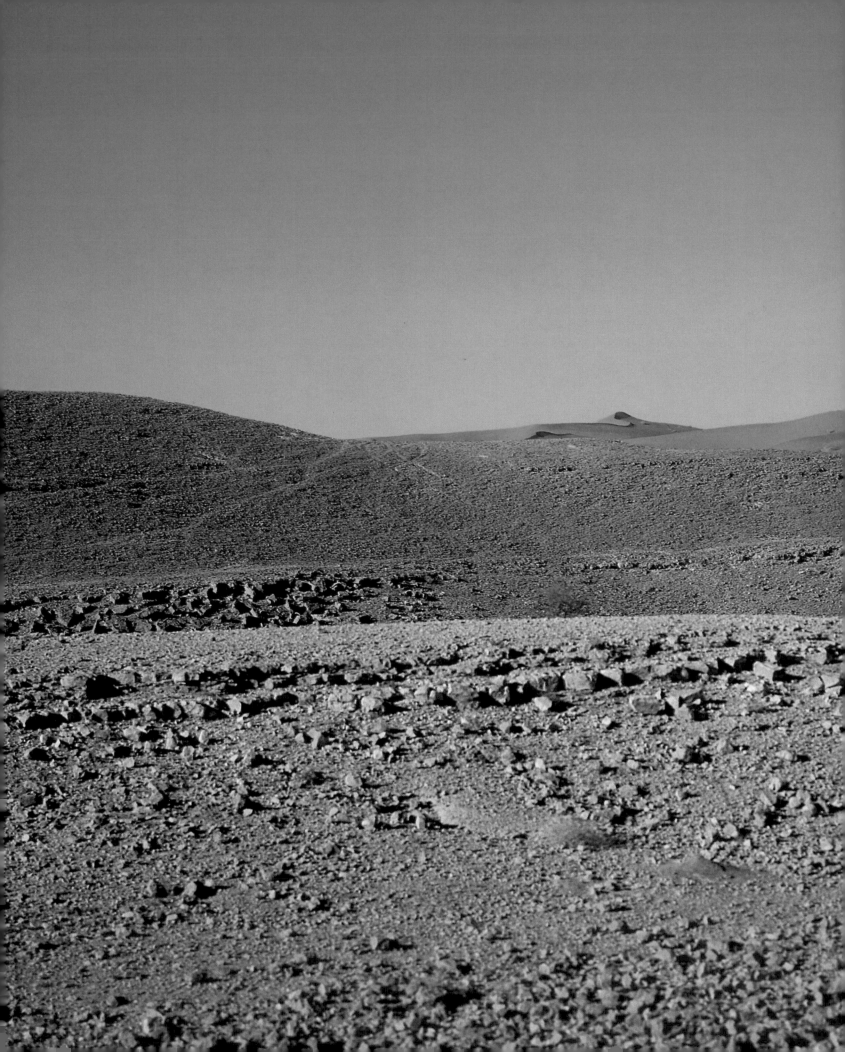

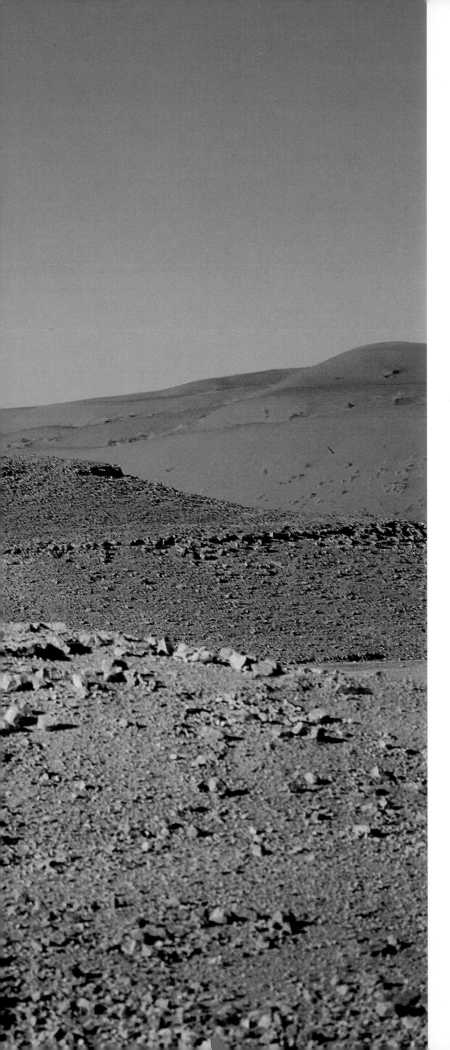

The creed of the desert
seemed inexpressible in
words, and indeed in thought.
It was easily felt as an
influence, and those who
went into the desert long
enough to forget its open
spaces and its emptiness
were inevitably thrust upon
God as the only refuge and
rhythm of being.

T. E. Lawrence
from Seven Pillars of Wisdom

A visually appealing contrast of color and texture.

O land veiled to our sight from ages past,
Which way to you? Which path? How long? How wide?
What wasteland hems you in? What mountain range
Enfolds your realm?

*Gibran Kahlil Gibran
from "Veiled Land"*

*Spectacular desert vistas
have been the inspiration
of poets over the centuries.*

In every head is some wisdom.

Arabic Proverb

Saudi men, dressed in the traditional thobe
and ghutra, *reflect on the wonders of the Asir.*

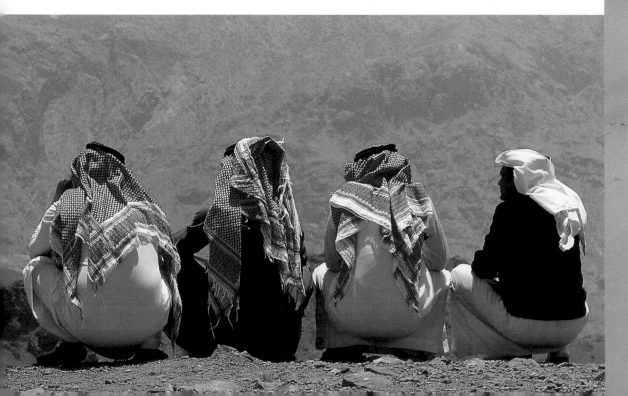

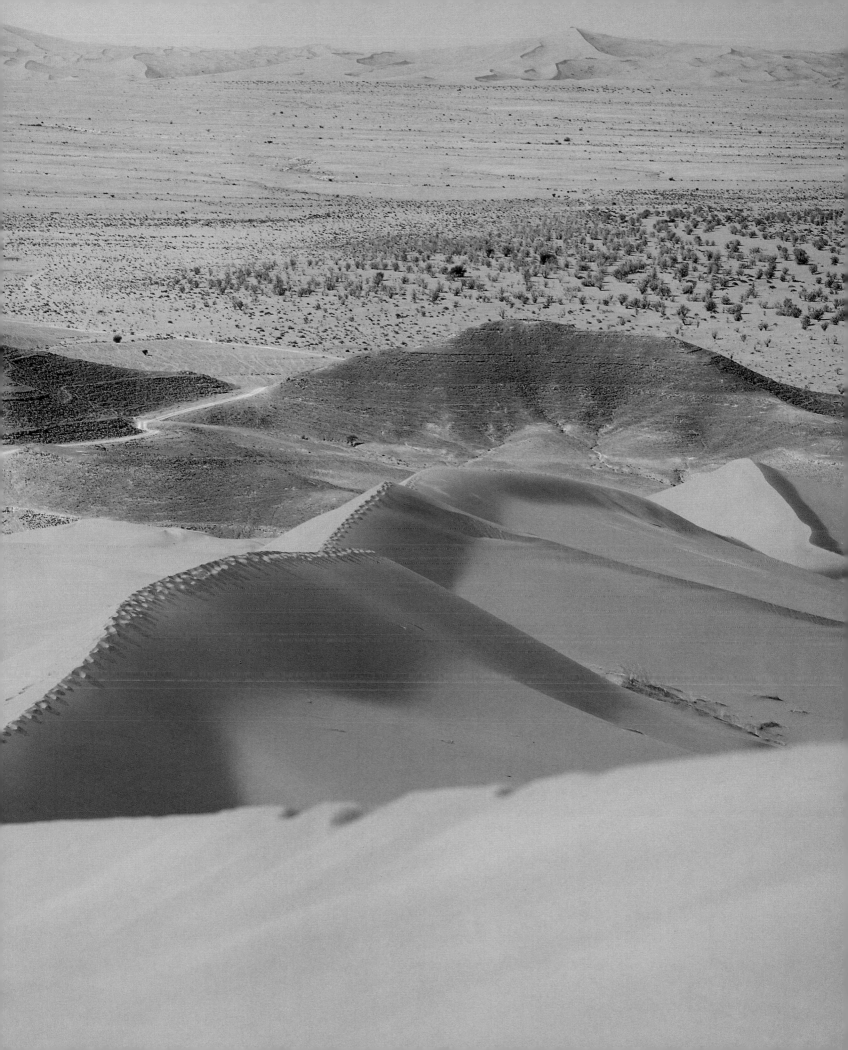

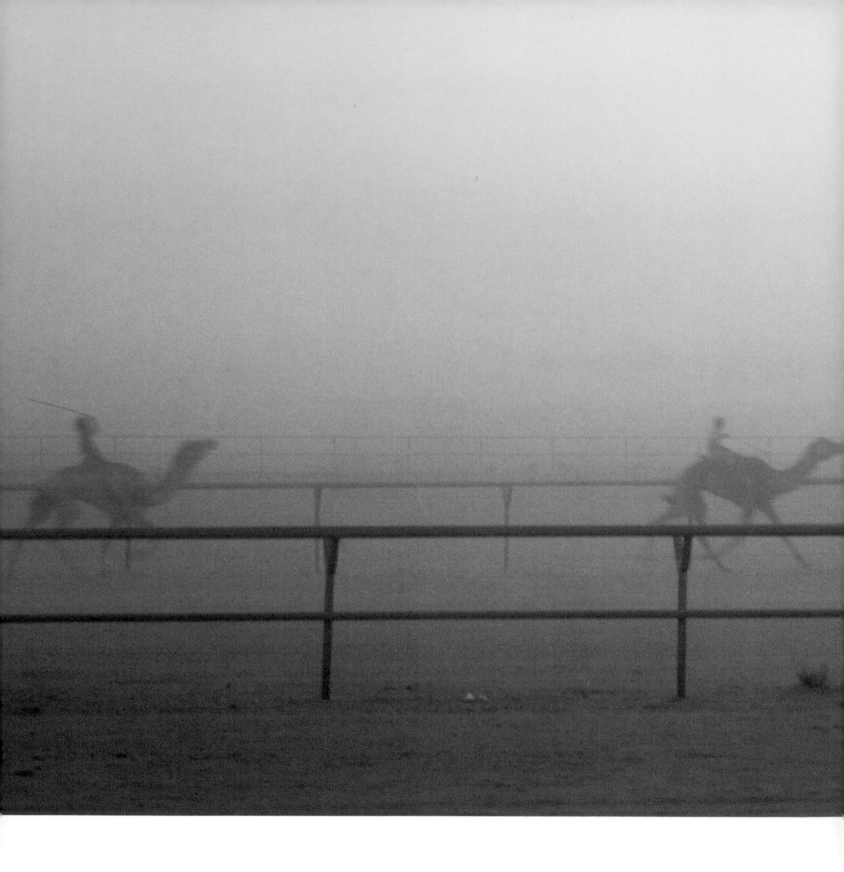

The annual camel race which takes place at the Janadriyah, outside Riyadh.

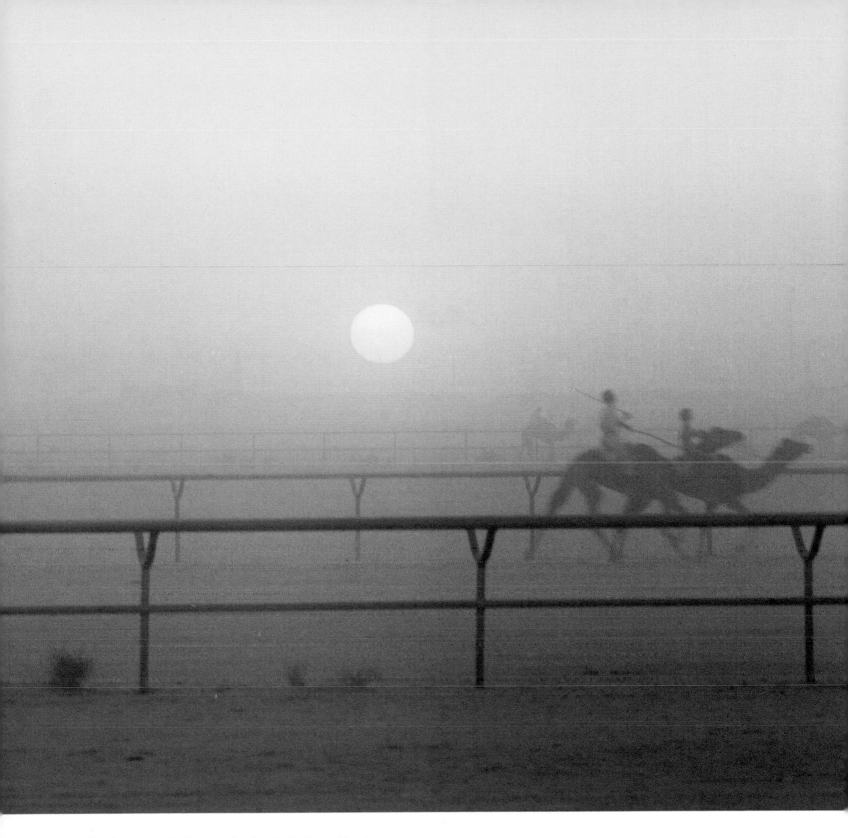

Hardy runners in the noon heat and all night without pause,
Like ships at sea lurching on the waves. . . .

Ad-Dindan

She charmed me, veiling bashfully her face;
Keeping with quiet looks an even pace;
Some lost thing seem to seek her downcast eyes:
Aside she bends not—softly she replies.
Ere dawn she carries forth her meal—a gift
To hungry wives in days of dearth and thrift
No breath of blame up to her tent is borne
While many a neighbour's is the house of scorn.
Her husband fears no gossip fraught with shame,
For pure and holy is Umayma's name.
Joy of his heart, to her he need not say
When evening brings him home—"Where passed the day?"
Slender and full in turn, of perfect height,
A very fay were she, if beauty might
Transform a child of earth into a fairy sprite!

Shanfara
from Ode XLV, the Mufadd aliyyat

Bedouin woman with traditional symbols of Arab hospitality: gahwa *(cardamom coffee) and incense.*

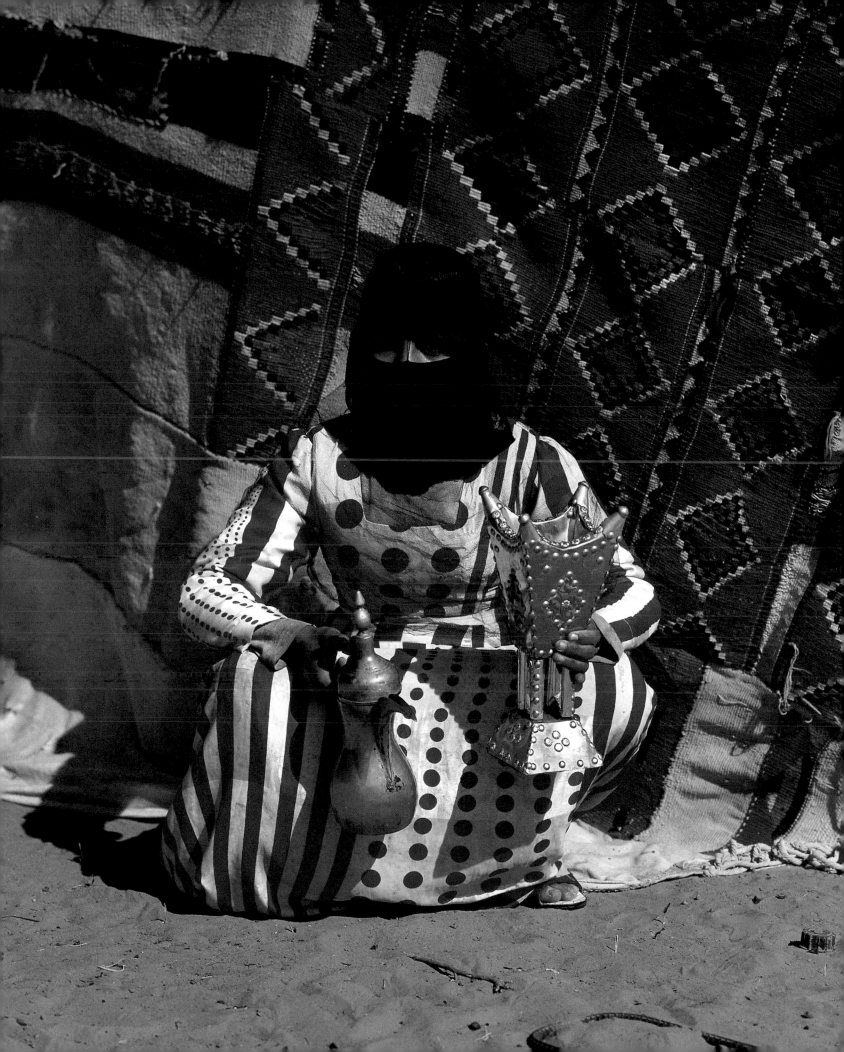

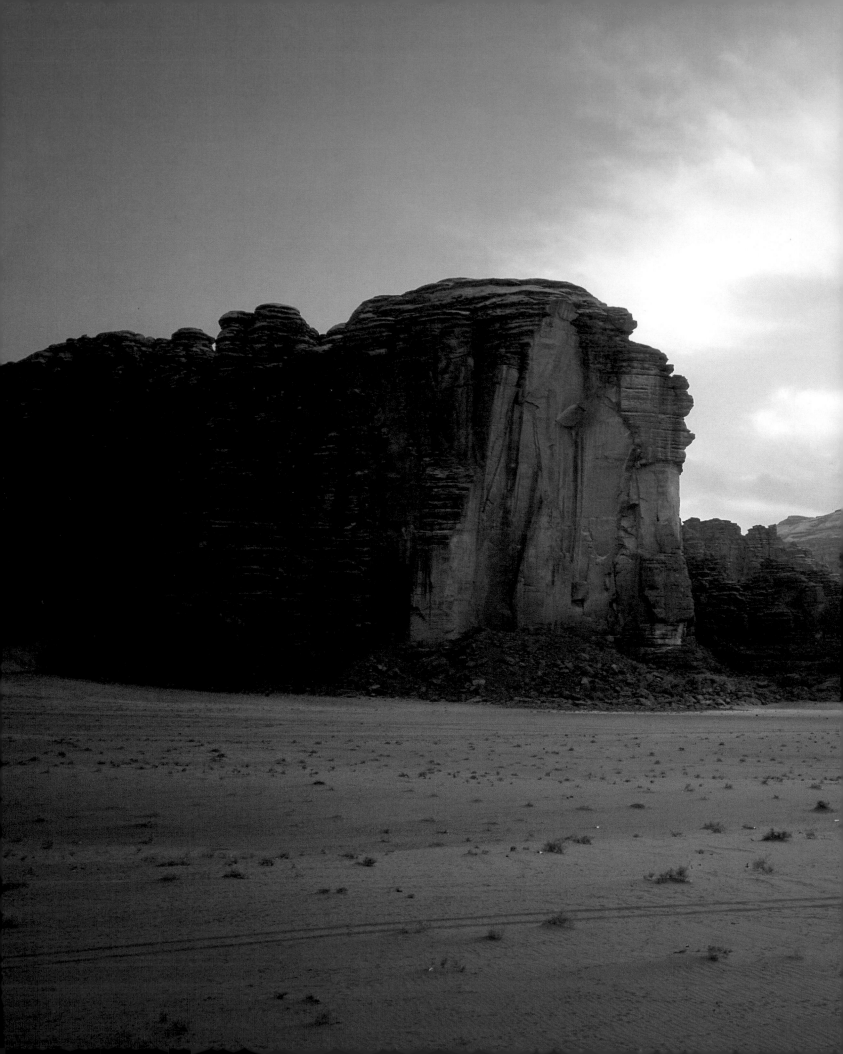

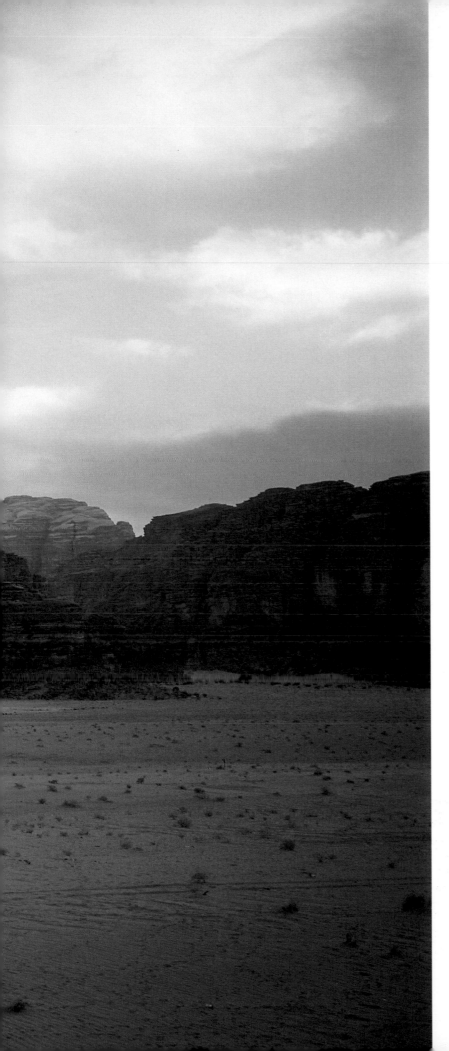

We looked up on the left to a long wall of rock,
sheering in like a thousand foot wave
towards the middle of the valley;
whose other arc, to the right,
was an opposing line of steep, red broken hills.

T. E. Lawrence
from The Seven Pillars of Wisdom

The sheer precipices of the Tabuk region create a startling sight.

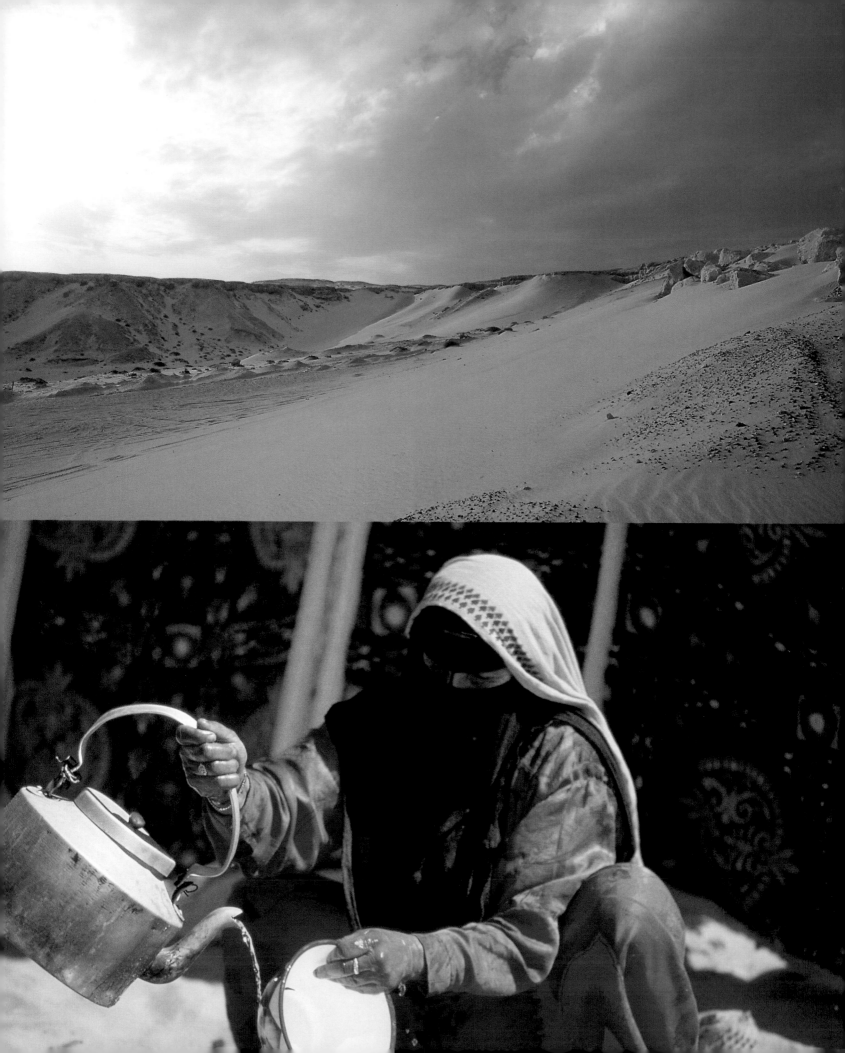

What pain
 When the heart darkens gloomily
 Thick clouds
come crowding my mind, densely
densely
gradually.
What sadness when thunder shakes
 the mountains of anguish in my heart
violently
violently it comes.
It destroys me,
this lightning
that gleams in the desert of my
 soul
but illuminates nothing!

Sulaiman al-Fulayyih
from "Clouds"

Gentle slopes await the storm.

 Though you might see me
sun-beaten as a sand daughter,
 ragged, shoeless,
with worn feet,

Still I am the master of patience,
 wearing its armor
over the heart of a sand cat,
 shod with resolution.

 Sometimes I have nothing,
sometimes all I need.
 Only one who gives himself,
far-seeing, will prosper.

I don't lose nerve in adversity,
 exposing weakness,
nor do I prance, self satisfied,
 in my riches.

 The hot-neck fool will not provoke
my self-command, and I am not seen
 begging at the heels of conversations
and slandering.

Shanfara
from "Arabian Ode in 'L'"

Bedouin woman washing bowl that she will use to serve yogurt.

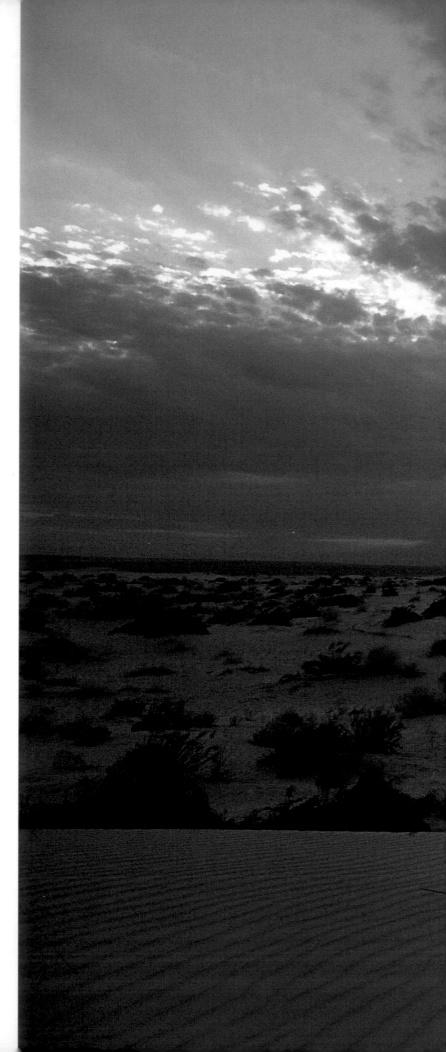

84

I find no kinship with anything;
The world is alien, the times estranged—
As if I came in an age too soon or too late.
Or perhaps in an interim.

Abdallah al-Baraduni
from "End of Death"

Early morning in the Rub al-Khali.

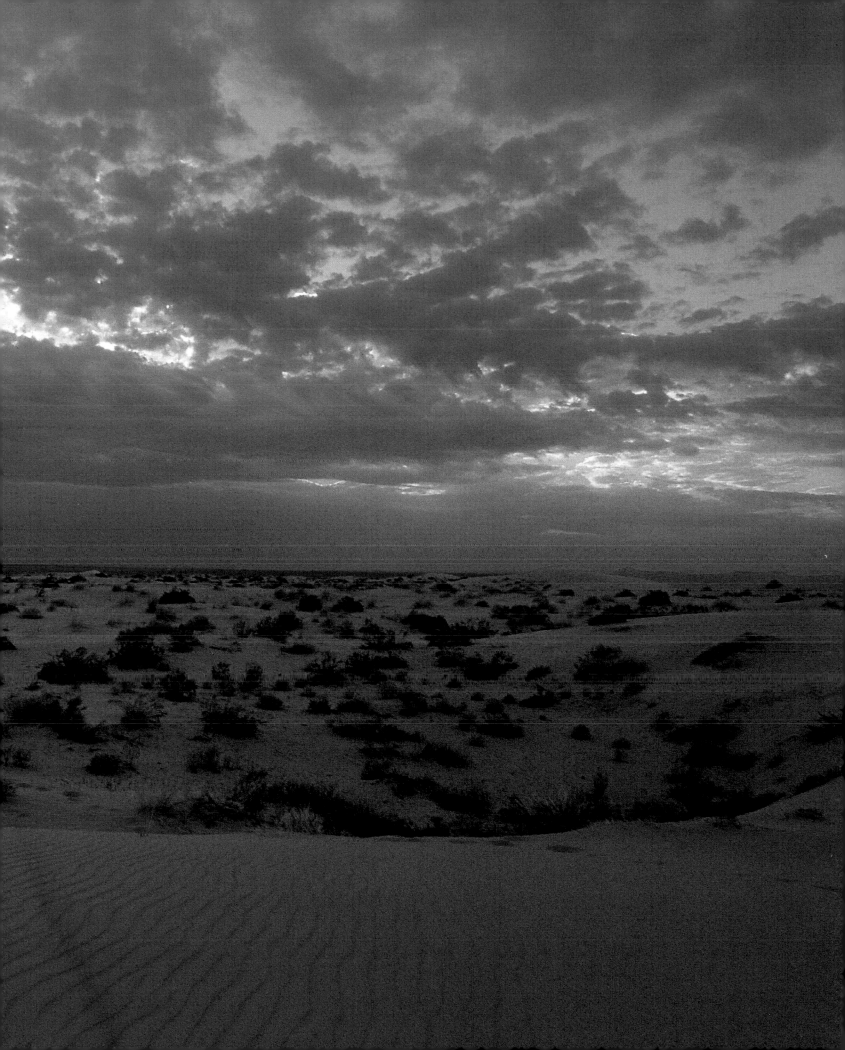

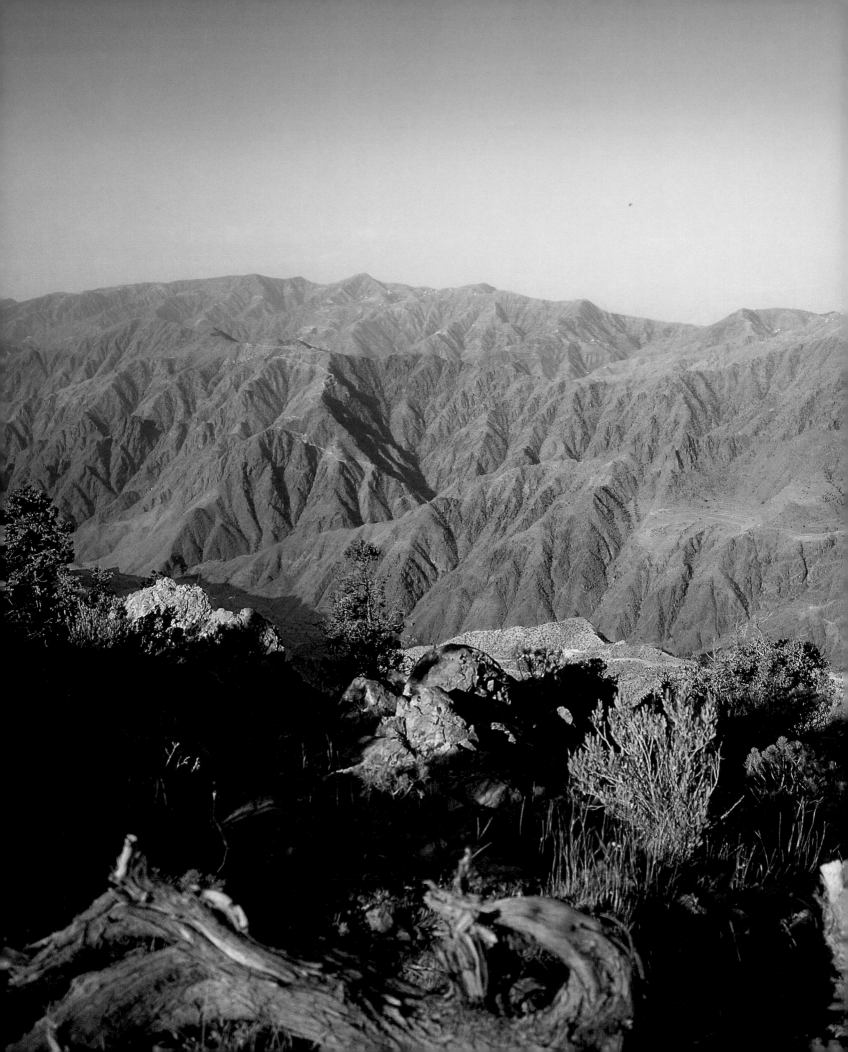

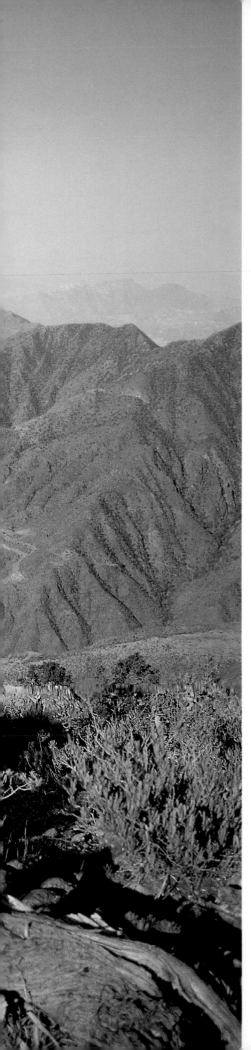

They said, will you travel? No more travel, said I
 Some people like travel, I like other things
They said, where's your summer? The best place, said I
 My summer's Abha, home of the good and the high
I warm to the dance of its clouds when they fly
 And when the breeze blows and the bird sings

Khalid Al-Faisal
"They Said"

The mountainous region of the Asir offers a cooler climate
than the great deserts of the Nafud and the Rub al-Khali.

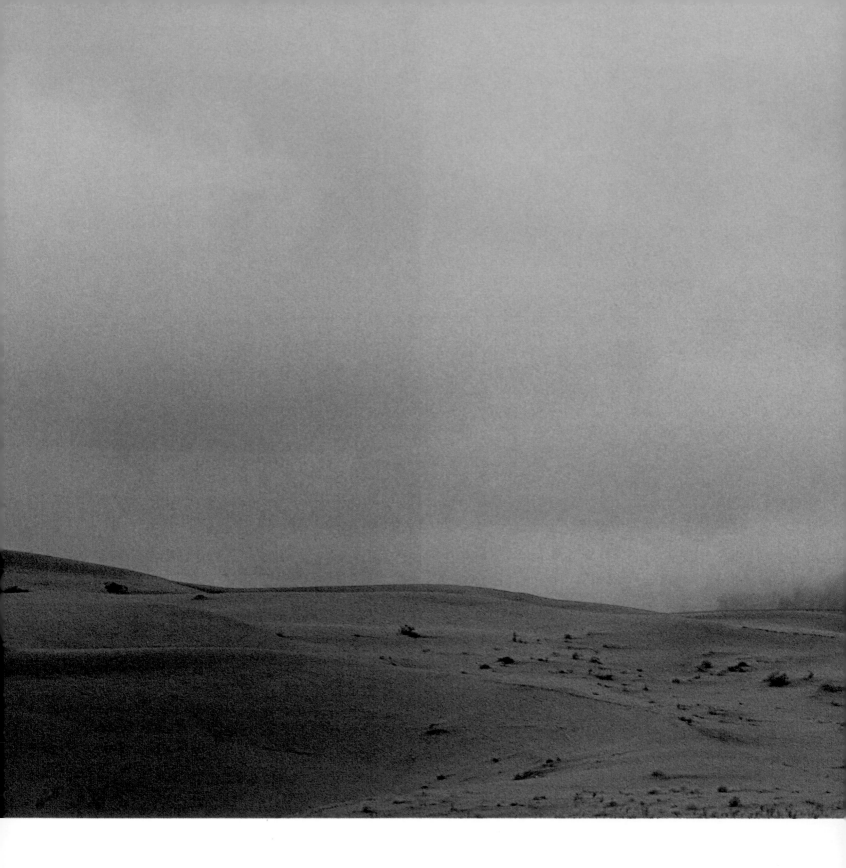

Mist shrouding cliffs in the Najd, southwest of Riyadh.

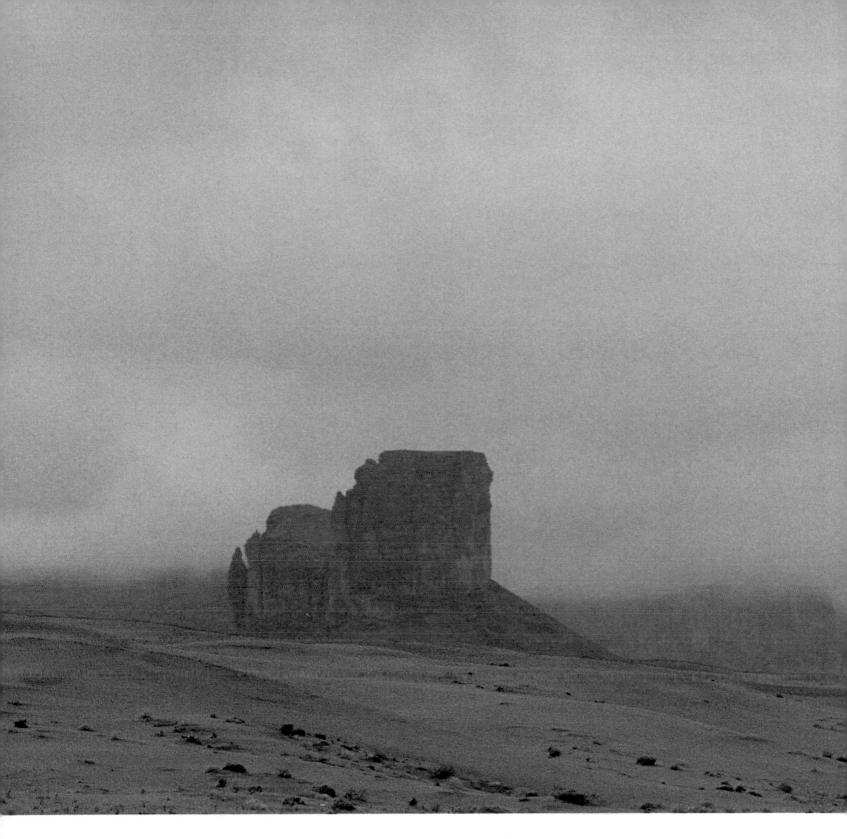

Gray are the high peaks, gray the stones, gray the leafless little plants. And a wind has come up, swirling this heavy omnipresent sand like ashes while clouds of the same gray as the earth race across the sky in a mad flight to the West.

So from now until evening, we have the kingdom of gray, a flat gray, as if powdered with ashes and veined here and there with burnt sienna.

Pierre Loti
from Le Desert

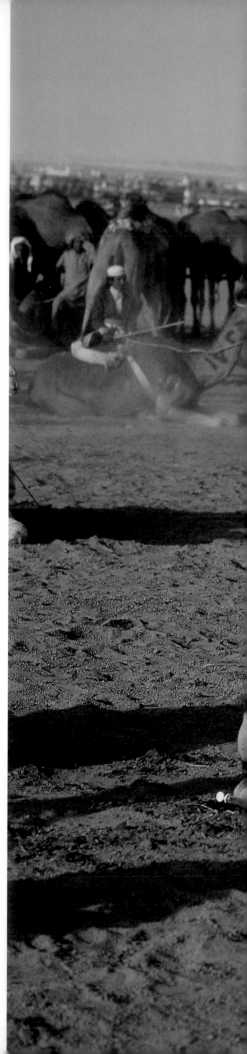

90

Trust in God, but tie your camel.

Arabic Proverb

Camel race at the Janadriyah.

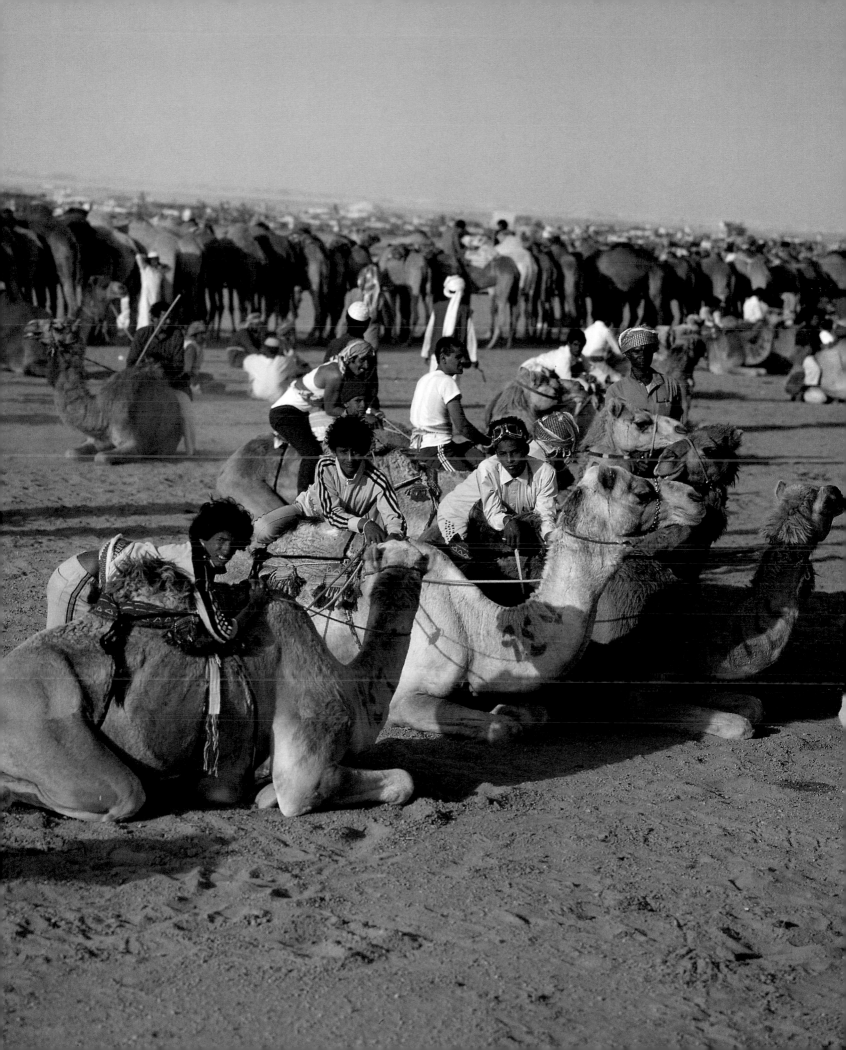

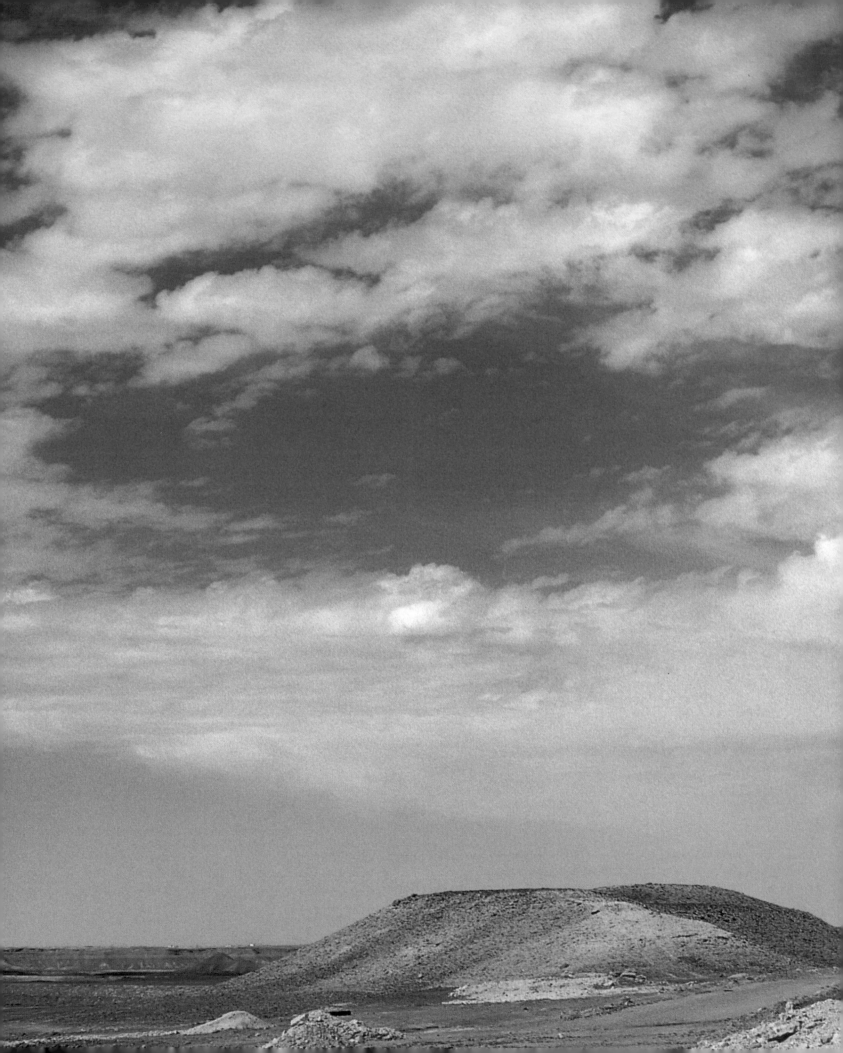

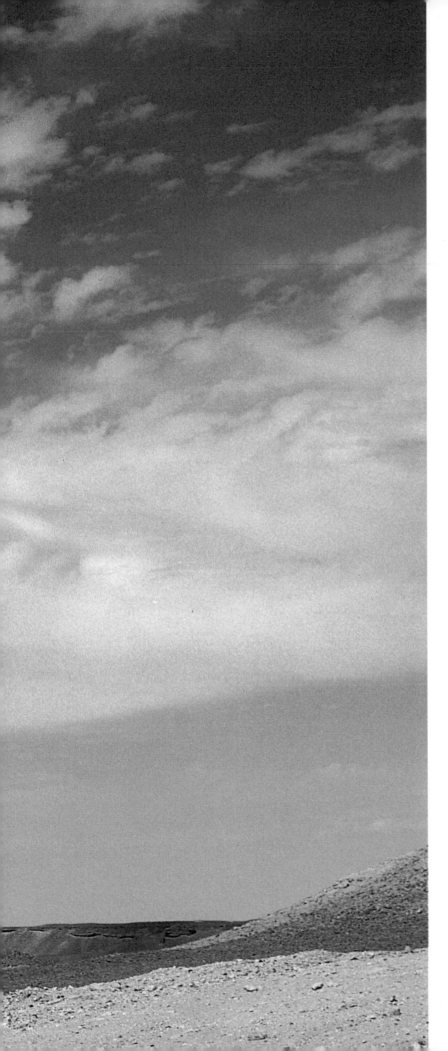

I, the Desert,
wake up and come to You;
before coming, I put on the clothes of Your giving.
O Designer of Night and Day,
Owner of the sun
 in Easts and Wests,
to You I submit my endless thanks.
The sun is one of Your gifts;
I clothe myself with it like a bride
 on her wedding day.
Teach me how to enlighten my sand
 with each ray of the sun;
With Your gift of light,
 I enwrap myself, and contemplate.

Assad Ali
from "With My Children"

Stretching between the Great Nafud to the north and the Empty Quarter to the south, the al-Dahna Desert is a narrow sandy crescent approximately 750 miles in length.

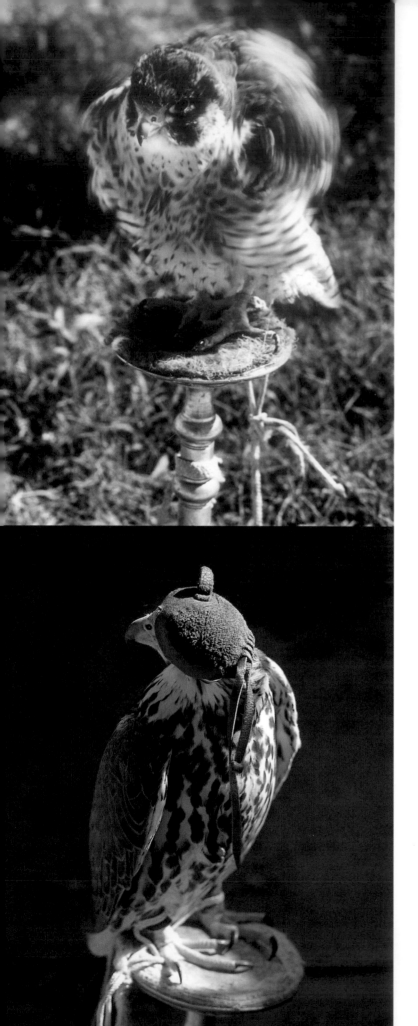

Sanctioned by the Holy Quran, falconry is considered a national sport of Saudi Arabia and is revered throughout the Arab world.

In my breast my heart fluttered like a falcon chick flapping
 its wings,
Once it feels strong enough to fly from its nest.

Ad-Dindan

*Here, in his welcoming tent, a falcon
trainer proudly exhibits his prize.*

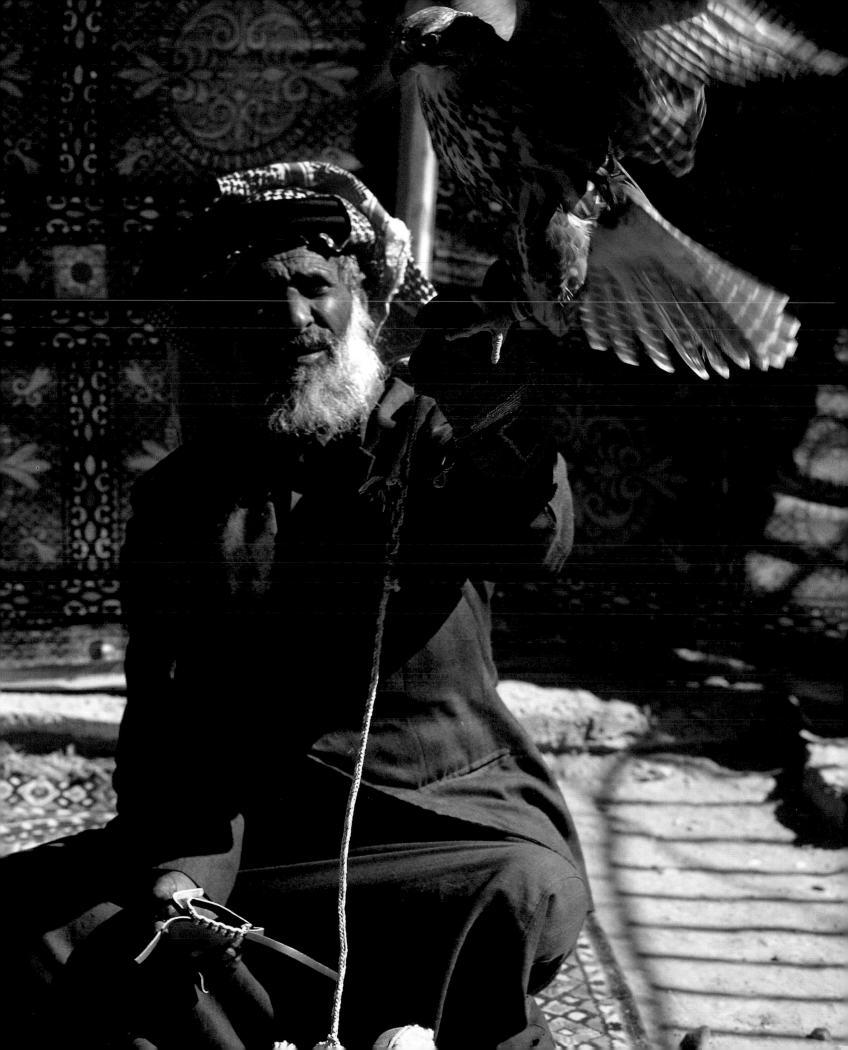

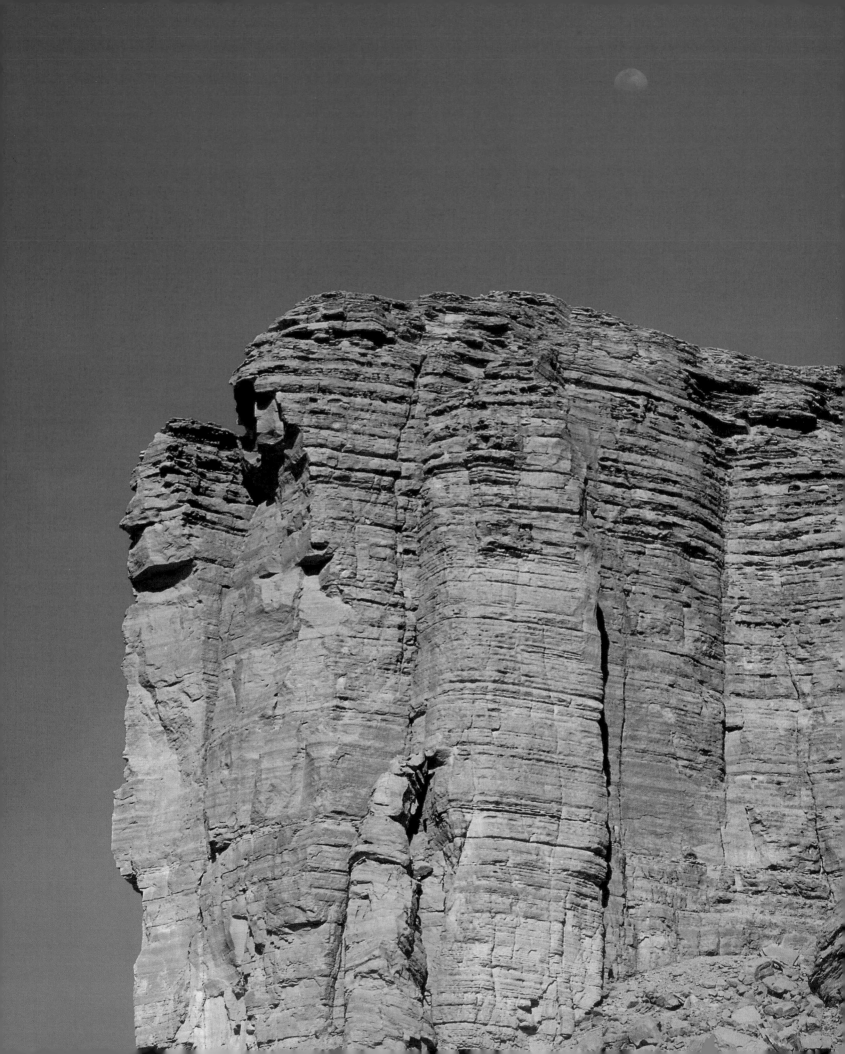

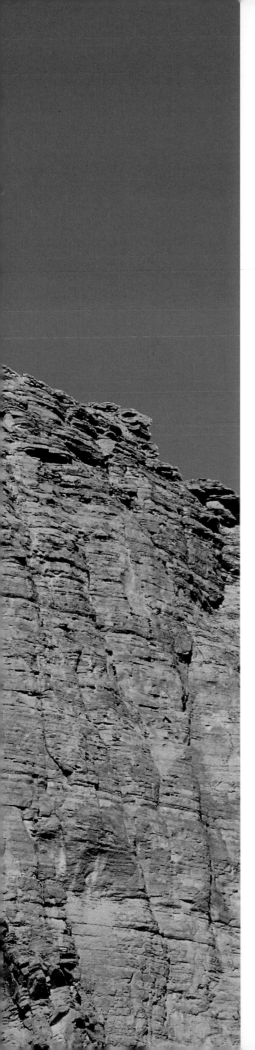

If the moon be with thee, thou needest not to care about the stars.

Arabic Proverb

Moon over the Tuwaiq escarpment, region of the Najd.

In me, as in the sea, are
 shells, sand, and pearls.
And I contain, like the Earth,
 the meadow, plain, and
 mountain.
Like the air, I hold star,
 cloud, and darkness.
But am I Earth, sea, or sky?
I know not.

Abu Madi
from "The Mysteries" (al-Talasim)

The infinite varieties of desert textures are
produced by the erosion of rock over the years.

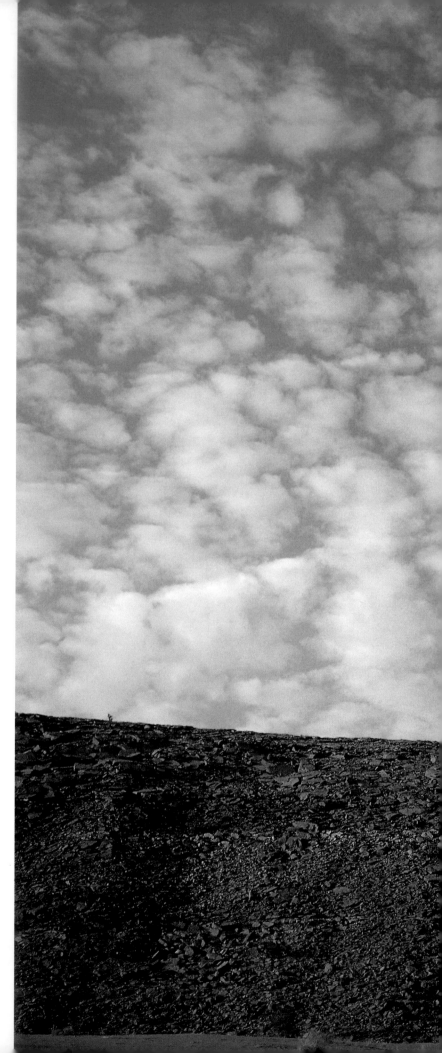

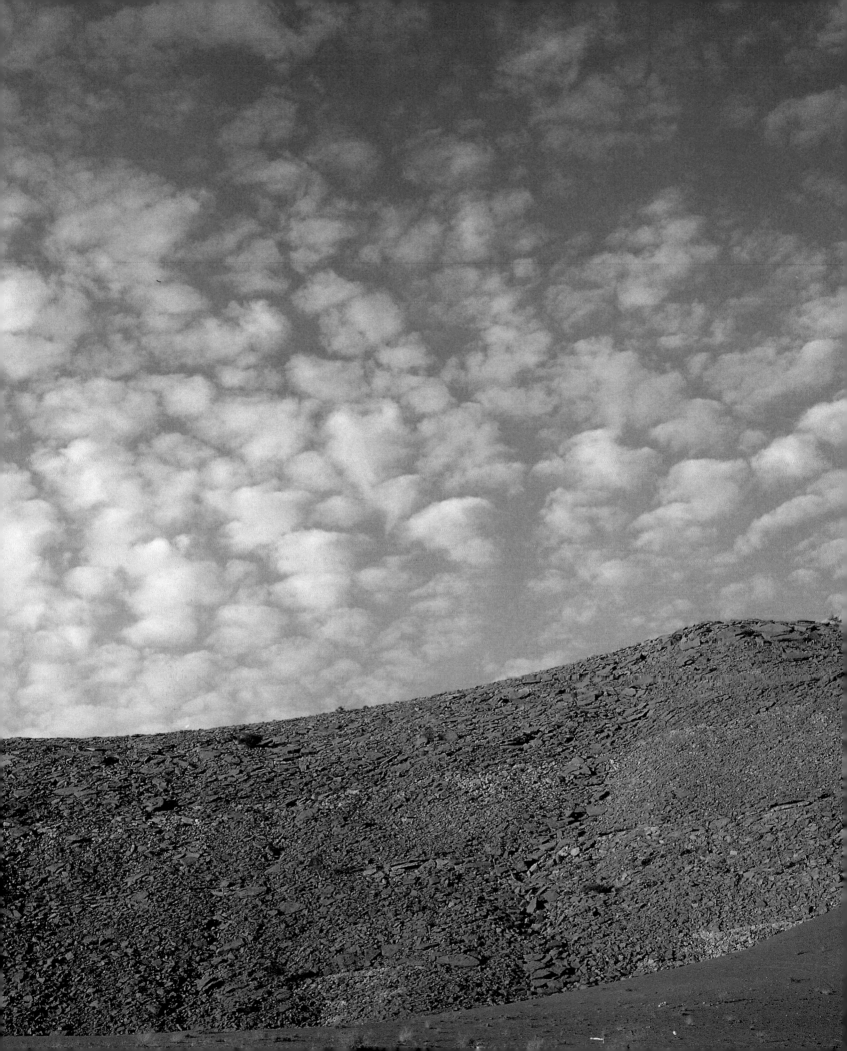

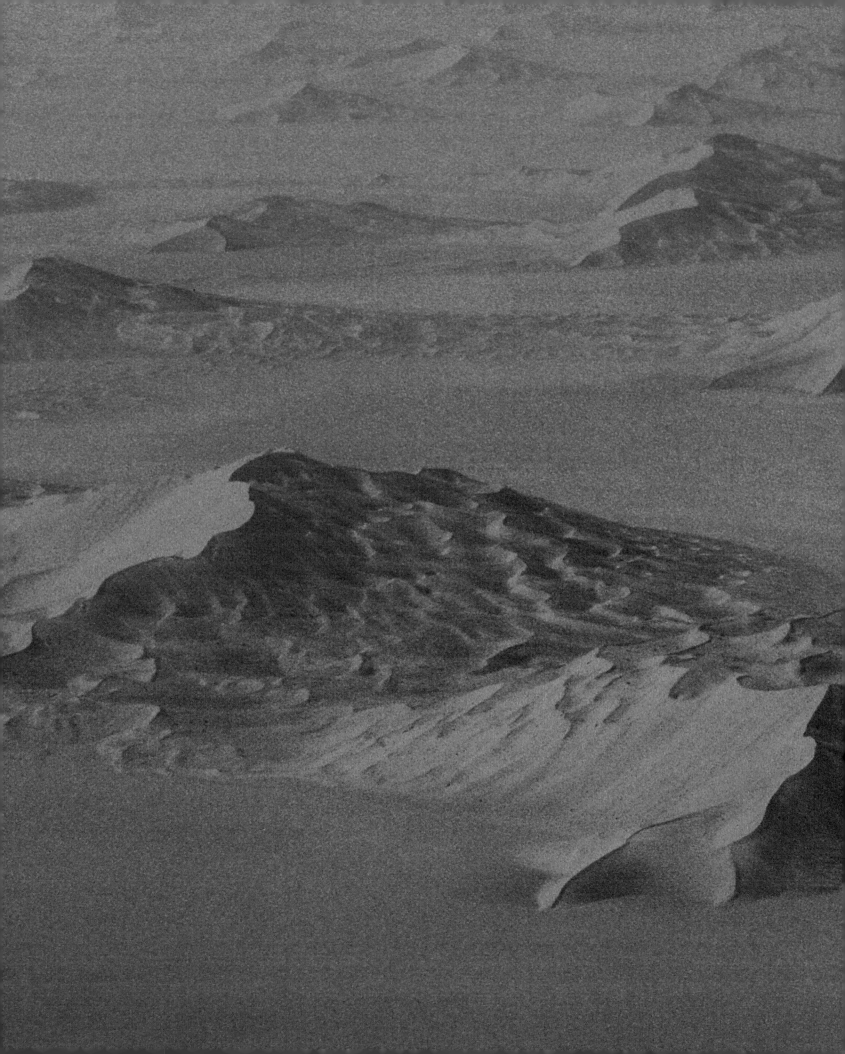

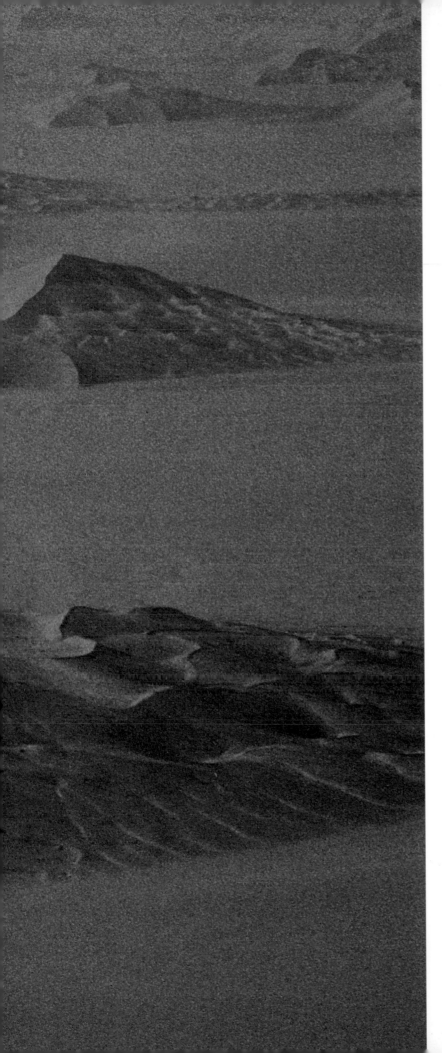

Now I am the empty landscape
which is stripped of trees,
willows, valleys.
Now I am the settler
of empty spaces, open
places
praying wherever
prayer settles.

Maysun Saqr al-Qasimi
from "Cycle"

Eight-hundred-foot sand dunes create the
lunarlike landscape of the Rub al-Khali.

Their halter's cords under their cheeks merrily dancing in the
 wind,
Their necks short-haired and their bodies built in muscular
 profile,
It is sheer delight to watch them carrying their dark-coloured
 saddles,
And their double saddle-bags embellished with red-dyed tufts
 of wool.

Ad-Dindan

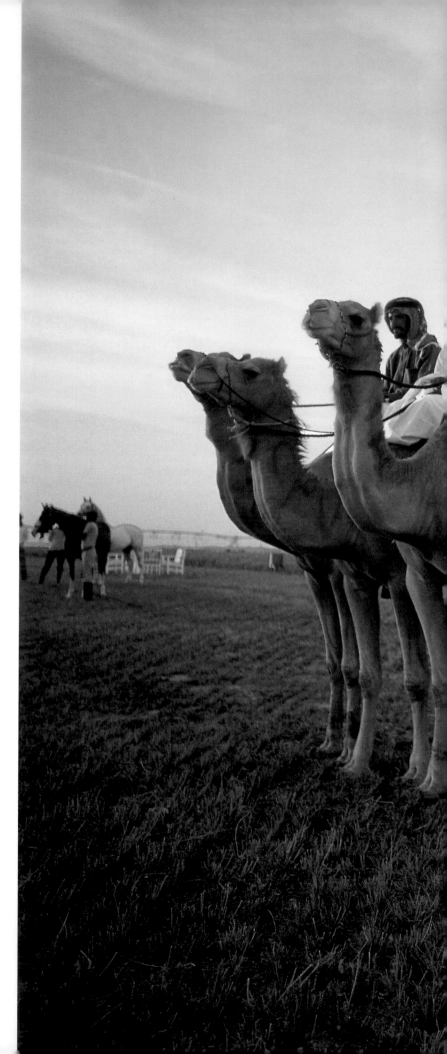

Camel and helicopter: old meets new in the desert.

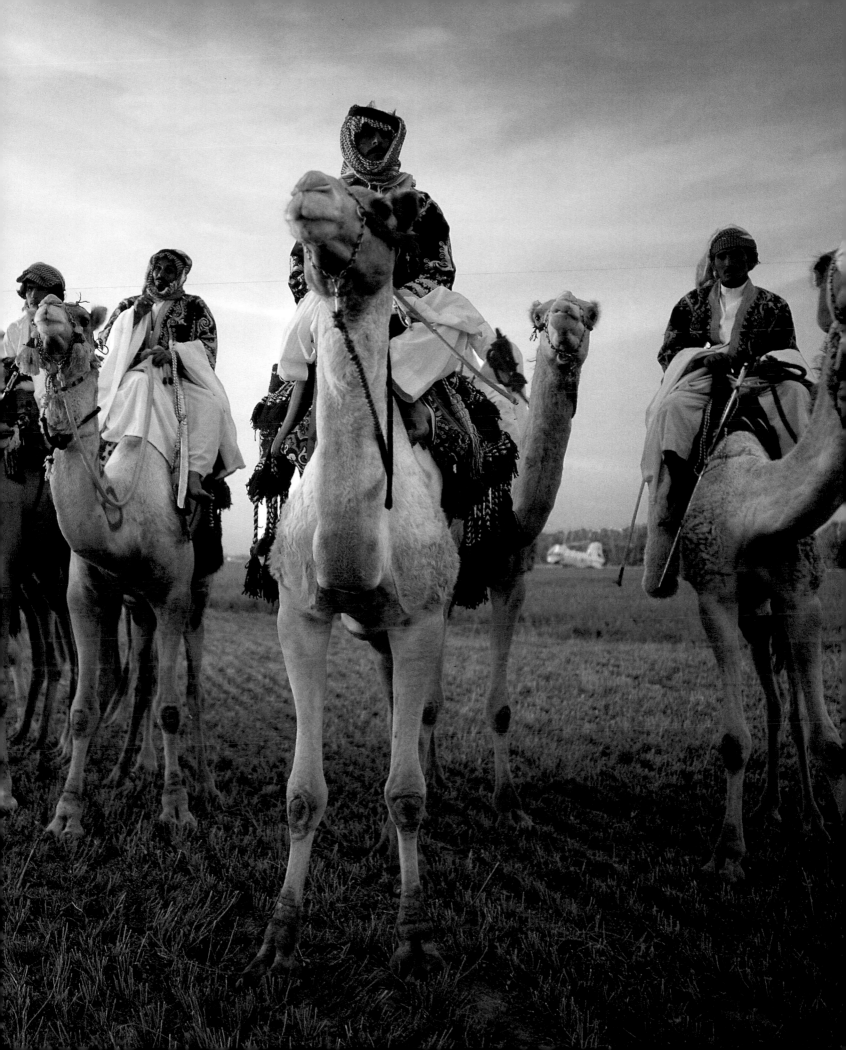

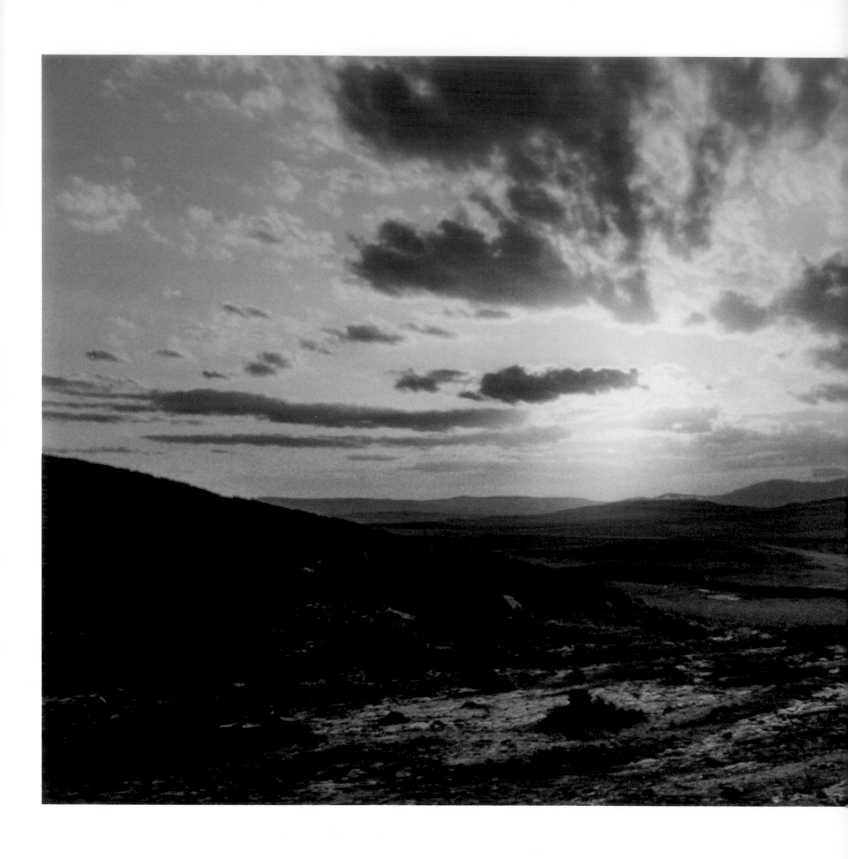

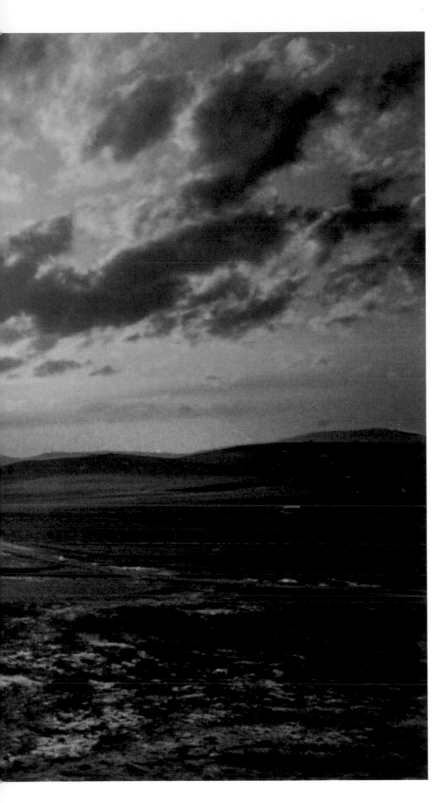

The clouds roll along like
 masses of pregnant,
 long-necked camels,
The ones in front curving
 back to rejoin the black-
 humped in the rear. . . .

Ad-Dindan

*Sands darken as night hovers and
clouds race in the Eastern province.*

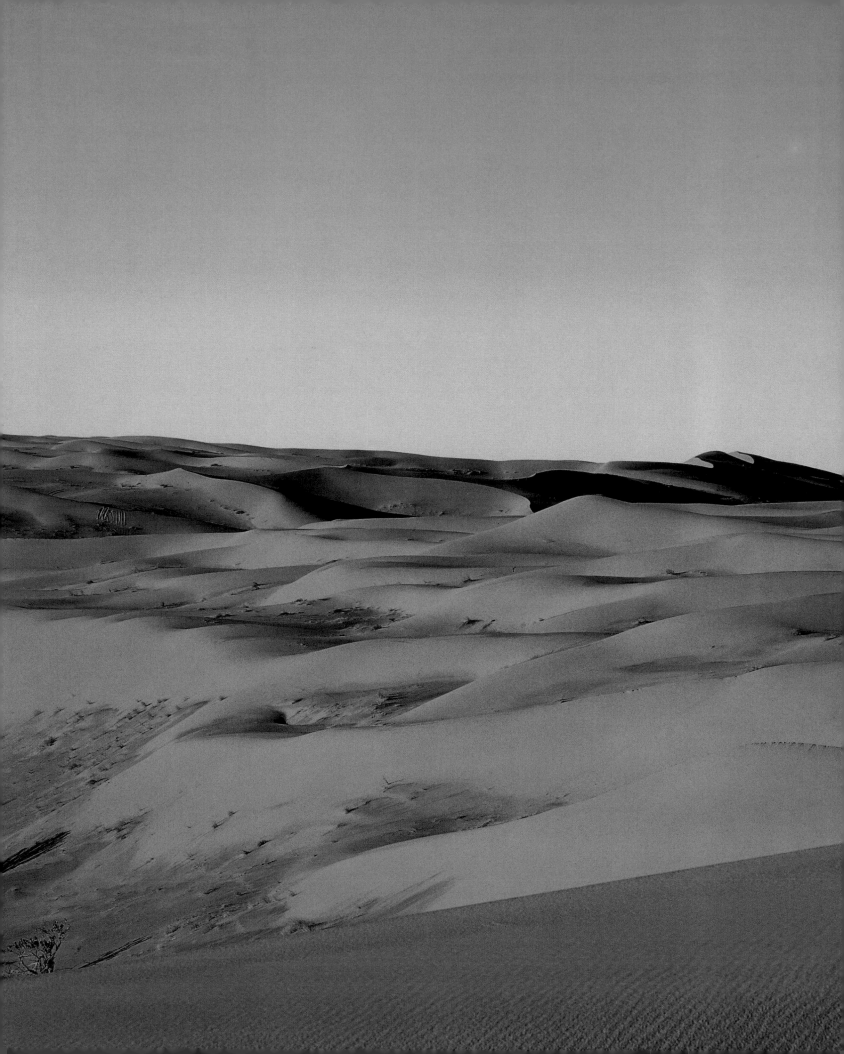

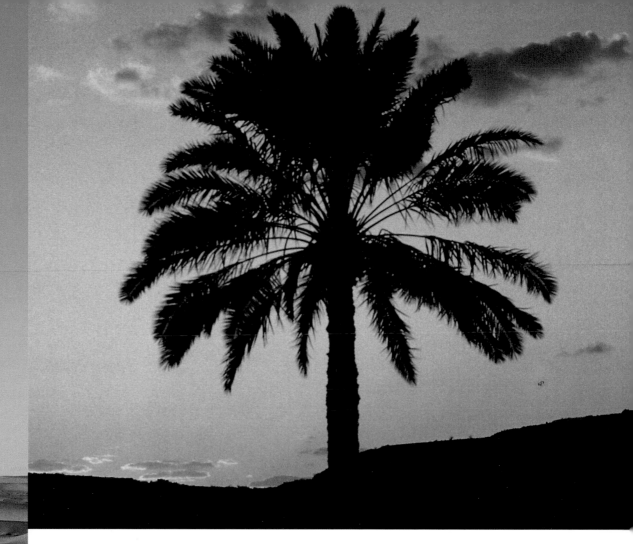

But evening comes, evening with its magic, and we
let ourselves be charmed all over again. . . .
It is the delicate and charming moment in the dying
light that is no longer day, but not yet night. . . .

Pierre Loti
from Le Desert

The majestic date palm, a national
symbol of Saudi Arabia.

Never, while life endures, does a man reach the
summit of his ambition or cease from toil.

Imru'u 'l-Qays
from the Diwan Imru 'u 'l-Qays

The Great Nafud Desert.

Always at the fore with the leading ladies she calls her calf
With a yearning gurgle that would make one startle from his
 slumber.
Ah, she is like a proud and defiant beauty throwing off the
 veil,
Before stepping into the dancing maidens' circle to upstage
 them all.

Ad-Dindan

Fierce pride of motherhood.

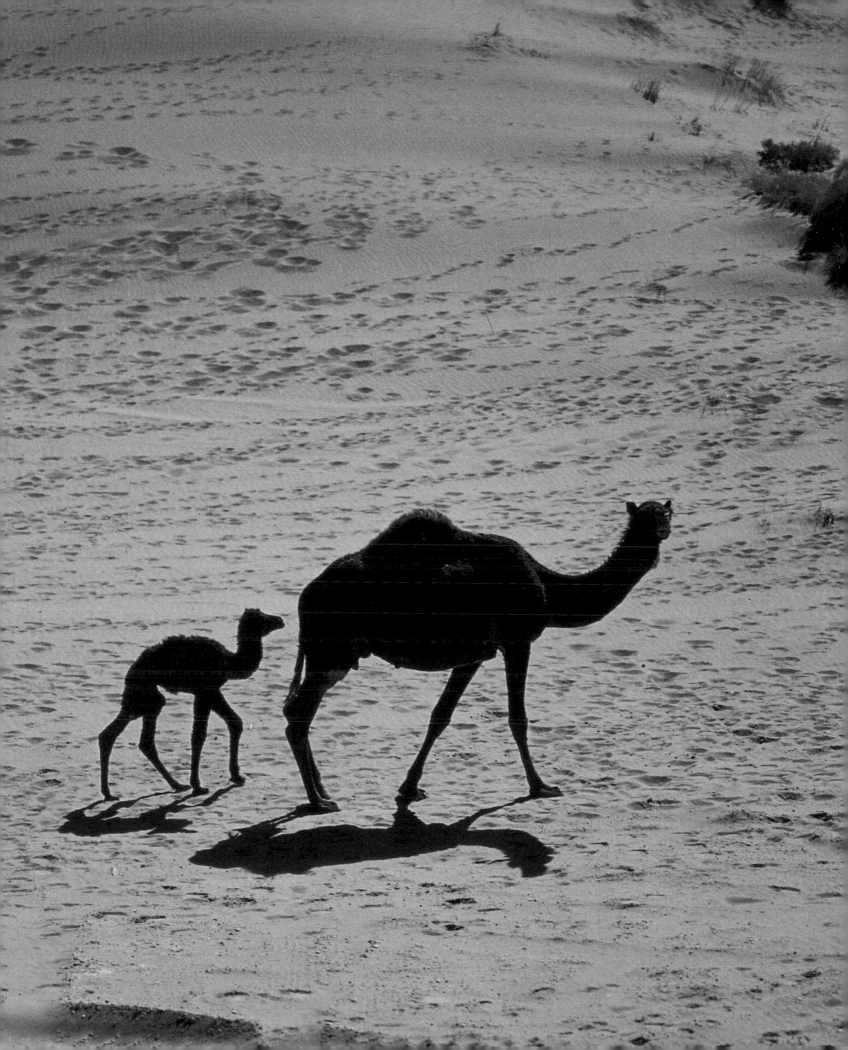

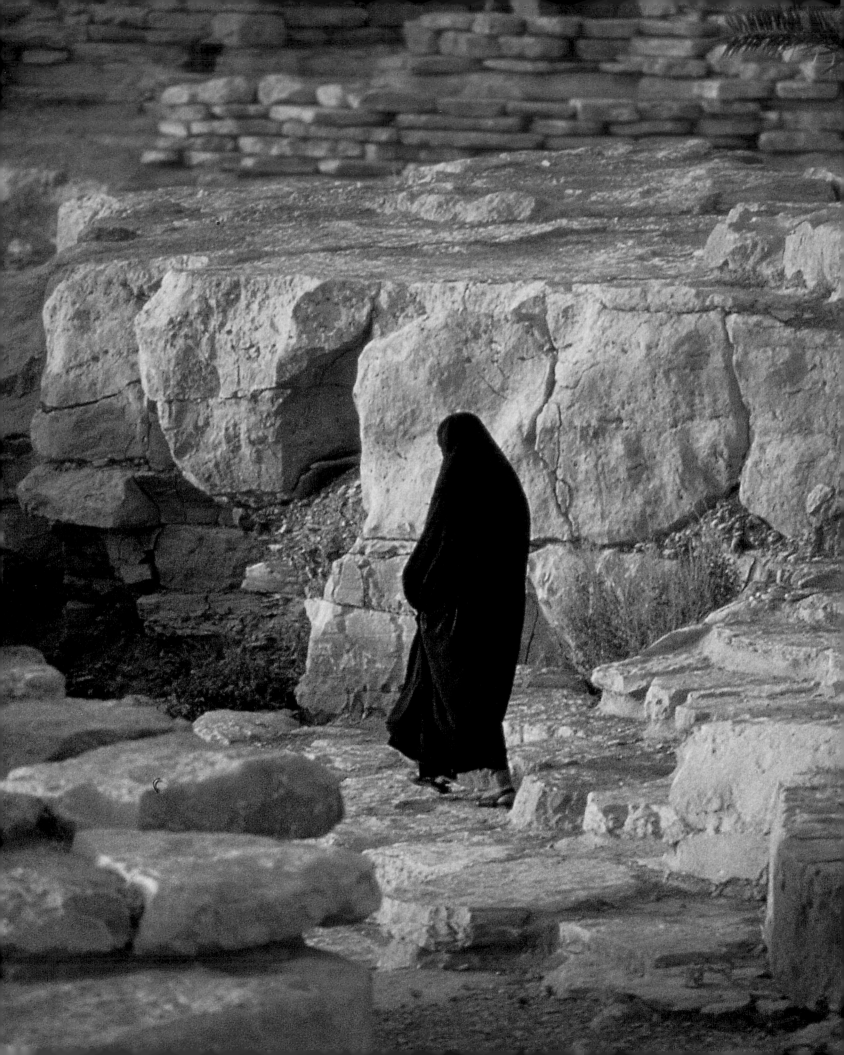

I who may look on every land
Change my robe at will
Enter any door
Would learn from you, O veiled and silent one,
My sister
Hidden in your black djellabah gown;
Are you a prisoner, shackled within
The shadow of enclosing Atlas towers
Or are you—more free than I?

Rosalind Clark
from "To a Berber Woman"

A woman walking in the park of the Diplomatic Quarter, Riyadh.

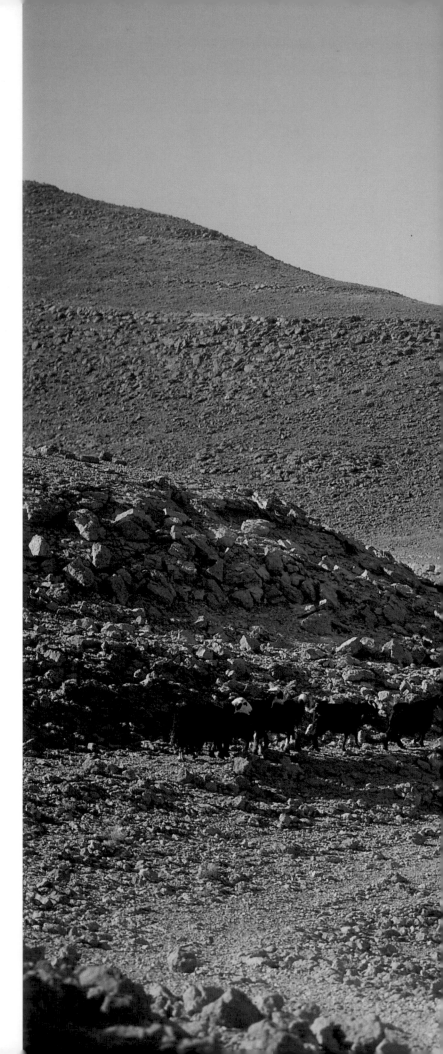

In the corners are hidden treasures.

Arabic Proverb

*Although the land seems barren, goats search
for food behind the stony mounds.*

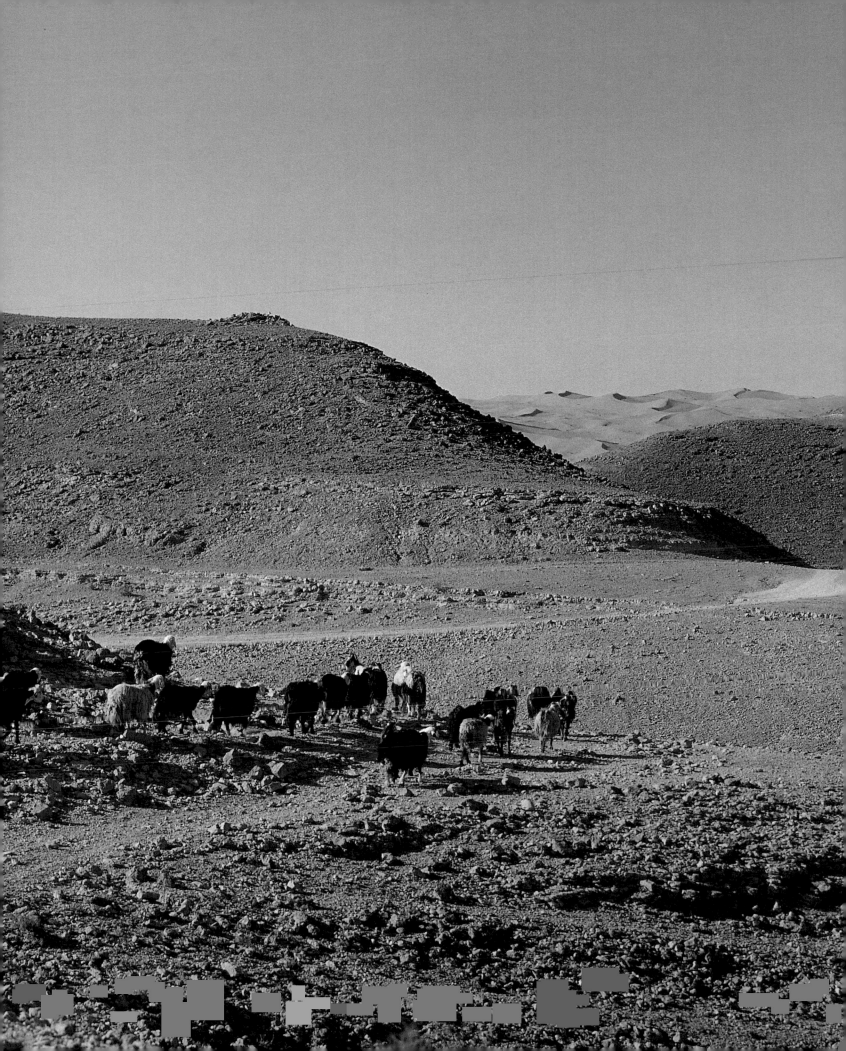

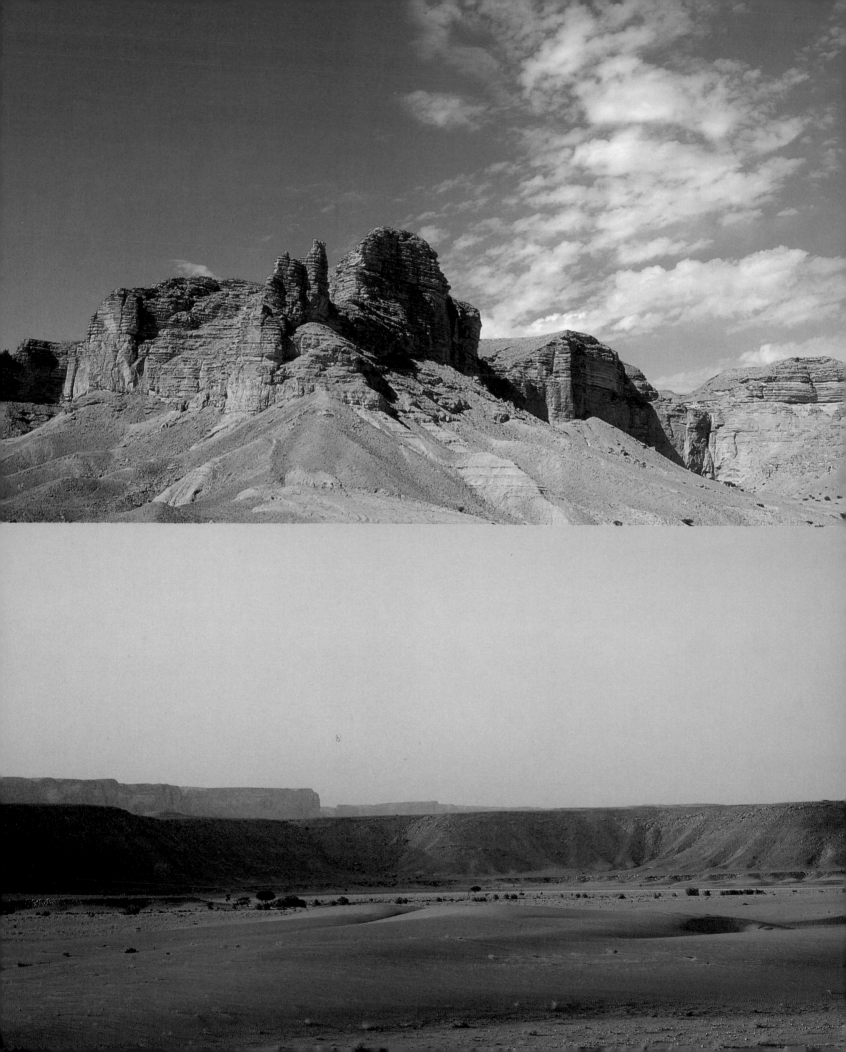

Echoes are soundless.
Memories have no memory
except for those
who hear sounds in echoes
and discover memories in memory.

Orkhan Muyassar
from "Transformations"

A brisk autumn day in the Najd where imposing white cliffs reach majestically toward the sky.

For man there is no escape from the destiny written by the Lord;
His duty is to accept in obeisance what the Lord has allotted to him.

Ibn-Batla

An aura of calm and the sprouting of a few small shrubs follows a spring rain.

Let's head straight for the
land of lush pastures,
Meadows covered with
blossoming annuals to
your heart's delight.

Ibn-Batla

An impressive sprouting of desert shrubbery.

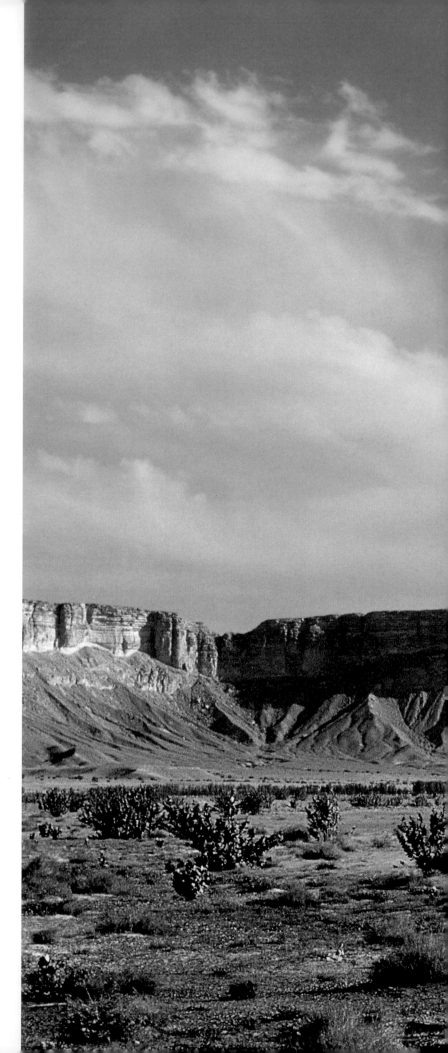

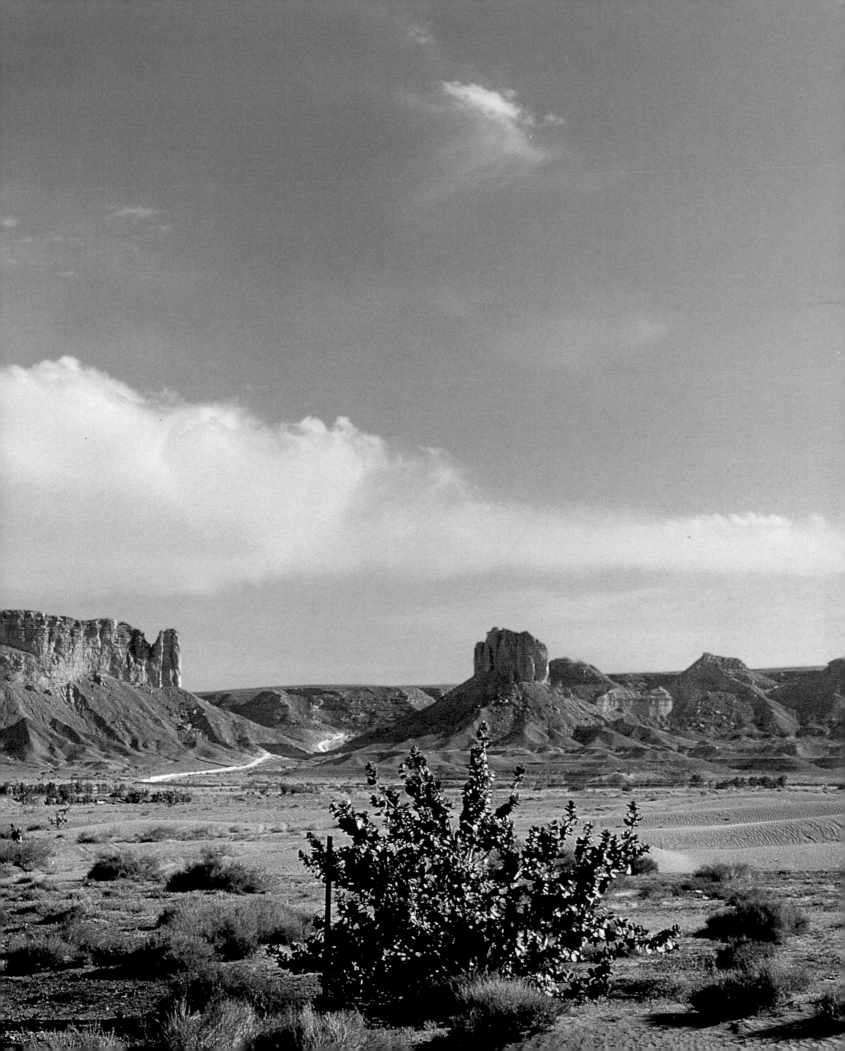

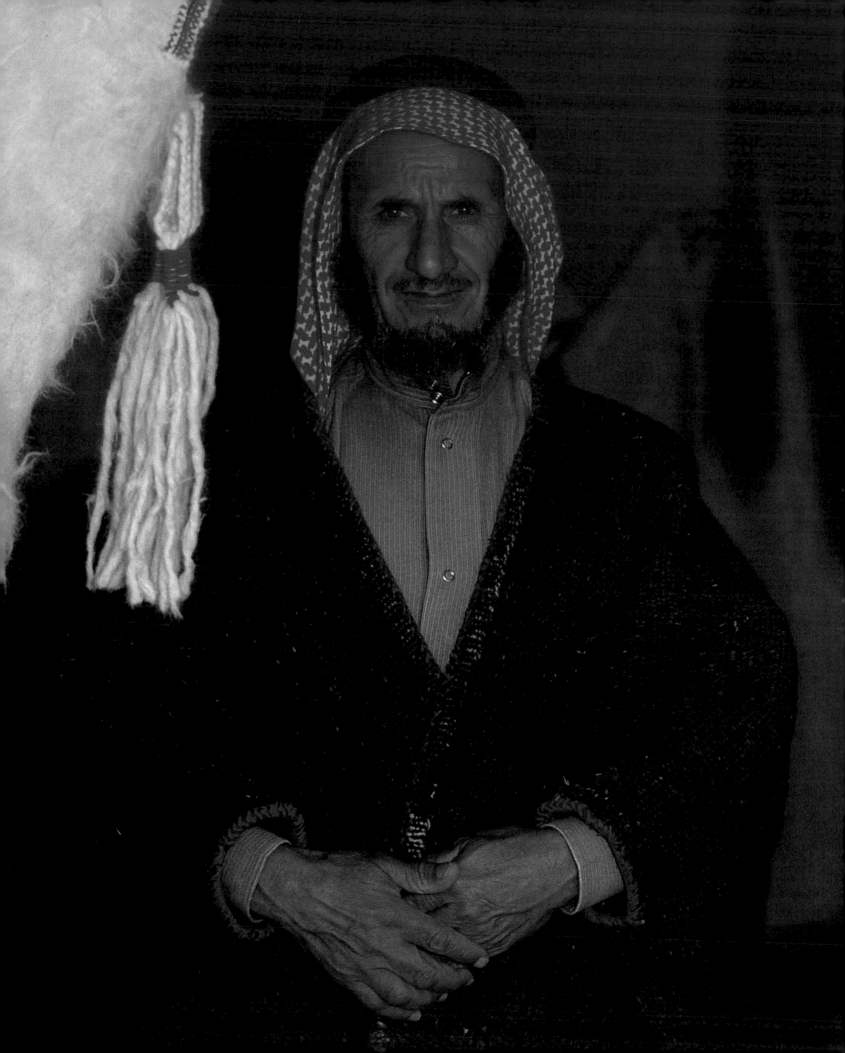

All that is known is not told.

Arabic Proverb

Although Saudi men traditionally wear white thobes, the heavier fabric of the gray thobe under the outer cloak provides additional warmth during the colder months. The ghutras may be either red and white, or white.

An oryx finds a natural shelter in wildlife preserve near Taif.

So exquisitely has God moulded
her gazelle-like shape,
That I am at a loss for words to
describe her peerless beauty.

Ibn Batla

Alert, gazelles explore the area near the ancient ruins of Dira'iya, former citadel of Al-Saud clan.

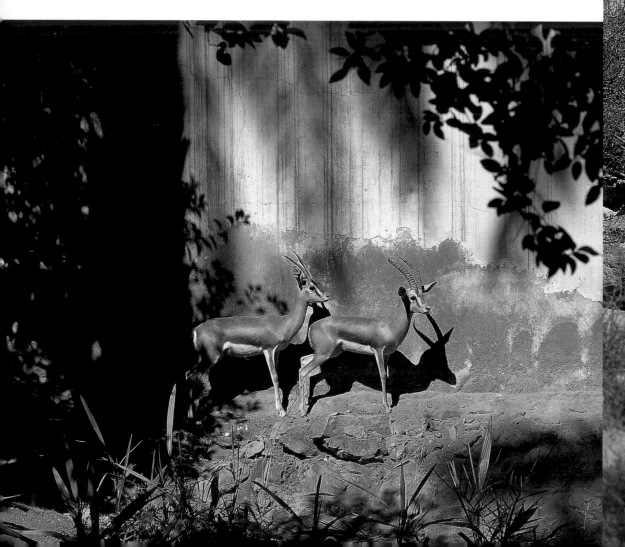

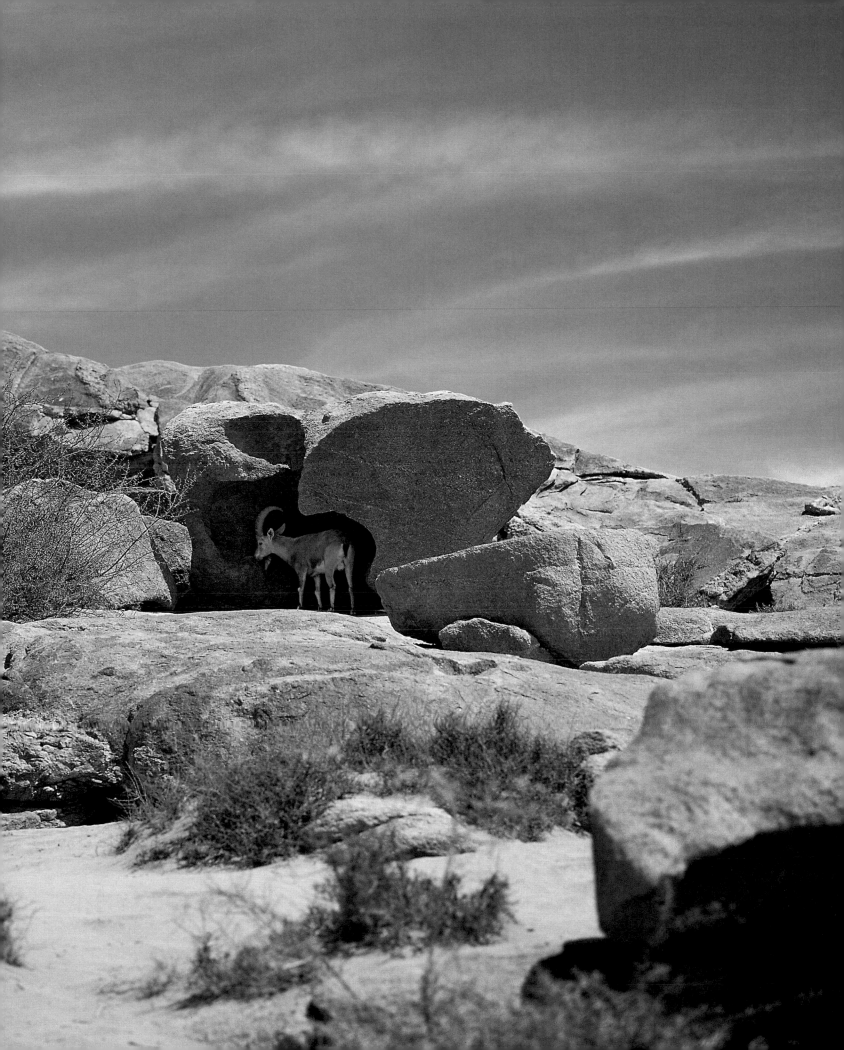

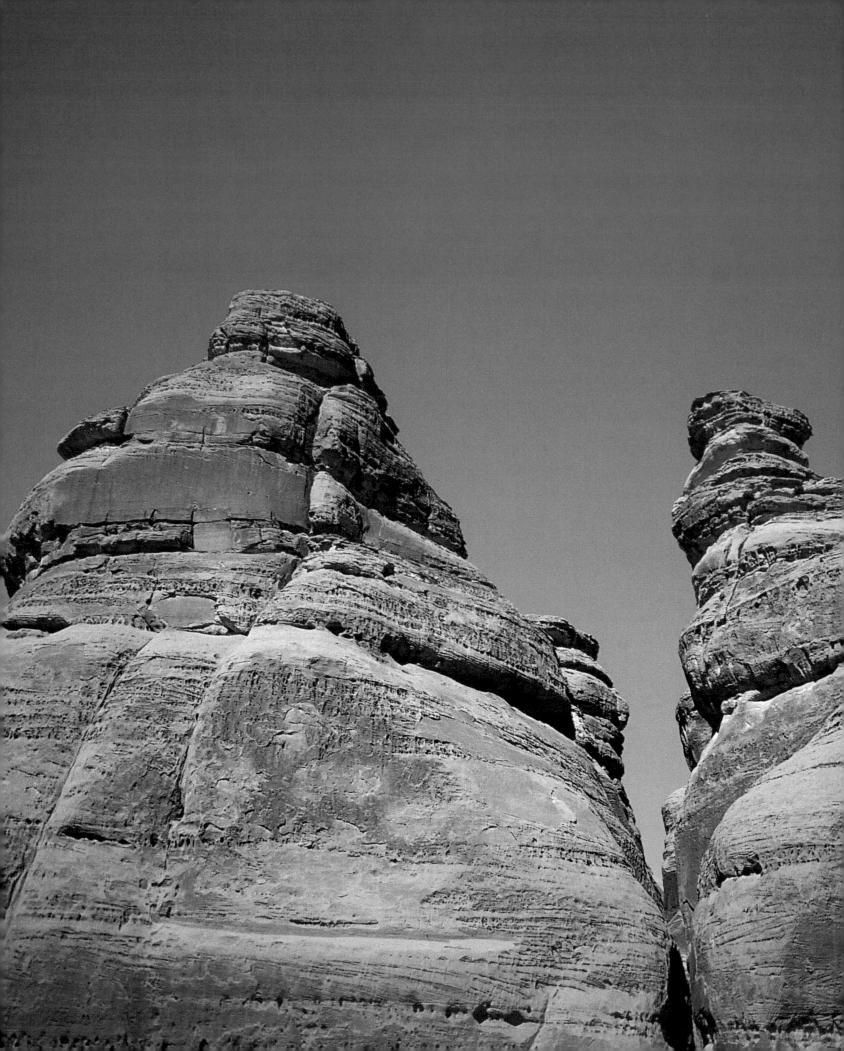

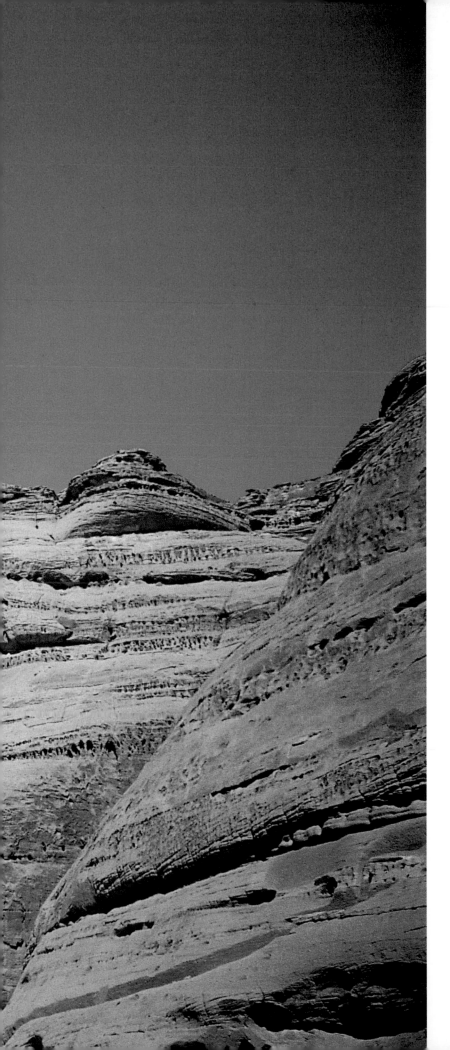

Shall we begin at zero point?
What harm in that?
The season of creation begins in the
season of nothingness:
 the arduous climb
 is the beginnng of the end.

Zuhur Dixon
from "Season of Beginning and End"

Rock formations at Madain Saleh, site of the
Nabataen ruins dating back to pre-Islamic times.

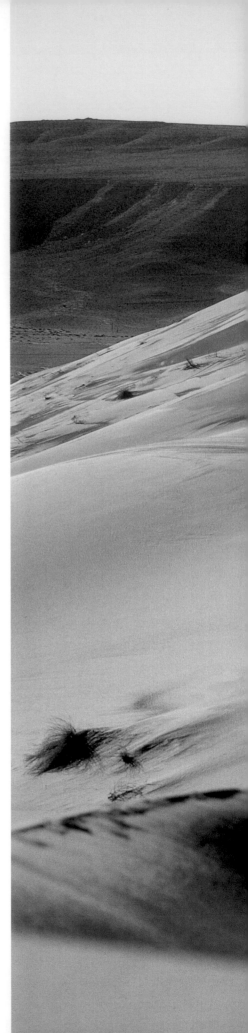

I've searched the world without finding
land more barren,
love more pure,
or rage more fierce than yours.

I came back to you, oh desert,
sea-spray on my face;
in my mind, a mirage of tears,
a shadow moving in the sea before dawn
and a golden flash of braided hair.
On my lips, two lines of poetry—
a song without echo.

I came back to you, disenchanted.
I've found there's
no trust between human beings.
I came back to you deprived;
the world's like a rib cage
without a heart.
Love is a word
devoid of love.
I came back to you defeated;
I've been fighting life's battles
with a sword forged from feeling.

I came back to you and laid my anchor
on the sand.
As I washed my face with dew
it seemed you were calling me.

Then you whispered:
"Have you come back to me, my child?"
Yes , mother, I came back to you.
A child, forever grieving,
flew to God's countries;
unable to find his nest,
he came back to search for his life in you.

I came back to you, oh desert,
I've thrown away my quiver and ceased wandering.
I dally in your night-web
of mystery,
breathing on the soft winds of the Najd
the fragrance of Araar.
In you I live for poetry and moons.

Ghazi al-Gosaibi
"Oh Desert"

124

A serpentine stretch of dunes southwest of Riyadh. Late afternoon.

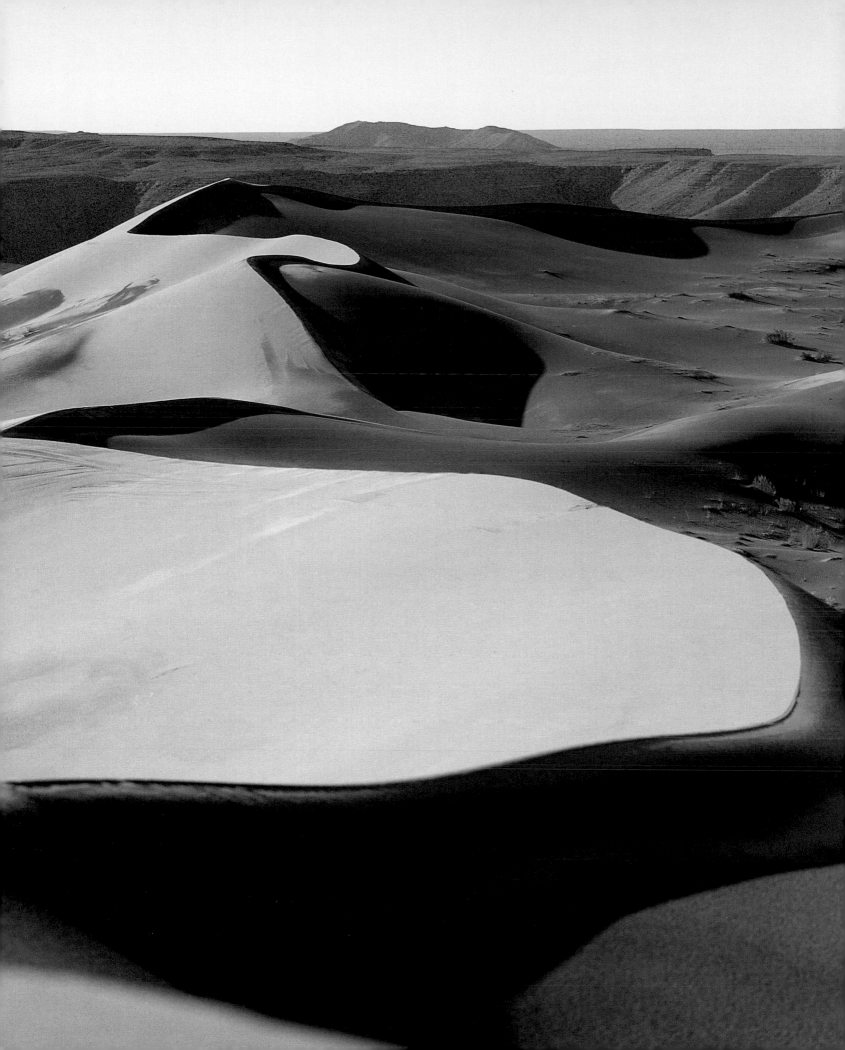

you see
 we haven't changed that much
 perhaps not at all
 our words are still
 strong, clear
the way we Bedouins talk
 long embraces
 asking after family and herds
 laughing thunderously
 the scent of old wood
 stored in barns
still breathes from our clothes

 you see
 we haven't changed that much

Amjad Nasir
from "Exile"

Brightly colored dresses and gold bangle jewelry offer an
often needed contrast to the starkness of the desert.

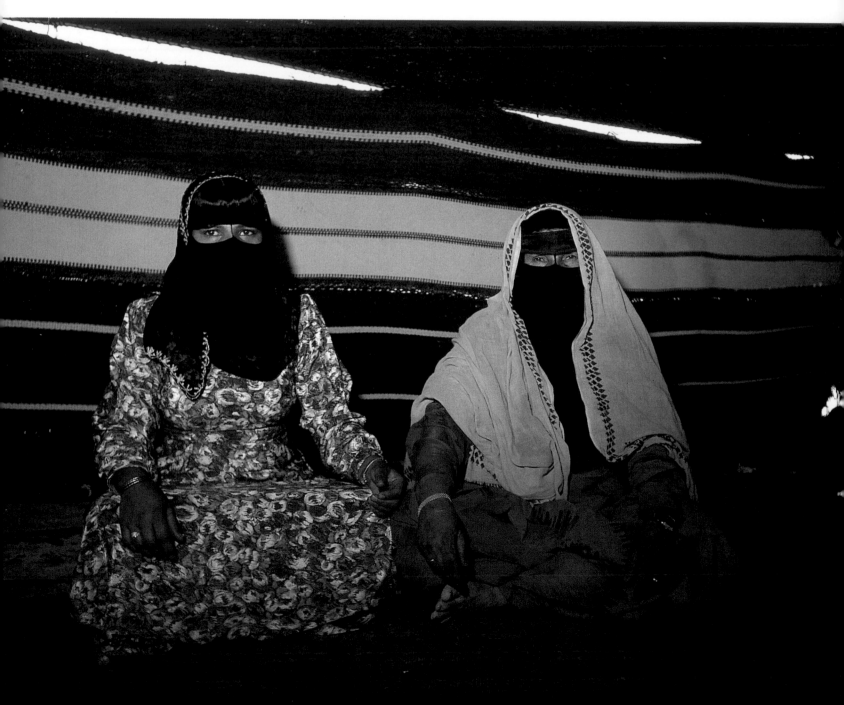

A tent with rustling breezes cool
Delights me more than palace high,
And more the cloak of simple wool
Than roles in which I learned to sigh.

Maysun, a Bedouin woman

A Bedouin encampment in the Dahna sands. Traditionally the women remain veiled in front of non-family members.

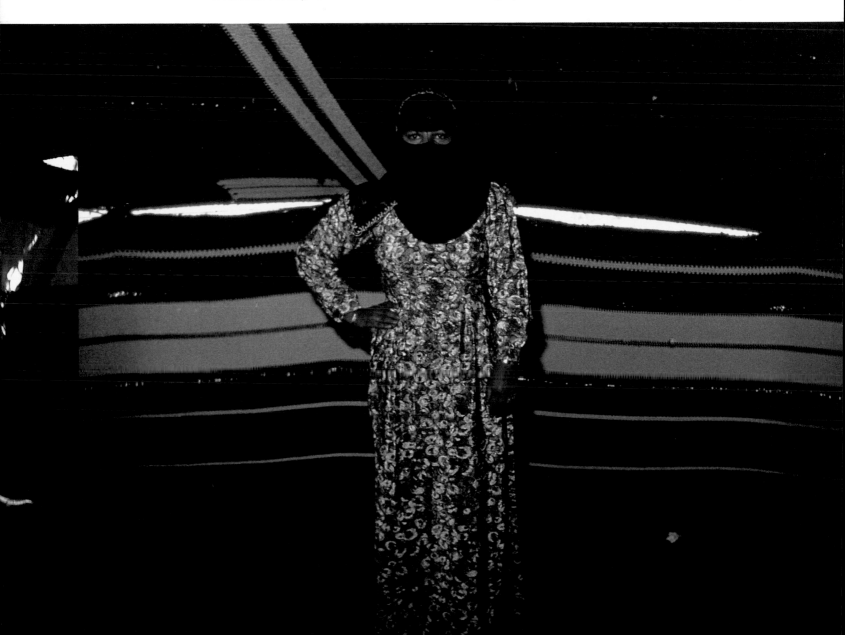

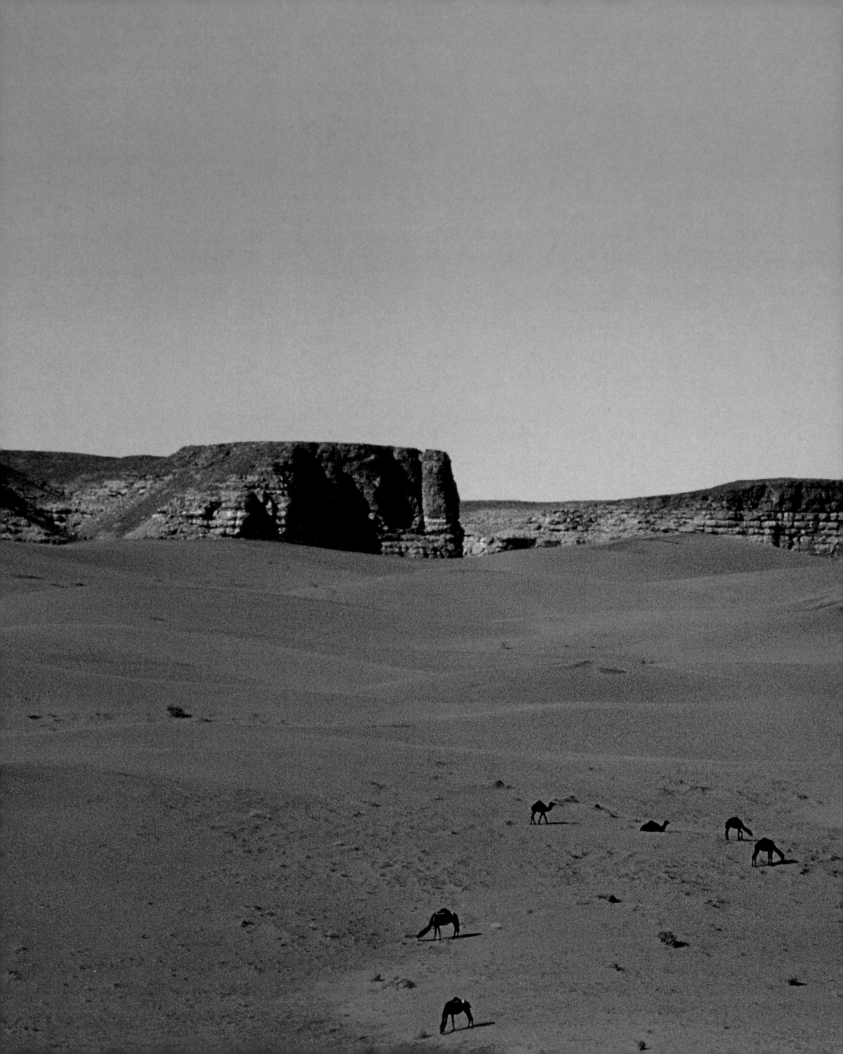

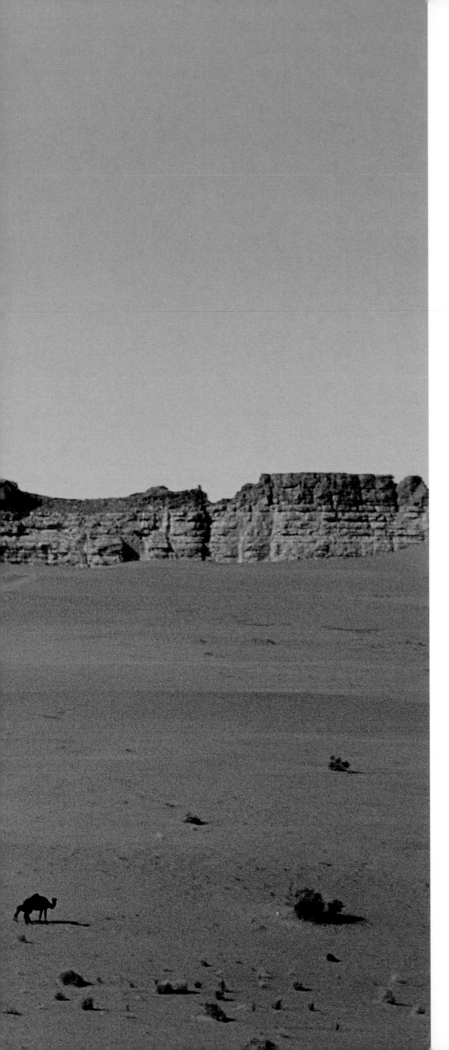

Camels! One cannot speak of
camels but with the deepest respect.
With the Lord no other species can
boast a comparable status.

Ad-Dindan

Scattered spots of vegetation provide food for grazing camels.

If death is sleep followed by a long awakening,
Why does our awakening while living fail to last forever?
Why can't we foretell the time of our departure?
When shall that secret be revealed?
I know not.

Abu Madi
from "The Tombs" (al-Talasim)

The mysterious shapes and undulations of the Rub al-Khali leave an unforgettable impression.

My joy in the sustenance I gave
Out of the very core of my life,
Is the joy of hands that give. . .

Khalil Hawi
from "The Bridge" (al-Jisr)

The traditional custom of decorating hands with henna is practiced by women throughout the Arab world.

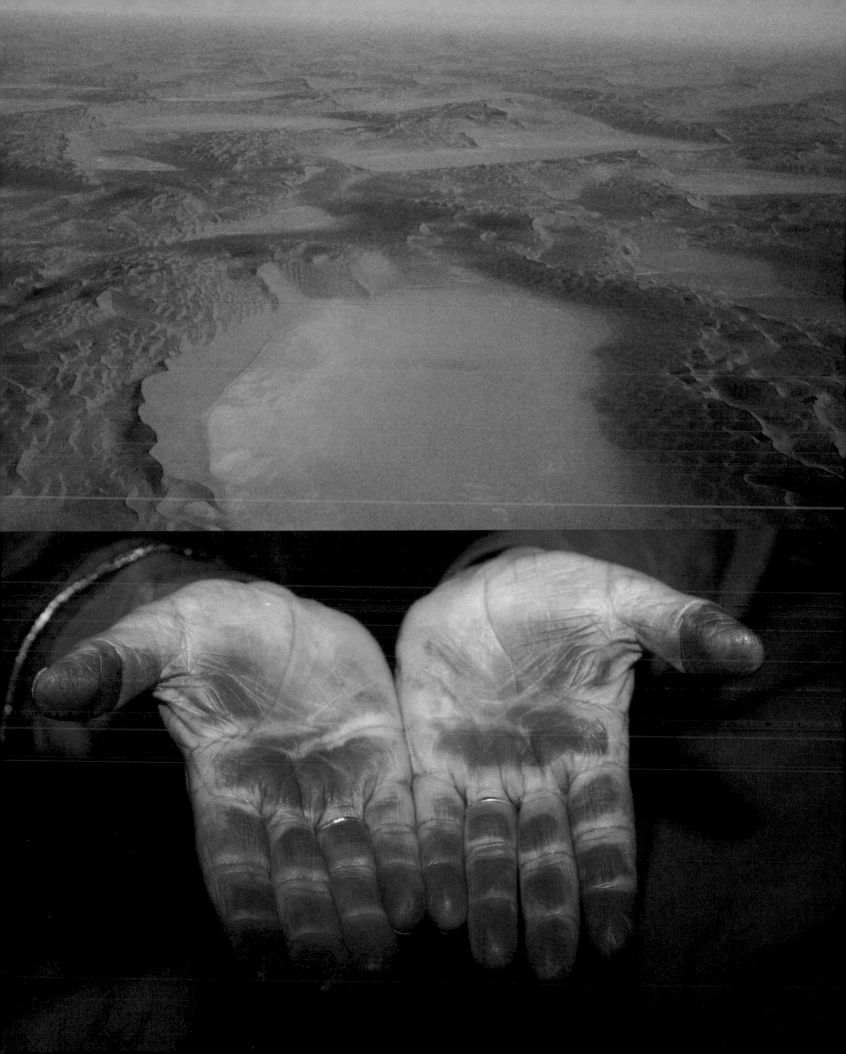

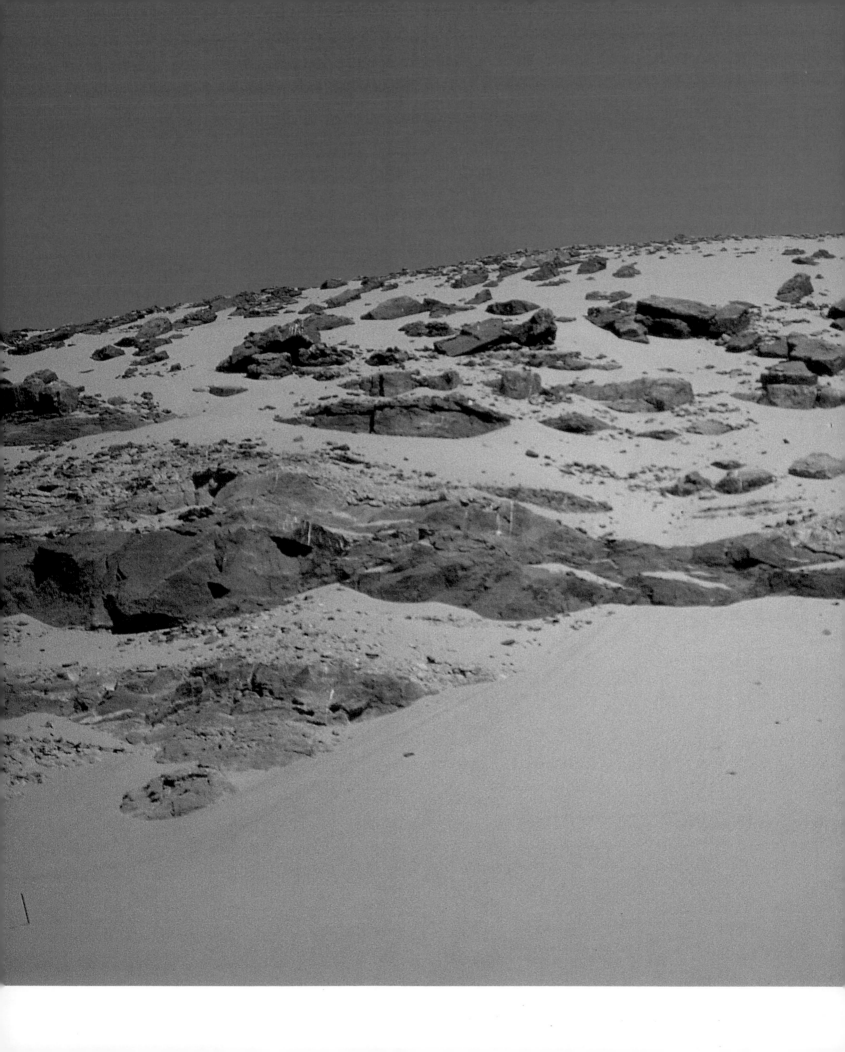

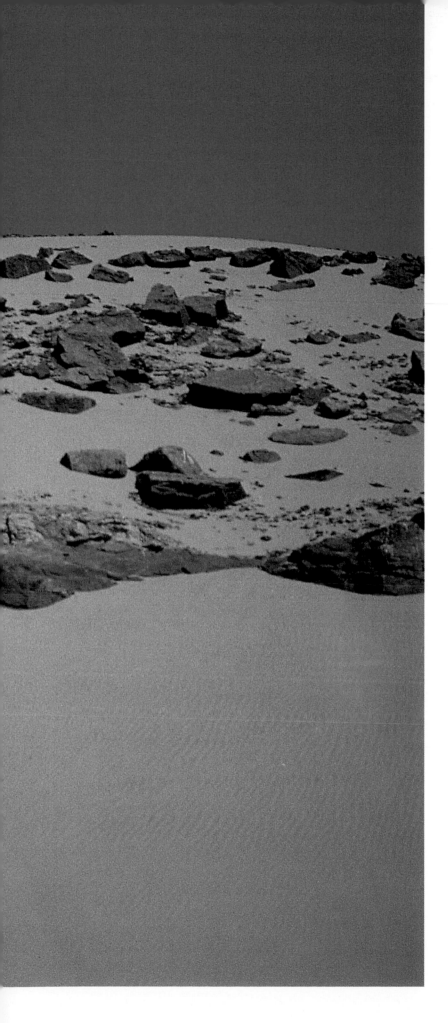

Time is Change, Time's fool is Man.
Wealth or want, great store or small,
All is one since Death's are all.

A Bedouin poet from the Hamasa

Stones and rocks are often covered by shifting sands.

Wait. This seems to be the kind of place
where I could lose myself in a trance . . .
the ruins of a palace fallen in the sand . . .

'Umar Abu Risha
from "A Roman Temple"

Bedouin woman.

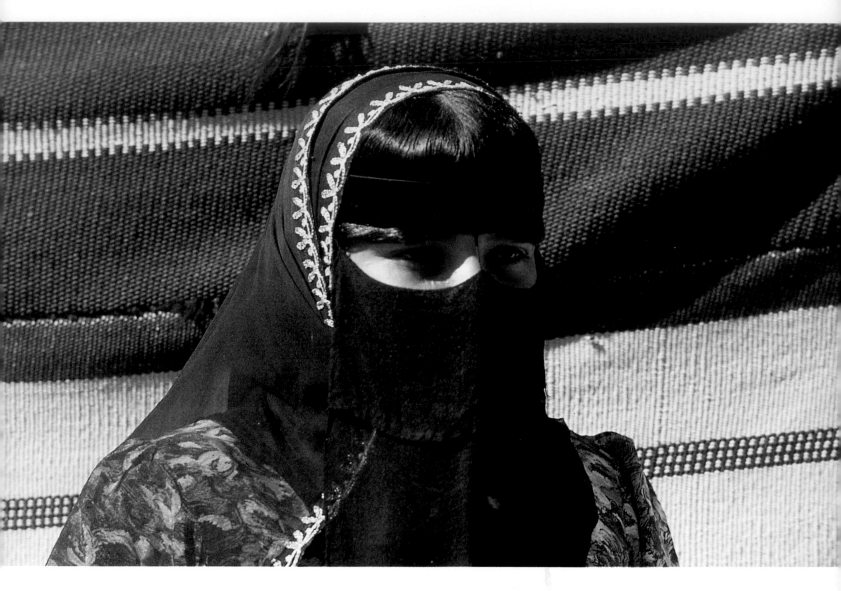

Home to the Bedouin and to the camel, the desert is also the resting place for palaces of the past. Dira'iya, ancient capital of the Al-Saud family.

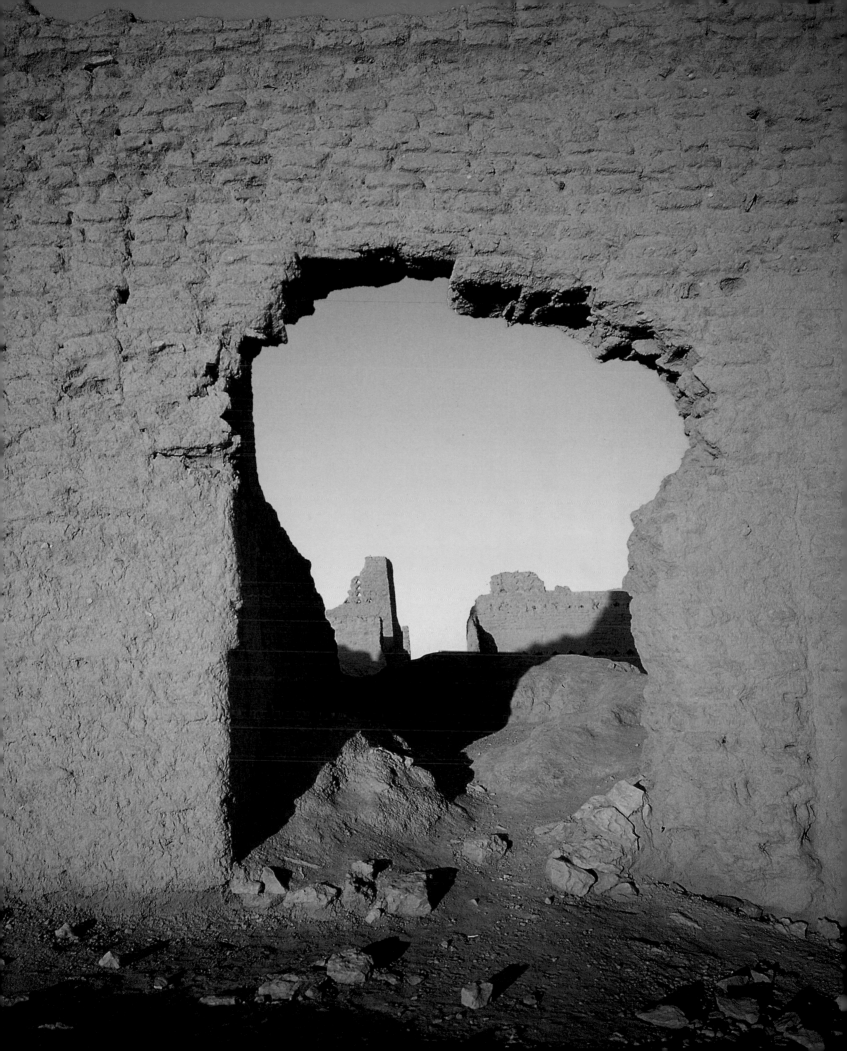

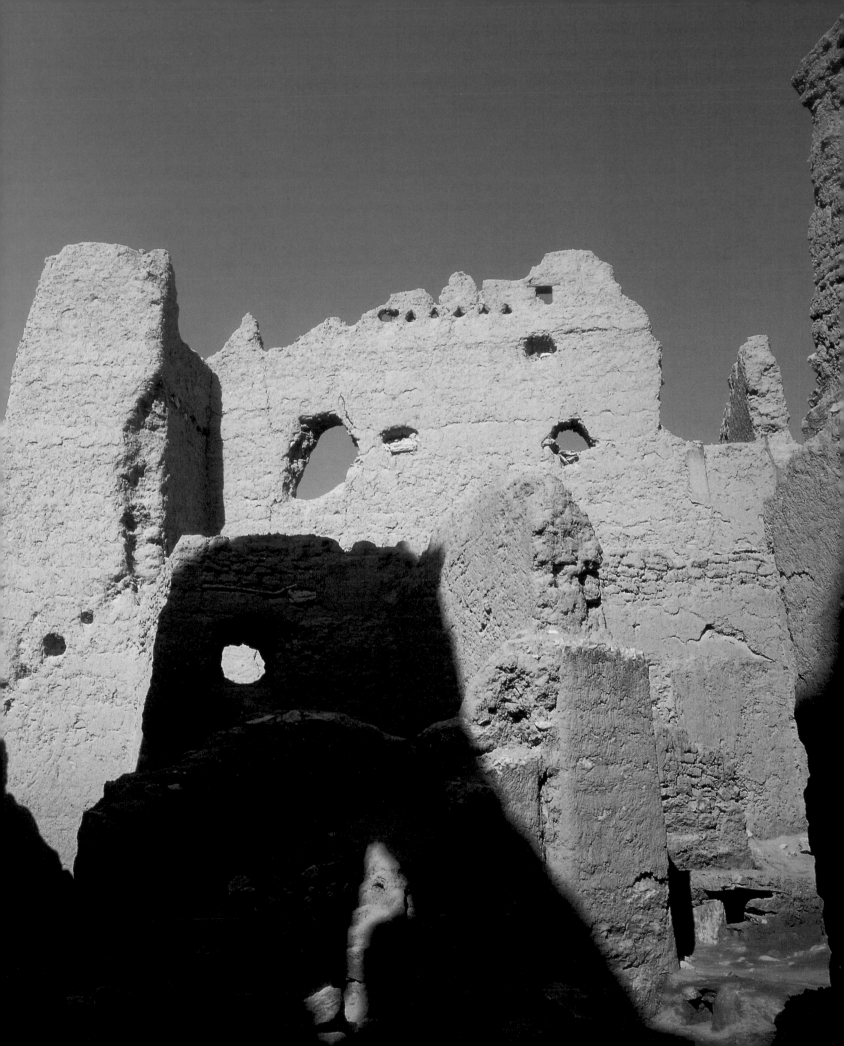

Does Time admit to this memory?
The fall of castles and walls
drought and rain
wheat and iron
and the power of the sword, at which men stare
with awe, as it lies
in its leather scabbard?

Mahmoud al-Buraikan
from "Tale of the Assyrian Statue"

Ruins at Dir'aiyah

The desert is also the site of Madain Saleh, ruins of the Nabataens.

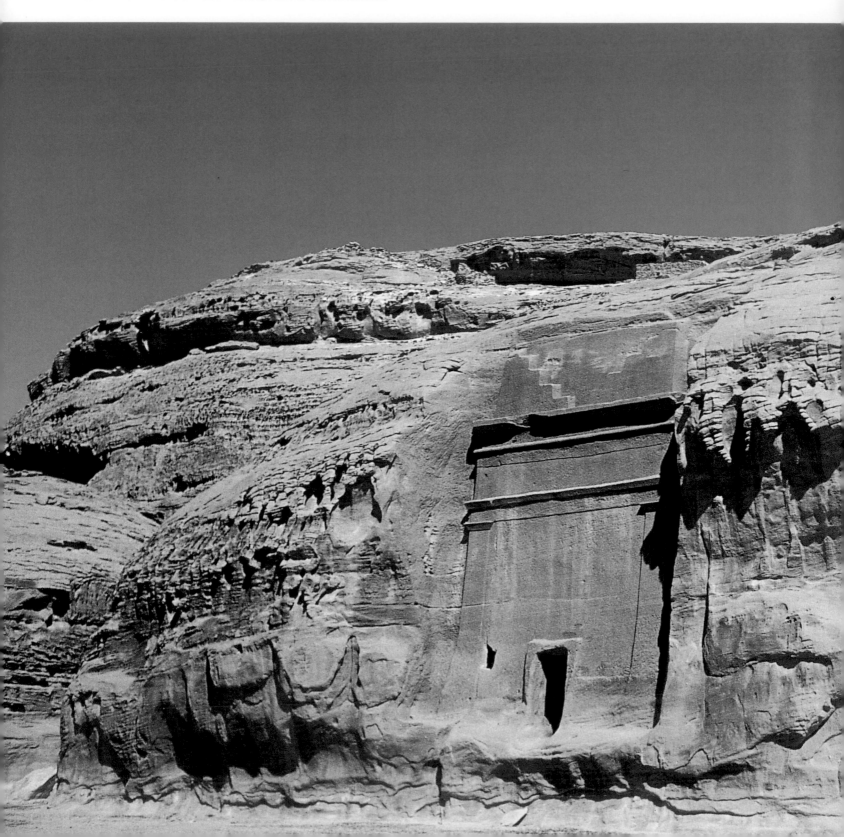

Successive rulers came;
 Pockets grew rife with gold;
Who bought us knew not why,
 Nor he who sold us knew what he has sold.

Abdallah al-Baraduni
from "Between Two Voids"

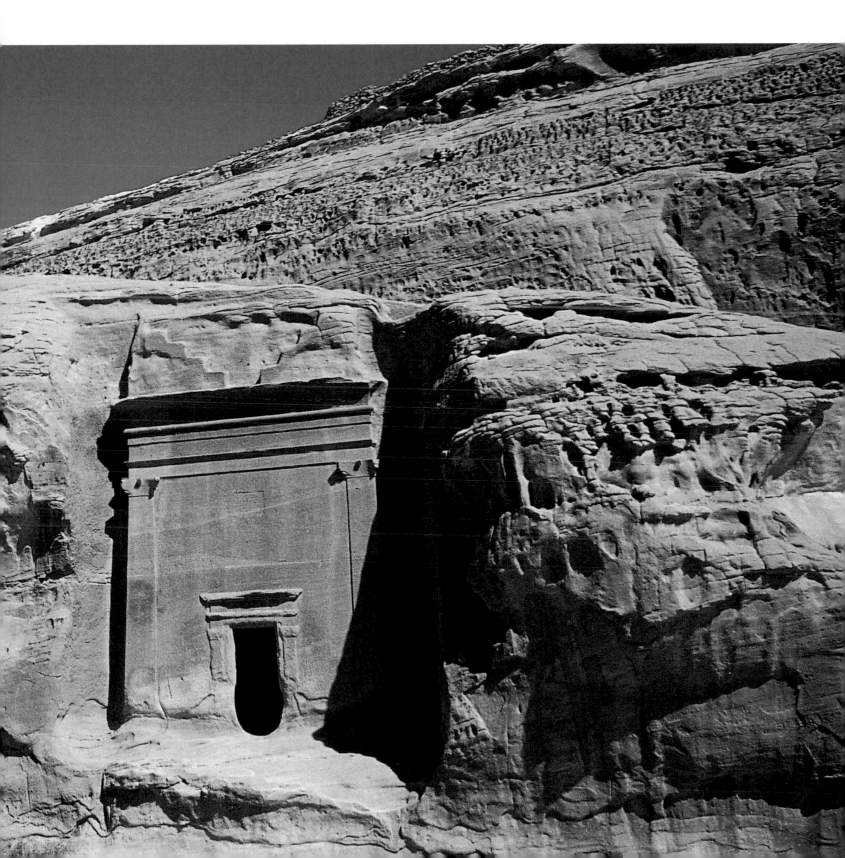

How much mystery this atom bears in the universe.
I stand reflecting, and merge in its essence.
How profound is this air, encompassing pious faith.
Let loose, I, an atom, move freely among God's creations,
Large and small.
I envision all the universe as incessant praise,
an invocation to God. True existence, how
ubiquitous in the soul, its serenity in communion,
how steadfast in the spirit!
All that is, flows in God's bosom.

Al-Tihani Yusuf Bashir
from "Tormented Mystic"

A morning walk in the windy mountains of the Asir.

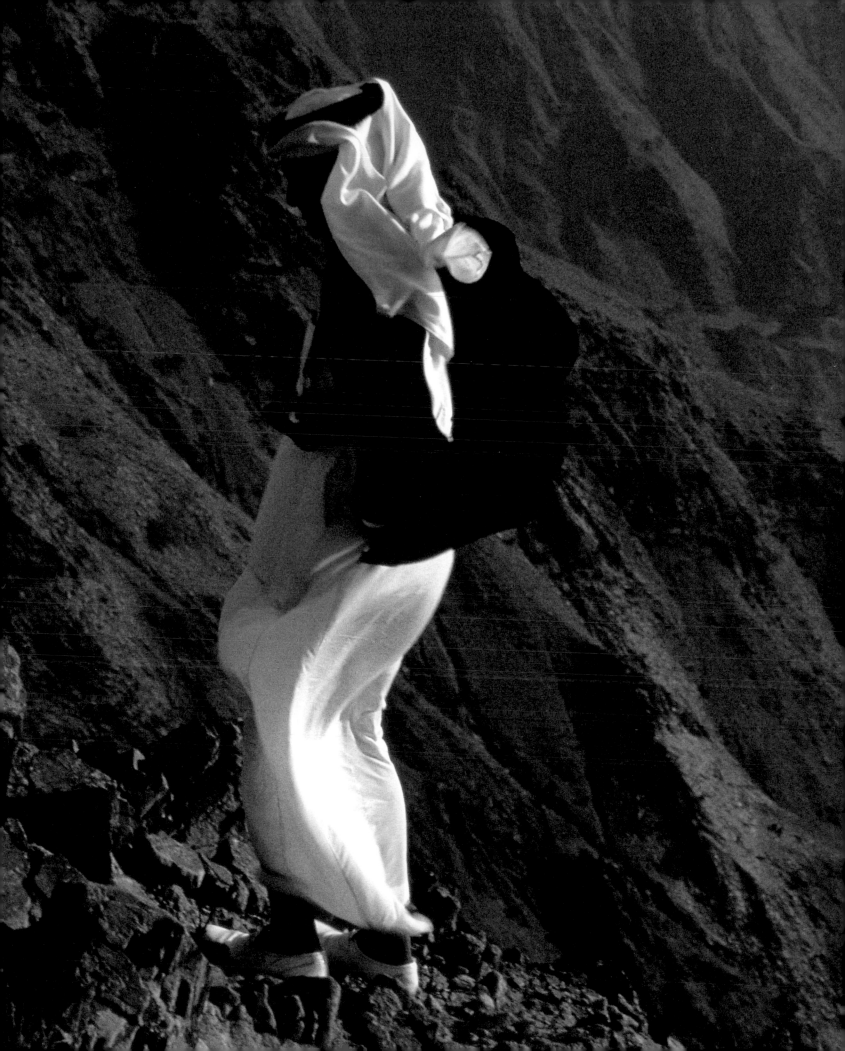

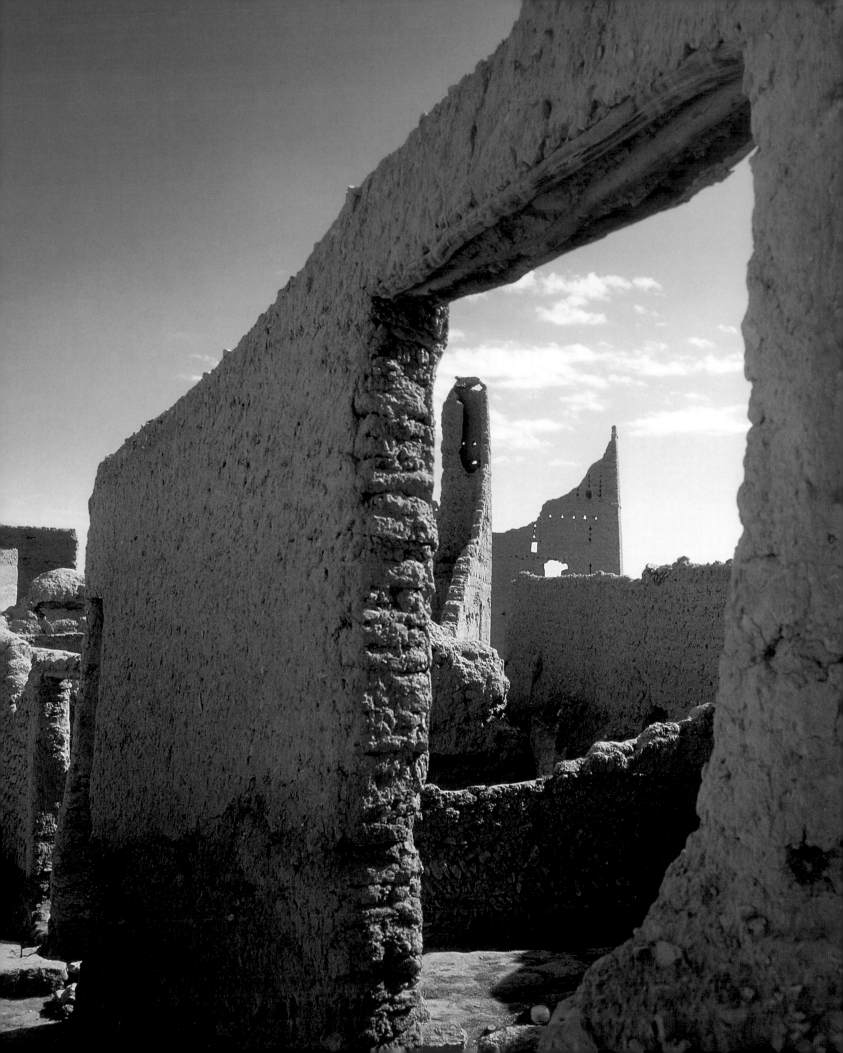

Stunned, I gaze around
and ask the present about its past.
Did life really flow here?
Did eyelids close on happy times
Did Fate decree its destiny and doom?
Shall I question the dumb rock
about those who carved it?
Can I summon up spectres from the grave?

'Umar Abu Risha
from "A Roman Temple"

The ruins of Dir'aiyah.

Alas my soul for Youth that's gone—
no light thing lost I when he fled!
What time I trailed my skirts in pride
and shook my locks at the tavern's door.
Nay, envy not a man that men
say, "Age has made him ripe and wise."
Though thou love life and live long safe,
long living leaves its print on thee!

Amr, son of Kami'ah
from the Hamasa

Early morning gathering of men in local marketplace (souk).

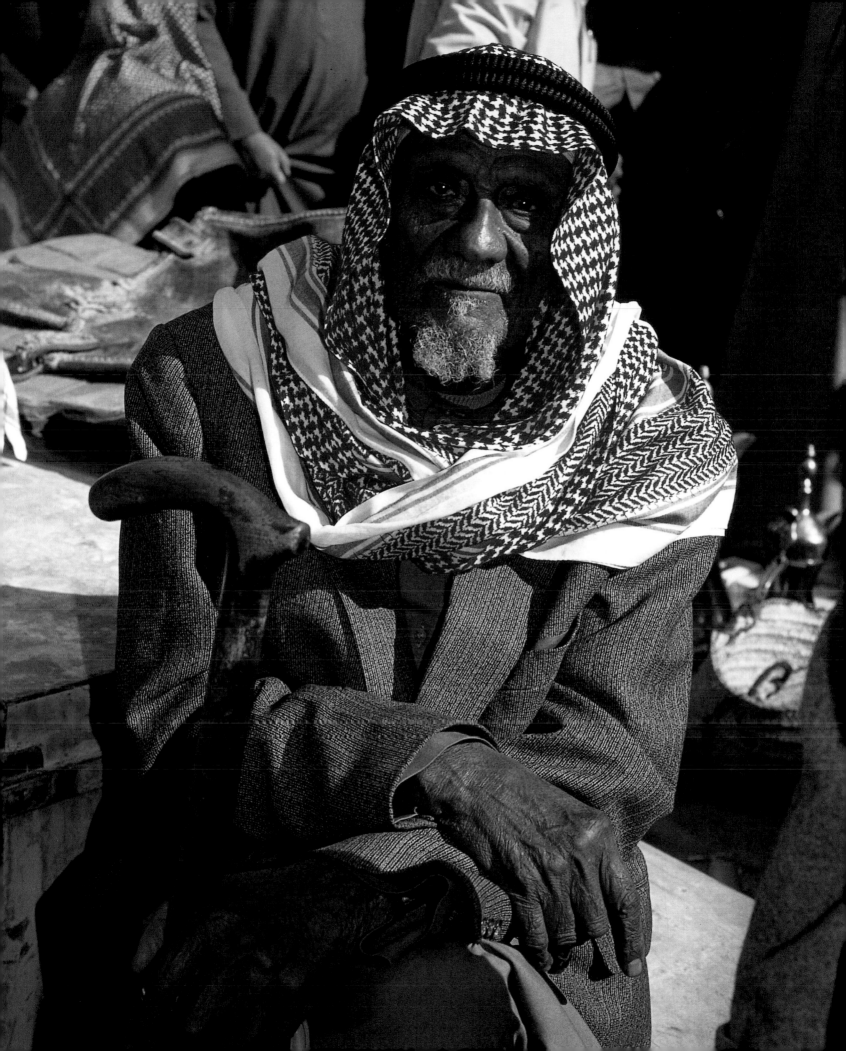

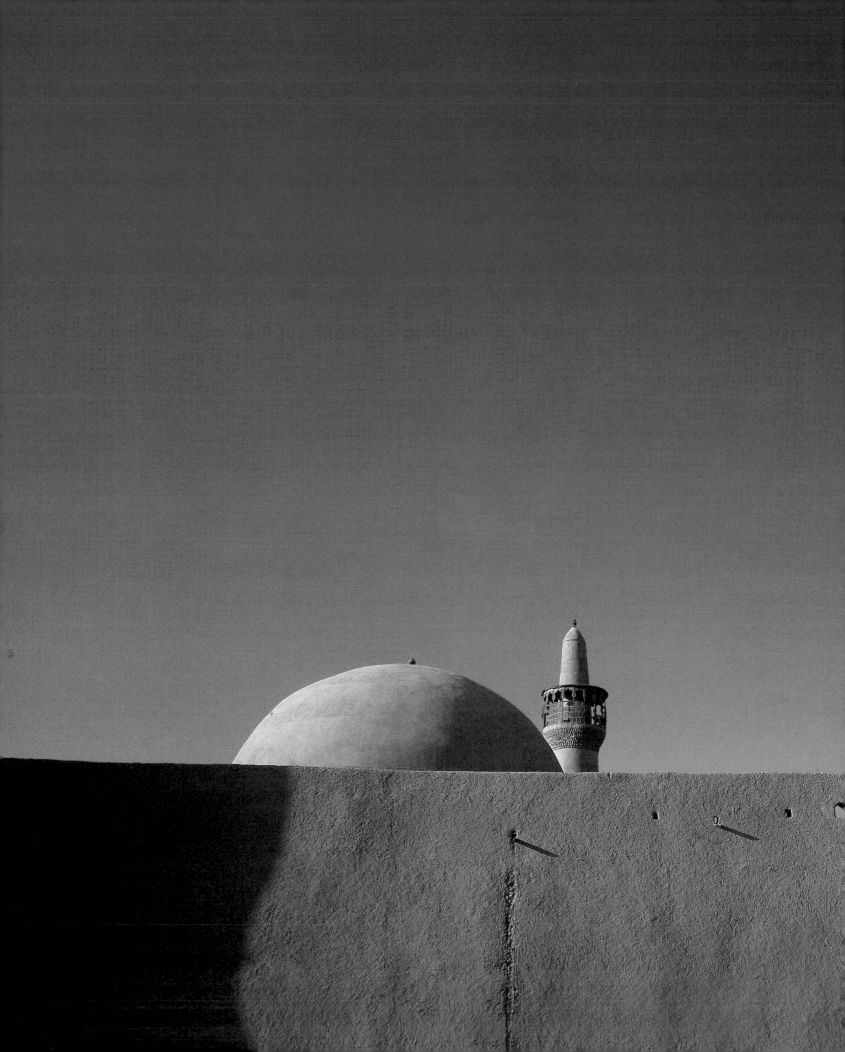

Whoever thinks life a heavy burden
 is himself life's heavy burden.
Enjoy then the morning as long as it lasts,
 fear not its loss before it is lost.
Oh you complain when nothing ails you
 be beautiful and you will see the world
 to be beautiful

Abu Madi
from "Philosophy of Life"

Dome and minaret of ancient mosque of Ibrahim. Hofuf, Eastern province.

148

A face floated on the water
but did not sleep
It was the face of God

Zuhur Dixon
from "Two Hands on the Water"

One of several mosques on the Jeddah corniche
by the architect Abdel Wahed Wayqil.

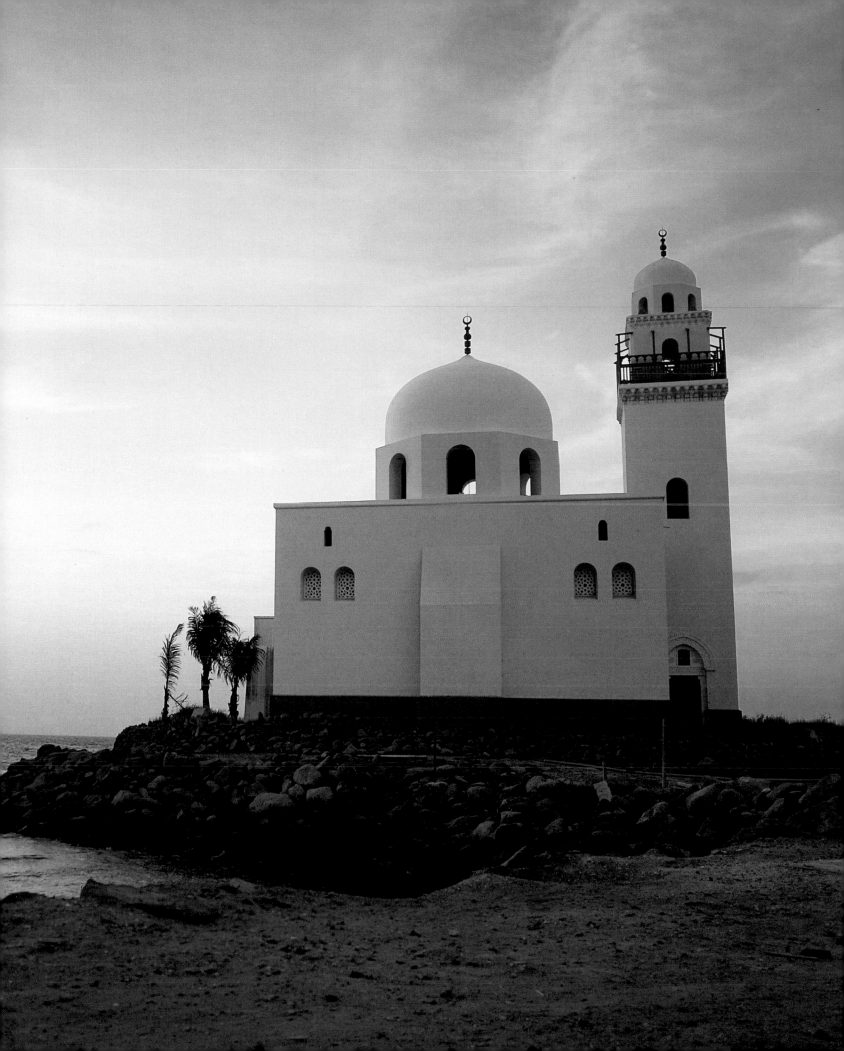

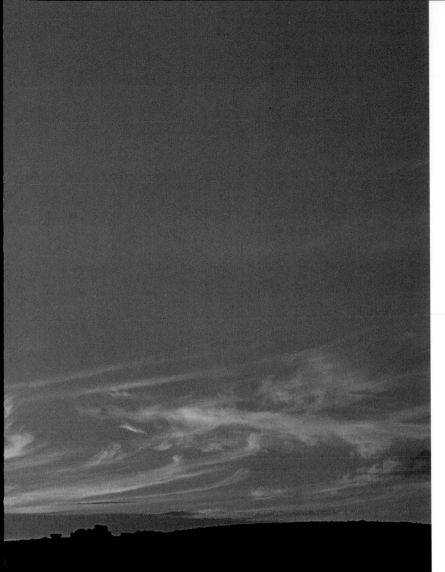

Don't ask me why I
 Adore Khuzama in love
For if you knew me
 You'd know the secret of passion

My origin a black tent,
 The desert my kin's home
My bed the earth my roof heaven
 And its dust is dear to me

I thrill to a young gazelle
 On a dune above a pool
And sight of a sand grouse bevy
 From meadow to meadow they fly

God, for the setting sun
 And the night when its breeze blows
And the fire sparked by burning coals
 And the star that sparks in the sky.

Khalid Al Faisal
"Don't Ask Me"

Sunset in the Najd.

Speak to me,
for the night is oriental fragrance,
a whisper of forgotten ages
and colored images and shadows,
coursing through my blood,
lighting me up,
forging chains out of my thirst,
to spread my hair like a waterfall
to hide you from the night and hide me.

Thurayya al-Urayyid
from "The Night"

Sunset over the date palms in the oasis of Dir'aiyah.

He that honors not himself lacks
 honor wheresoe'er he goes
Be a man's true nature what it will,
 that nature is revealed
To his neighbors, let him fancy as
 he may that 'tis concealed.

Zuhayr
from the Mu'allaqat

Friday mosque, Diplomatic Quarter, Riyadh

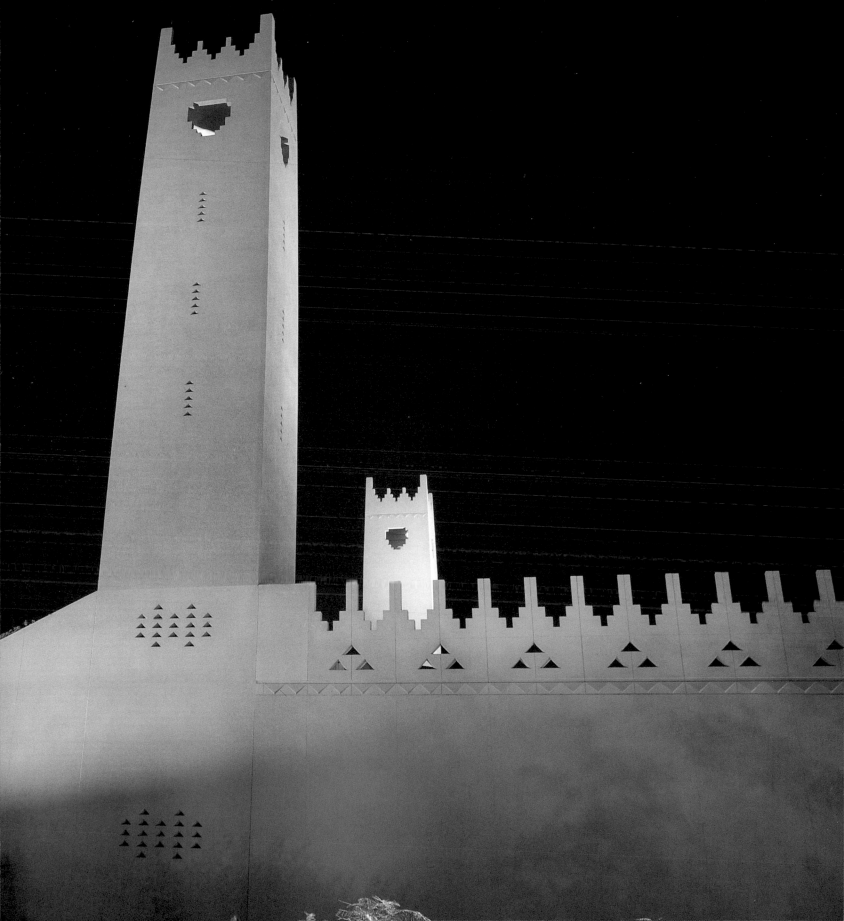

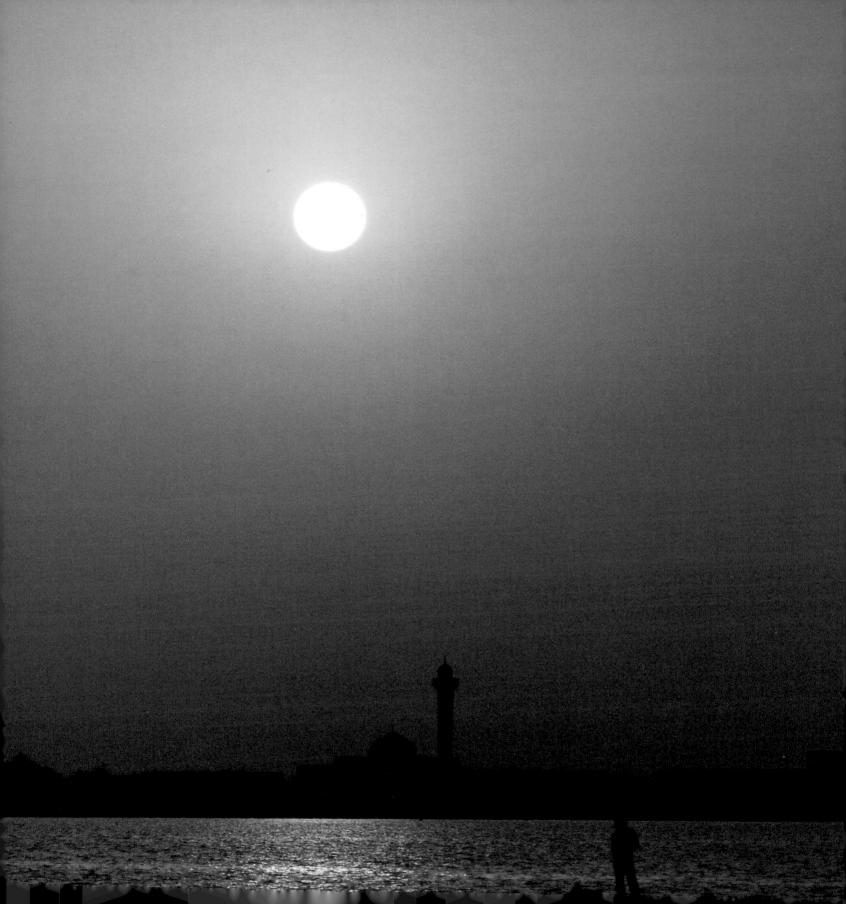

In my Muslim land, God,
we have returned to You;
depending, O my God, solely on you.
We remember tonight the Chosen Guide
who filled our spirit
with His purity and patience.

Muhammad al-Mahdi al-Majdhoub
from "Birth" (al-Maulid)

Mosque silhouetted at sunset on the Jeddah corniche.

Praise to You, God!
Powerful Willful God,
You sent us a herald,
a warning sign of light,
a great flame to guide us,
a messenger of Your Eye
without whose light
we wouldn't have seen you,
the Maker of all things,
in so many of this world's things:
yes, Your Prophet
who made death hope
and deathlessness a tree
whose flowers refusing to wither
never die.

Muhammad al-Mahdi al-Majdhoub
from "Birth" (al-Maulid)

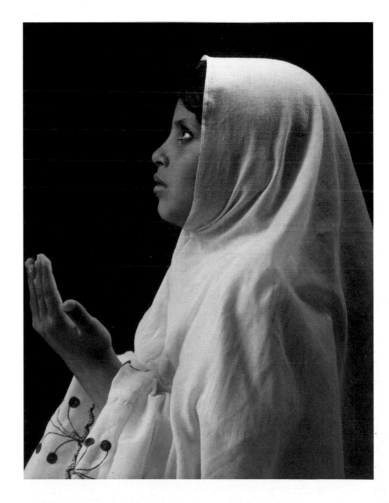

Young girl during Ramadan (annual month of fasting for Muslims).

BIBLIOGRAPHY

Al-Faisal, Khalid. *Poems by Khalid Al-Faisal*, translated by Alison Lerrick. Riyadh, Saudi Arabia: King Faisal Foundation, 1996.

Al-Hariri-Rifai, Wahbi and Mokhless. *The Heritage of the Kingdom of Saudi Arabia*. Washington: GDG Publications, 1990.

Ali, Assad. *Happiness Without Death: Desert Hymns*, translated by Camille Adams Helminski, Kabir Helminski, and Ibrahim Al-Shihabi. Brattleboro, Vermont: World Union of Arabic Writers, Threshold Books, 1991.

Arabic Proverbs, translated by John Lewis Burckhardt. London: Curzon; and Totowa, N. J.: Rowman & Littlefield, 1972. 3rd edition.

Bailey, Clinton. *Bedouin Poetry from Sinai and the Negev: Mirror of a Culture,* with foreword by Wilfred Thesiger. Oxford: Clarendon Press, 1991.

Fairbairn, Anne, and Ghazi Al-Gosaibi. *Feathers and the Horizon: A Selection of Modern Poetry from Across the Arab World.* Canberra: Leros Press, 1989

Imru'al-Qais, *Diwan Imru' u al-Qais,* ed. Mohammed Abu al-Fadl Ibrahim. Cairo: Dar al Ma'arif, 1964.

Jayyusi, Salma Khadra (editor). *The Literature of Modern Arabia.* London: Kegan Paul International, 1990.

Jayyusi, Salma Khadra (editor). *Modern Arabic Poetry.* New York: Columbia University Press, 1987

Khouri, Mounah A. *Studies in Contemporary Arabic Poetry and Criticism.* Piedmont, Calif.: Jahan Book Company, 1987.

Kurpershoek, Marcel. *Oral Poetry and Narratives from Central Arabia, Volume I: The Poetry of ad-Dindan, A Bedouin Bard in Southern Najd.* Leiden, The Netherlands: Koninklijke Brill, 1994.

Kurpershoek, Marcel. *Oral Poetry and Narratives from Central Arabia, Volume III: Bedouin Poets of the Dawasir Tribe between Nomadism and Settlement in Southern Nadj.* Leiden, The Netherlands: Koninklijke Brill, 1999.

Lawrence, T. E. *Seven Pillars of Wisdom.* London: Jonathan Cape, 1935.

Loti, Pierre. *Le Desert* (The Desert), translated by Jay Paul Minn. Salt Lake City: University of Utah Press, 1993.

Lyall, Charles James. *Translations of Ancient Arabian Poetry.* Concord, New Hampshire: Gibson Press, 1987.

McKinnon, Michael. *Arabia: Sand, Sea, Sky.* London: BBC Books, 1990.

Nicholson, Eleanor. *In the Footsteps of the Camel.* London: Stacey International Publishers, 1984.

Nicholson, Reynold A. *A Literary History of the Arabs.* London and New York: Cambridge University Press, 1930.

Sells, Michael. *Desert Tracings: Six Classic Arabian Odes by Alqama, Shanfara, Labid, Antara, Al-Asha and Dhu al-Rumma.* Hanover, New Hampshire: Wesleyan Universtiy Press / University Press of New England, 1989.

Thesiger, Wilfred. *Arabian Sands.* New York: Penguin, 1980.

Topham, John, and others. *Traditional Crafts of Saudi Arabia.* London: Stacey International Publishers, 1982.

Wilberding, Stevie. *Dir'aiyah: A Guidebook to the Ruins in Dir'aiyah.* Riyadh, Saudi Arabia: S. Van C. Wilberding Publishing, 1987.

p. 21, 29, 33, 70, 124, 152—from *Feathers and the Horizon: A Selection of Modern Poetry from across the Arab World*, selected by Anne Fairbarn, Ghazi Al-Gosaibi, Leros Press, Canberra, 1989.

p. 24, 35, 37, 41 (bottom), 47 (top, bottom), 57, 58, 61, 62, 66, 74, 115 (top), 123, 126, 134, 137, 140, 143, 148, 157 (top, bottom)—from *Modern Arabic Poetry*, ed. Salma Khadra Jayyusi, Copyright © 1987, Columbia University Press. Reprinted with the permission of the publisher.

p. 26—from *Bedouin Poetry from Sinai and the Negev: Mirror of a Culture*, ed. Clinton Bailey, with a foreword by Wilfred Thesiger, Clarendon Press, Oxford, 1991. Preface © Wilfred Thesiger 1991. © Clinton Bailey 1991.

p. 27, 73, 81—from *Seven Pillars of Wisdom*, by T.E. Lawrence, published by Jonathan Cape, 30 Bedford Square, London, 1935; Printed at the Alden Press © Seven Pillars of Wisdom Trust, London.

p. 31, 41 (top), 48, 69, 77, 94 (top), 102, 105, 108, 116—from *The Poetry of ad-Dindan: A Bedouin Bard in Southern Najd, Volume I of Oral Poetry and Narratives from Central Arabia*, by Marcel Kurpershoek. © Koninklijke Brill N.V., Leiden, The Netherlands, 1994.

p. 43—from *Diwan Imru' 'u al-Qais*, edited by Mohammad Abu al-Fadl Ibrahim, published by Dar al-Ma'arif, Cairo, 1964.

p. 45—from *Arabia, Sand, Sea & Sky* by Michael McKinnon, London, 1990.

p. 51, 52 (bottom), 94 (bottom), 144—from *Translations of Ancient Arabian Poetry*, by Charles James Lyall, Gibson Press, Concord, New Hampshire, 1981.

p. 65, 83 (bottom)—Michael R. Sells, translator, excerpts from *Desert Tracings: Six Classic Arabian Odes by Alqama, Shanfara, Labid, Antara, Al-Asha and Dhu al-Rumma*; translation © 1989 by Michael Sells, Wesleyan University Press, reprinted by permission, University Press of New England.

p. 78, 107 (bottom), 127, 133, 154—from *A Literary History of the Arabs*, by Reynold A. Nicholson, Cambridge University Press, London, 1930. Reprinted with the permission of Cambridge University Press.

p. 83 (top), 84, 101, 139—from *The Literature of Modern Arabia*, ed. Salma Khadra Jayyusi. © Kegan Paul International, London, 1990.

p. 87, 107 (top)—from *The Desert (Le Desert)*, by Pierre Loti, translated by Jay Paul Minn, University of Utah, Salt Lake City, 1993.

p. 89, 151—from *Poems by Khalid Al-Faisal*, translated by Dr. Alison Lerrick, published by King Faisal Foundation, Riyadh, 1996.

p. 93—from *Happiness Without Death: Desert Hymns*, by Assad Ali, translated by Camille Adams Helminski, Kabir Helminski & Ibrahim Al-Shihabi—World Union of Arabic Writers, Threshold Books, Brattleboro, Vermont, 1991.

p. 98, 130 (top, bottom), 147—from *Studies in Contemporary Arabic Poetry and Criticism*, by Mounah A. Khouri, published by Jahan Book Co., Piedmont, California, 1987.

p. 111—from *Enter Any Door: Collected Poems 1957–1977*, by Rosalind Clark, The Golden Quill Press, Francestown, New Hampshire, 1977. Reprinted with the permission of the author.

p. 115 (bottom), 120 (bottom), 129—from *Bedouin Poets of the Dawasir Tribe Between Nomadism and Settlement in Southern Najd. Volume III of Oral Poetry and Narratives from Central Arabia*, by Marcel Kurpershoek. © Koninklijke Brill N.V., Leiden, The Netherlands, 1999.

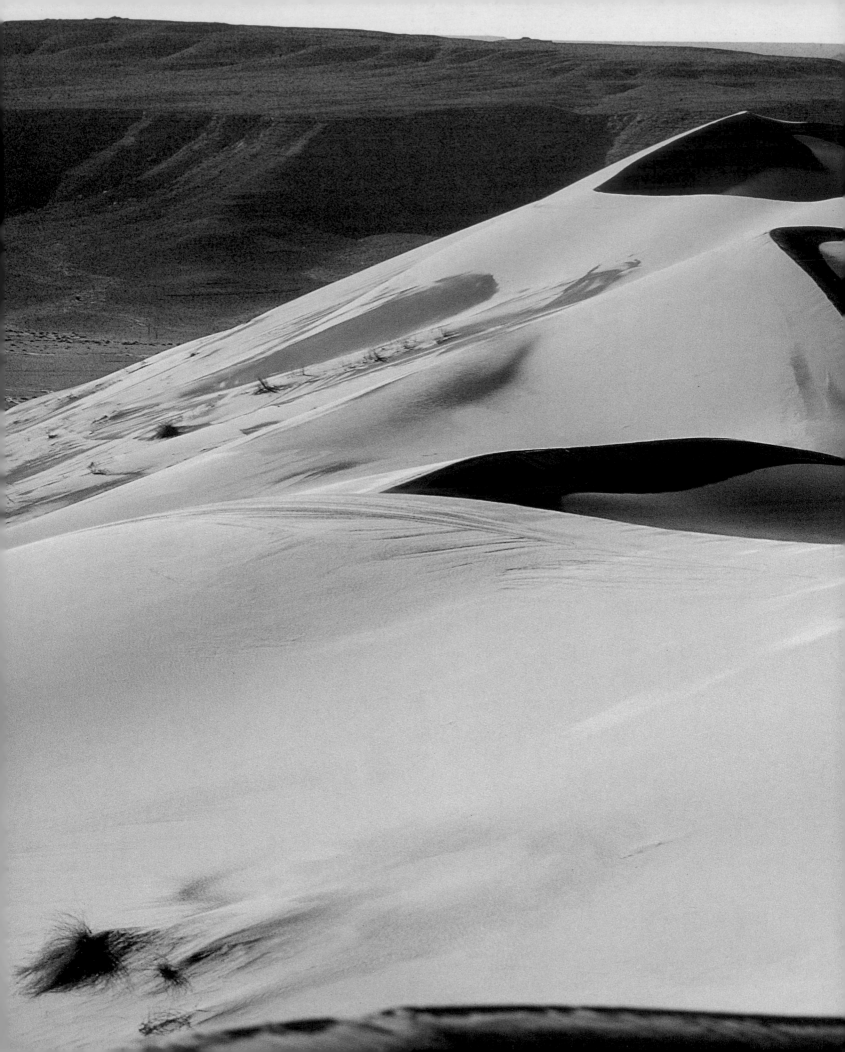